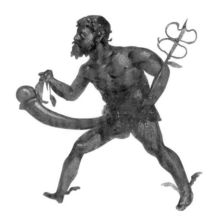

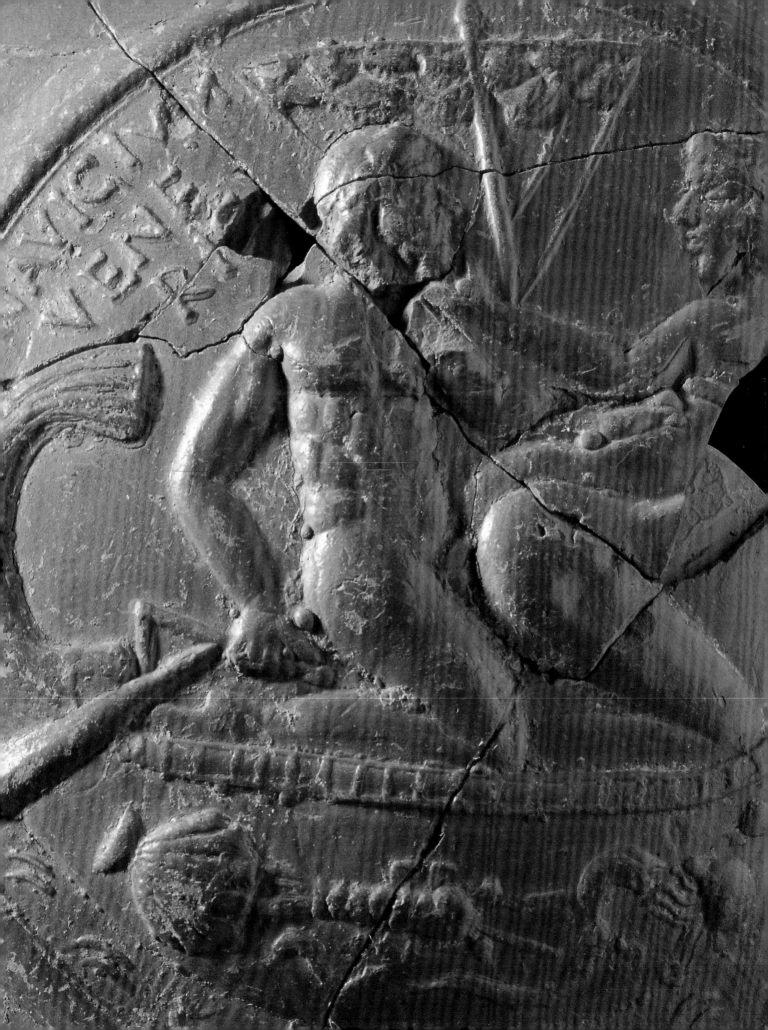

ROMAN SEX

100 BC • AD 250

by John R. Clarke

New photography by Michael Larvey

Harry N. Abrams, Inc., Publishers

For Michael

Project Director: Margaret L. Kaplan
Designer: Russell Hassell
Production Manager: Maria Pia Gramaglia

LIBRARY OF CONGRESS CATALOGING-IN-PUBLICATION DATA

Clarke, John R., 1945–
 Roman sex: 100 B.C. to A.D. 250 / by John R. Clarke ; new photography
by Michael Larvey.
 p. cm.
 ISBN 0-8109-4263-1 (hardcover)
 ISBN 0-8109-9158-6 (paperback)
 1. Art, Roman—Themes, motives. 2. Erotic art—Italy—Rome.
3. Sex customs in art—Italy—Rome. I. Larvey, Michael. II. Title.

N5760.c58 2003
700′4538′0937—dc21

 2002013157

Front and back cover: details, figs. 73 and 74; endpapers: detail, fig. 16;
page 1: fig. 71; pages 2–3: detail, fig. 96; page 5: fig. 7; page 6: fig. 64; pages
8–9: detail, fig. 27; page 10: detail, fig. 89; page 16: detail, Priapus fountain
statuette, House of the Vettii, Pompeii; page 36: detail, fig. 27-1; page 58:
detail, fig. 43; page 76: detail, fig. 53; page 94: detail, fig. 76; page 114:
detail, fig. 86; page 134: detail, fig. 106; page 156: detail, fig. 37

Printed and bound in Italy

10 9 8 7 6 5 4 3 2 1

Harry N. Abrams, Inc.
100 Fifth Avenue
New York, N.Y. 10011
www.abramsbooks.com

Abrams is a subsidiary of
LA MARTINIÈRE
G R O U P E

Contents

Acknowledgments

My first debt of thanks is to Michael Larvey, whose new photographs are but one aspect of his dedication to this project. He also offered me much encouragement, as did all of our friends—most notably Mary Wilson, who was the first to suggest that I undertake this project. Luciana Jacobelli, Andrew Riggsby, François Uginet, Nassos Papalexandrou, Anthony Corbeill, Lindley Kirksey, and Fifi Oscard each helped this project along in special ways. My research assistant, Álvaro Ibarra, deserves thanks for his dedication to this project, as does Kirby Conn, digital artist. Thanks also to administrative assistants in the Department of Art and Art History at the University of Texas at Austin: Alene DeLeon, Irene Roderick, and Elaine Stanfield.

I am also most grateful to the individuals who facilitated work at archaeological sites and museums in Europe and the United States. Pompeii: Pietro Giovanni Guzzo, Antonio Varone, Antonio D'Ambrosio; Naples: Stefano De Caro, Maria Rosaria Boriello; Ostia: Anna Gallina Zevi; Rome: Thomas Fröhlich, Laura Ferrea, Anna Mura Sommella, Carla Martini, Rosanna Friggeri; Lyons: Dominique Tisserand, Armand Desbat, M. J. Lasfargues; Nîmes: Dominique Darde; Arles: Michel Martin; Geneva: George Ortiz; London: Catherine Johns; Cyprus: Demetrios Michaelides; Boston: Christine Kondoleon.

Finally, I am most grateful to Margaret L. Kaplan, who edited the book, and to Russell Hassell, who designed it.

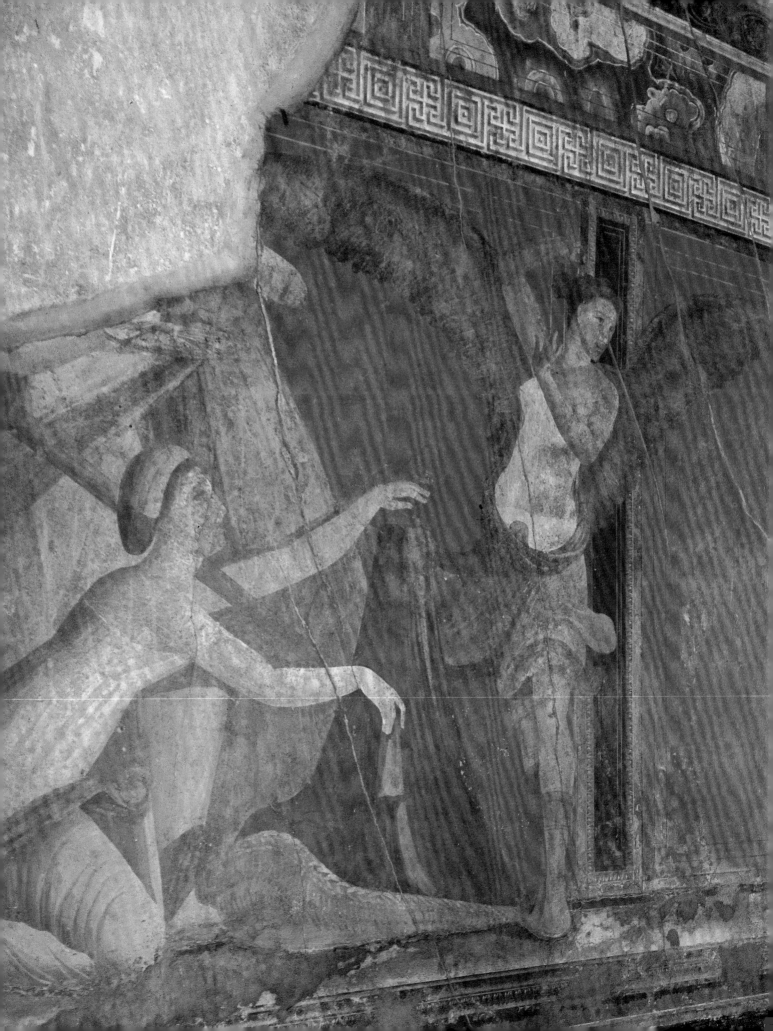

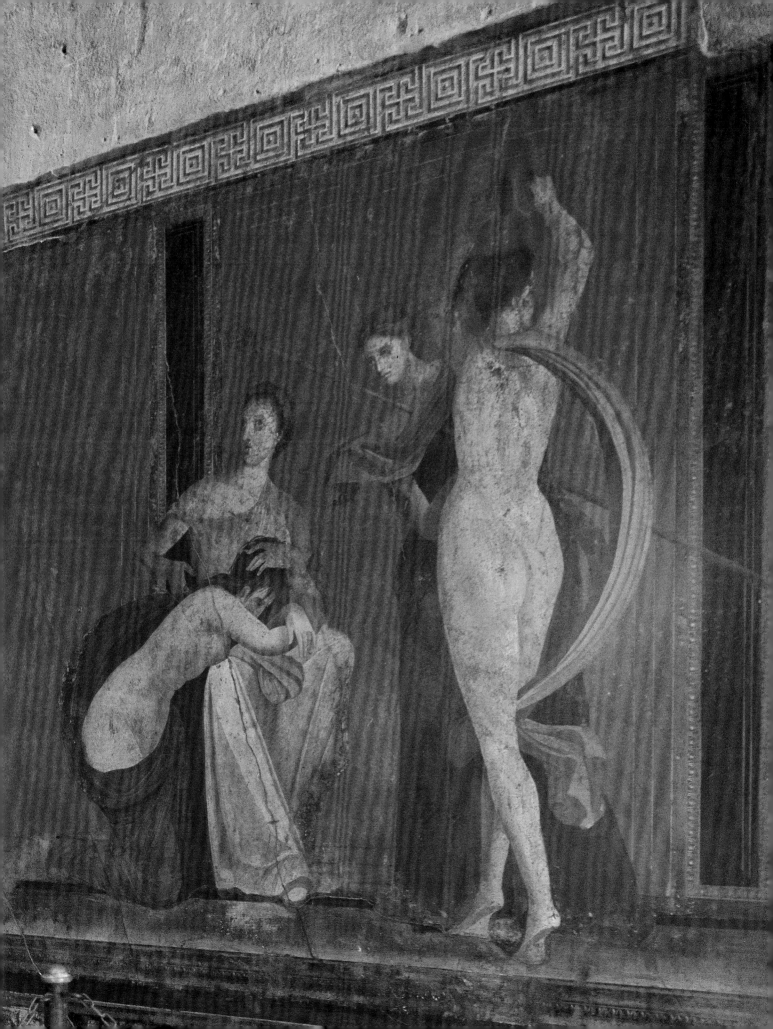

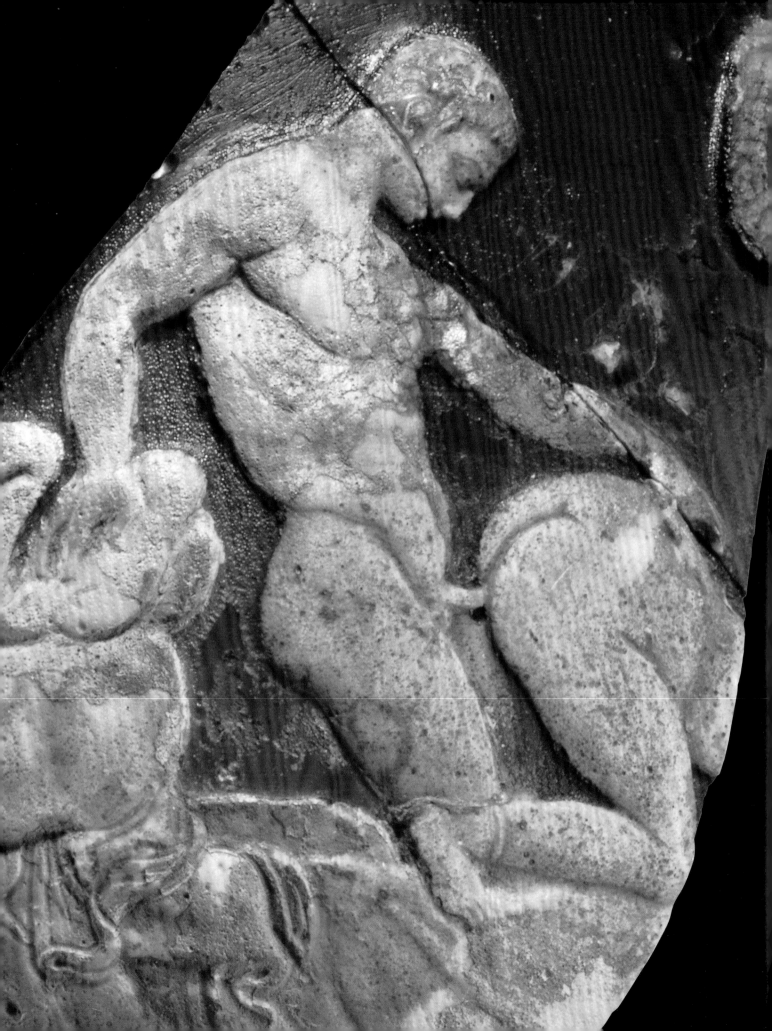

Introduction

WHY A BOOK ON SEX in ancient Rome? Many of the images are familiar enough—thanks to picture books of the "coffee table" variety. And for the erotic literature, there are good translations of sexually graphic poets like Catullus, Ovid, Martial, and Juvenal. Petronius's provocative novel, the *Satyricon*, was the basis for a popular film by Federico Fellini. What is there to say that's new?

For one thing, it turns out that the illustrated books ignore ancient *Roman* attitudes toward sexual imagery. To be sure, they present pictures of Roman "erotica"—paintings, mosaics, metalwork, and sculpture. But instead of presenting these objects in context—after all, archaeologists found most of them in ancient houses—these books treat them like modern pornographic photos. Because they are pictures of sex, it seems that they need no explanation. The accompanying captions offer little help. Usually, all we find is a scrap of Greek or Latin erotic poetry, or a bit of steamy dialogue from Petronius—all completely unrelated to the image itself. We get no idea of how these "erotic" images might have fit into the everyday lives of ancient Romans. Did they consider them sexually exciting? Did they hide them away from women and children? Did both rich and poor people have erotic art? Did the Romans find some of this art funny, as we do today? These are all questions the existing picture books fail to answer.

Roman erotic literature presents another set of interpretive problems. For one thing, elite men wrote all the erotic literature that has come down to us. You will not hear the voices of women. Nor will you hear the voices of men of the lower classes. For another, Roman sexual writing follows artistic forms quite unfamiliar to the lay reader: We find Catullus pining for his female lover, Lesbia, then heaping scorn on her as he sings the praises of his boy-love. Martial's acid attacks defame his enemies by accusing them of base sexual acts, using a form called "invective"—the sort of character assassination that would put a modern author in jail. Petronius's bisexual antihero, Encolpius, spends the whole novel trying to regain his erection, all the while having sexual (mis)adventures with a variety of men, boys, women, and girls. None of this literature fits modern notions of sexual behavior—let alone our practice of separating out "straight," "bi," and "gay" sexuality. The modern reader needs a great deal of background to understand the sexual practices these Roman writers were depicting.

Archaeology and the Creation of Pornography

Perhaps the greatest barrier to our seeing ancient sexuality clearly is one that we ourselves erected only a century and a half ago. It is the creation of "pornography." It is hard to believe that it was a German archaeologist, C. O. Müller, who invented the word pornography in 1850. Writing a scientific handbook on archaeology, Müller searched for a word to describe the many objects

found at Pompeii and elsewhere that he and other archaeologists considered "obscene." Like any good academician, he delved into his Greek dictionary and found a likely word, *pornographein*, meaning "to write about prostitutes." Ancient Greek literature had passed down this term to describe men who wrote about famous *pornai*—highly skilled women who, somewhat like the Japanese *geisha*, entertained men at drinking parties with music, dance, and sex.

Early social scientists before Müller had, in fact, also borrowed the word "pornography." For them, the word had the same meaning as it did in ancient Greece: writing about prostitutes. But rather than praising accomplished prostitutes, as the ancient Greek authors had done, these French and English gentlemen took it upon themselves to describe and try to regulate whores. For example, in 1769 Nicholas Edmé Restif wrote a treatise called: *The Pornographer (Le Pornographe): A Gentleman's Ideas on a Project for the Regulation of Prostitutes, Suited to the Prevention of the Misfortunes Caused by the Public Circulation of Women*. About a century later, William Acton published his thorough, scientific treatise, also defined at the time as "pornography"—that is, writing about whores: *Prostitution, Considered in Its Moral, Social and Sanitary Aspects, in London and Other Large Cities: With Proposals for the Mitigation and Prevention of Its Attendant Evils*. Until 1905, the Oxford English Dictionary still defined the word "pornography" in the old sense: "a description of prostitutes or of prostitution, as a matter of

public hygiene." So far we have no mention of the word "pornography" in today's sense of the word. We only have men writing about the social phenomenon of women selling sex.

What changes forced C. O. Müller to coin the word "pornography" in *today's* sense? On the one hand, scientific archaeology, just beginning to take hold around 1850, demanded that obscene objects be preserved. Up until then, the excavators either destroyed them on the spot or locked them up in secret cabinets accessible only to wealthy gentlemen. On the other hand, with the Industrial Revolution and the rise of the middle class came the notion that the public had to be protected from writing and images that might inflame their passions and lead them to sexual depravity. This was especially true for women and the "young person." In 1857, the British Parliament passed the Obscene Publications Act, "intended to apply exclusively to works written for the single purpose of corrupting the morals of youth." Lord Lyndhurst, who opposed the Act, asked a question that still is relevant today: "What is the interpretation that is to be put upon the word 'obscene'? I can easily see that two men will come to entirely different conclusions as to its meaning."

Our concept of pornography depends on our judgments about what is obscene. It is obvious that notions of the obscene have changed swiftly and unpredictably. Today, the censorship battles over *Lady Chatterly's Lover* and *Tropic of Cancer* seem quaint, while we hardly notice the sexual content that has become stock-in-trade in today's television

and movies—content that could never have passed the censors thirty years ago. If for us pornography means representation of actual sexual penetration in some form, remember that the censors of the 1970s tried to sequester *Hustler* magazine for displaying women's genitals.

The Invention of Sexuality, Heterosexuality, and Homosexuality

Even more recent than our concept of pornography are our concepts of sexuality, heterosexuality, and homosexuality— notions that would have been just as alien to an ancient Roman as space travel or telecommunications. Like the concept of pornography, academicians coined these words to allow them to describe human behaviors. Before 1890, there was no word to describe people who preferred same-sex relationships, nor even one to describe people who preferred opposite-sex rela- tionships. Yet today people routinely talk about their "sexuality." Throughout the twentieth century, the study of sexual prac- tices enlarged the public's understanding of various heterosexual and homosexual behaviors. And it was not only Freudian psychoanalysis that put sexuality on the map. Social movements such as feminism, the sexual revolution, and gay liberation all needed these terms to describe gender roles as well as sexual practices.

What a difference a century has made! Just as we have invented "sexuality," "homosexuality," and "heterosexuality," we have invented a new set of attitudes toward sexual representation, and these attitudes center on the words—in fact, they *require* the words—"pornography" and "obscene."

You may ask how and why I became involved in the study of sex in ancient Rome. My research into Roman ways of seeing sex started over ten years ago. I was fascinated by a beautiful silver cup with two explicit scenes of "gay" lovemaking. It was an "orphaned" art object if there ever was one. Hidden away in a Swiss museum, its owner afraid that it was a fake. Why? Because it was so—explicit! The more I probed, the more I found other ancient Roman art objects that museums and archaeological digs had deliberately hidden from the public or just locked up and ignored because they were "dirty."

By the time I completed my research, I had found a large number of Roman erotic objects that the public had never seen. It was an embarrassment of riches. But I didn't want to produce just another picture book. I wanted to peel away modern concepts of the pornographic and the obscene and try to understand the attitudes of ancient Romans. How to see ancient sexual imagery with Roman eyes?

As it turned out, the scholarly book that emerged from my research, *Looking at Lovemaking: Constructions of Sexuality in Roman Art, 100 B.C.–A.D. 250*, was able to deal with only a small portion of my discoveries. I decided to limit its scope to "case studies,"

*Ancient Romans
would find most
of our attitudes
toward sex strange,
even absurd.*

each concerned with representations of human beings in sexual intercourse. This decision arose from my realization that *Looking at Lovemaking* could only be a first step toward replacing modern notions of pornography with ancient Roman conceptions. I excluded many themes: that of the phallus as a good-luck charm, the images of gods and demigods having sex, and a whole range of imagery found in verbal and visual graffiti.

Yet in that book I did forge a method for investigating "pornographic" paintings, mosaics, and sculptures. For every case study, I asked the same common-sense questions. Who paid for the image? Where was it located? Who looked at it? What else did it look like? What purpose did it serve? Asking these questions allowed me to understand the differences between us and the ancient Romans in matters of sex. Often I was able to find out where the obscene objects, now hidden in museum storerooms, originally came from. I put them back into their original settings. In this way, I could reconstruct the ancient experience—the situations where men, women, and children originally looked at what we today consider "obscene."

In *Roman Sex* I have abandoned the "case study" approach so that I can examine the entire range of ancient Roman sexual representation, including the images and texts that I had to exclude from the scholarly

book. In the seven years since I completed *Looking at Lovemaking*, I have extended my study of Roman sexuality to new objects and areas. I have learned new ways of interpreting these objects. *Roman Sex* aims to convey the results of this new work to the nonspecialist reader. The result, I think, greatly expands the meanings that sex had for ancient viewers. By looking at the contexts surrounding this much larger range of images, I am able to show that ancient Roman responses were quite different from ours. For example, objects that seem quite obscene to us, like enormous phalli on the streets, had no such associations for the ancient Romans.

I think that this new, broad-based approach to ancient Roman attitudes toward sex will surprise you as much it did me. In no way do I "water down" the content or simplify my conclusions. But I have tried to write briefly and to avoid technical language. For readers who want more detailed information, I have provided a list of suggested further readings.

Just Like Us?

What I aimed for here is to bring to life the sexual images and literature that the ancient Romans looked at, read, and lived with. I also emphasize the differences between us and

the ancient Romans in matters of sex and sexuality; I demonstrate that the Romans were *not* "just like us."

There is a valuable lesson to be learned here. Although we moderns, in the wake of the century that began with Freud and ended with the Clinton-Lewinsky scandal, think we are fully liberated, our notions of sex are highly structured. Every aspect of what we call "our sexuality" rests on a set of assumptions about sexual acts and sexual roles that we are often not even aware of. Although we think we are completely free, we have many taboos and restrictions: about what we allow for men as opposed to women, about children's sexuality, about what is sexually acceptable and what is sinful or obscene, about what is heterosexual behavior and what is homosexual, and so on.

Ancient Romans would find most of our attitudes toward sex strange, even absurd. The rules we take for granted—rules that regulate what we do or do not do in bed—have nothing in common with the rules the ancient Romans followed.

This book will take you into the Roman mindset about sex. You will find out how Romans thought and felt about what we call straight, bi, gay, and lesbian sex; their attitudes toward such diverse subjects as group sex, penis size, men's versus women's roles in sex, cunnilingus, and fellatio. You will explore their worship of gods and goddesses who conferred the gifts of sexual pleasure.

You will enter a world filled with evil spirits banished by images of erect penises.

The sexual attitudes and practices that I describe here were typical of the whole Mediterranean world in the first two centuries A.D.—the same period that saw the emergence of the Christian tradition. I hope that in thinking about these seemingly strange sexual practices you will come to appreciate some of the positive aspects of Roman sexuality. Above all, good sex in whatever form was a much-appreciated gift of the gods. To pursue sex was a good thing—not a shameful thing. Romans stigmatized many fewer sexual practices than we do. If sex was a blessing of Venus, then why punish people for enjoying that blessing? The guilt that we associate with sexual enjoyment would seem very strange to the Romans. Sex was something to be enjoyed. Sex was fun. Pursuit of love was a favorite sport. In marriage, the Romans believed that you could only conceive healthy children if *both* partners had great sex.

These are but a few of the differences between us and the ancient Romans in matters of sex. I hope that you will read this book and look at the images with the same avid curiosity about sex, love, and social relations that an ancient Roman might. "Nothing human is alien to me," said the poet Terence. I might amend that saying to fit the aims of this book: "Nothing sexual is alien to us human beings." 𝕃

E V E R Y

H O M E

M U S T

H A V E

O N E

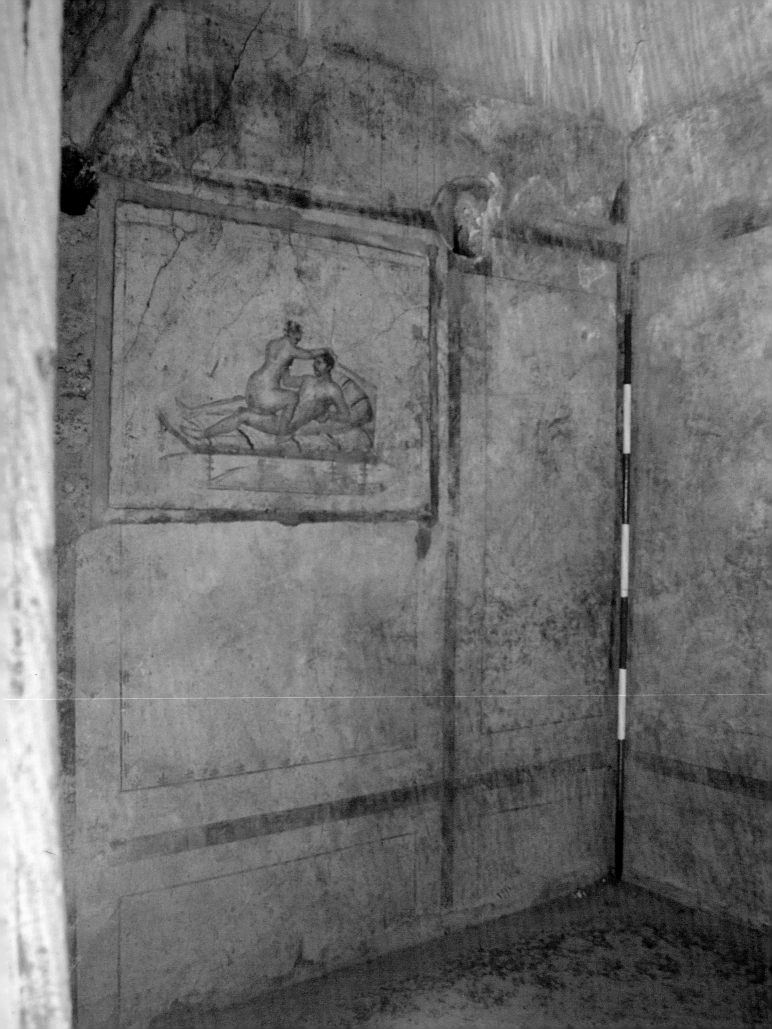

First Impressions

NOW THE WOMEN MUST LEAVE," the guard said, as he nodded to us men (I was just twenty-three at the time). With a flourish he took out a key. The women retreated to another part of the ancient house, and we men entered the cramped, windowless room. As our eyes got accustomed to the darkness, we realized why women were not admitted: In the middle of each wall was a picture of a man having sex with a woman, each in a different position (fig.1). What is more, tucked away in a niche in the corner was a three-foot-high statue of a man with an enormous erection (fig. 2). I could see that the statue's uncircumcised penis was drilled so that water could squirt out of it. Surely it didn't belong here, in this little room with its steel security door. It must have come from the garden, where it served as a fountain.

"There is more," and with a conspiratorial leer our guard ushered us out of the X-rated room, locked the door, and took out another key. This time—again making sure there were no women present—his key unlocked a small shuttered door covering a portion of the wall in the vestibule of the house to reveal another figure with an enormous erection (fig. 3). Even the grumpiest man in the group began to laugh at this genial figure. His enormous erect member rested on one pan of a balance-scale; the counterweight in the other pan was a bag filled with coins. Would his big penis win out? Heavier—and more valuable—than gold? As the laughter subsided and the women and girls, curious to know why we were laughing, approached, our guard snapped closed the little door and gave his explanation: "You see, this was a bordello—how you say—a whorehouse." Grateful to have this secret information—and to have seen something more hardcore than *Playboy*—we discreetly slipped him some *lire*.

Little did I know, back then in 1968, that I would spend many years of my life studying that very house in Pompeii, and that I would come to be an authority on sex in ancient Rome.

1

◄ **Authorities outfitted this room with a steel door, and until the** 1970s allowed only men to see the erotic paintings. Pompeii, House of the Vettii, looking into the cook's room off the kitchen.

2

▼ **Priapus fountain statuette,**
kept in the cook's room, House
of the Vettii. For its original
placement, see fig. 71.

3

▶ **This painting of the rustic god
Priapus weighing his enormous**
member was the first image a
visitor to the Vettii brothers'
house saw. While the painted
Priapus guarded the doorway,
his statue originally protected
the garden.

Flash-forward another decade, and I am in Pompeii again—this time with three younger friends: two beautiful women (one blonde, the other brunette) and their handsome boyfriend. They are art history graduate students and I am a fledgling professor. Back at the House of the Vettii, the little door and its frame are gone: the colorful image of Priapus weighing his member is in full view of all. There are hordes of visitors. The "back room" still has its steel door, but women (not children) are allowed in. Sexual liberation has hit Italy, so it seems.

A guide picks up on our interest and suggests that he can show us more. Sure, we're game—we're here to see it all. He takes us to a house closed to the public on a silent street devoid of tourists. We thread our way through its enormous columned spaces, down a narrow passage to an elegant suite of rooms. Again, a locked door. But this time it is a well-lit, colorfully frescoed room (fig. 4). In the middle of the left and right walls are beautifully painted, full-color pictures, each depicting a man and woman having sex (figs.

5 and 6). The details are amazing—a far cry from the crude pictures in the "back room" of the House of the Vettii. My blonde friend presses the guide for an explanation, flirting a little in her perfect Italian:

"So why can't everyone see these paintings, they're very beautiful."

"You are a *dottoressa*, a scholar, but these tourists—they would just laugh. They don't understand that our ancestors thought lovemaking was a gift, a blessing."

"But why," she insists, "are these pictures here in this private part of the house? Didn't you say that they turned this house into a *lupanar*, a bordello?"

"They didn't want anyone to see. They wanted the, uh, business to be hidden."

My third lasting impression of Roman sexual imagery followed a couple of days later, when our foursome was lucky enough to be admitted to the Pornographic Cabinet in the Naples Archaeological Museum. Once again, it was the blonde charmer who got the guard to find the key to the heavy wrought-iron door with its steel backing. "You will excuse the

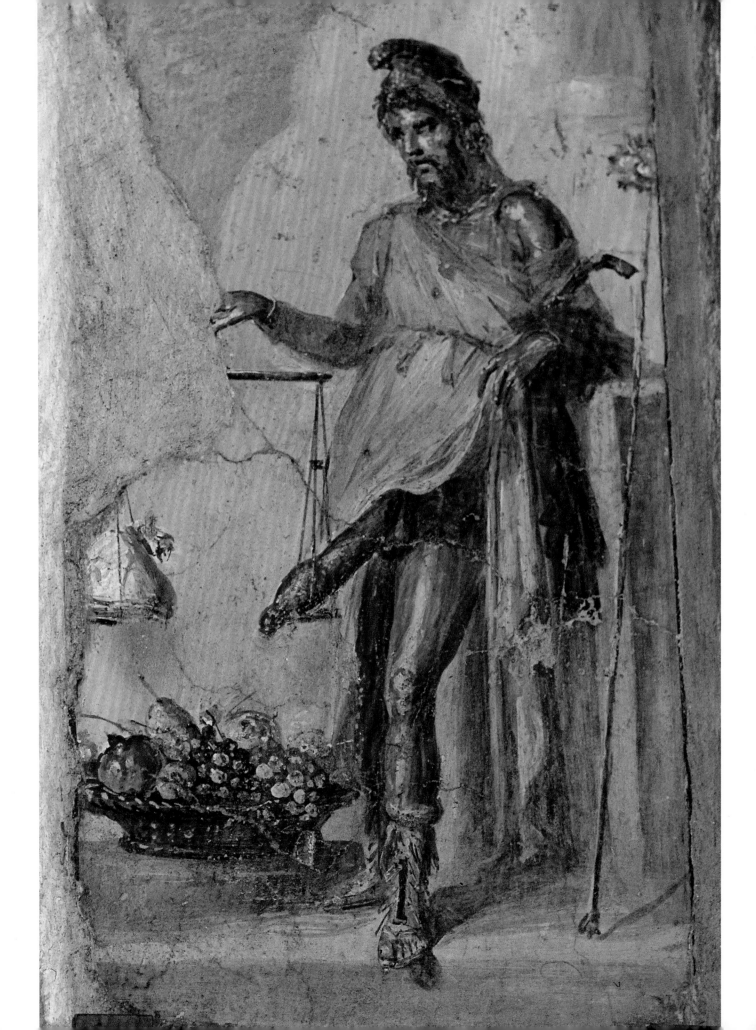

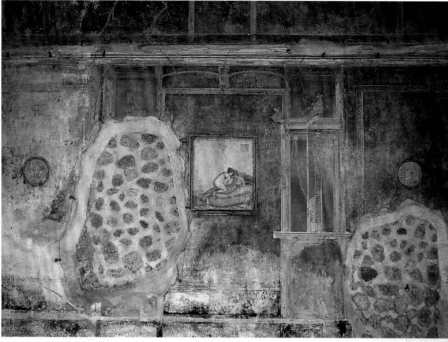

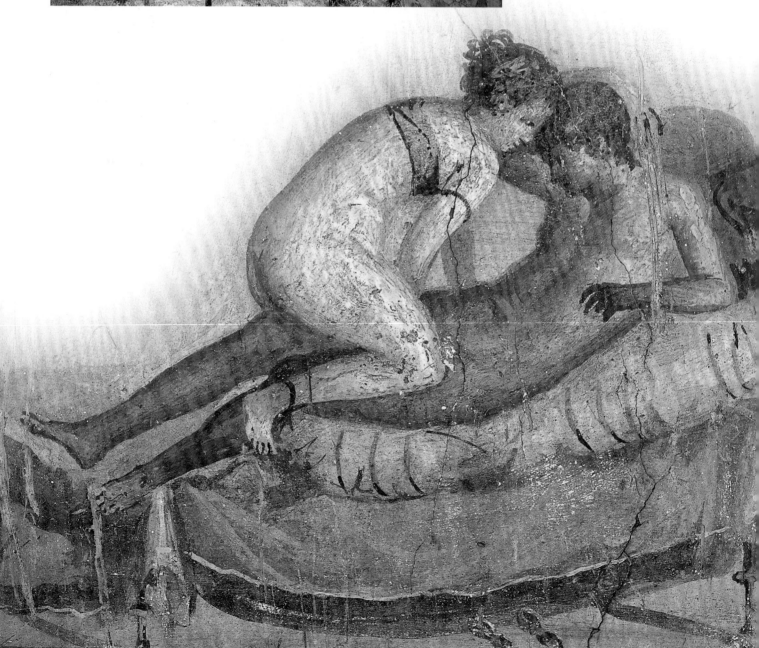

4

◄ **The House of the Centenary, Pompeii. This was one of the** largest and most lavishly decorated homes in the city. When excavators found two erotic paintings in this large, secluded room, they concluded it was used as a bordello. Analysis of the paintings' context tells a different story.

5

◄ **The center picture on the south wall. The artist used** shadows to indicate a strong light coming in from the right. The woman is astride the man, who leans on his left elbow while holding his right arm crooked around his head in the gesture of "erotic repose." She reaches down with her right hand to grasp his penis, hidden behind her right thigh.

6

► **The center picture on the north wall. Although damaged,** remains of underpainting reveal the architecture of the chamber. The light panel in the background is the artist's attempt to open up the scene to a landscape garden. The woman has her back to the man and places her hands on her knees as she squats down on his penis.

disorder," he said, "but they were photographing." We could see nothing until the guard unbarred the solid shutters on the window and the hot July light streamed in. Scattered over the floor and leaning against the wall were thick squares and rectangles of plaster in wooden frames, obviously removed from their wall mounts for the photographers. Dust covered everything. As we looked, our astonishment grew. These were frescoes cut from walls of ancient Roman buildings buried by the eruption of Vesuvius in A.D. 79—not only Pompeii, but the towns of Herculaneum, Stabia, and the villas that once dotted the Bay of Naples. When excavators found a wall

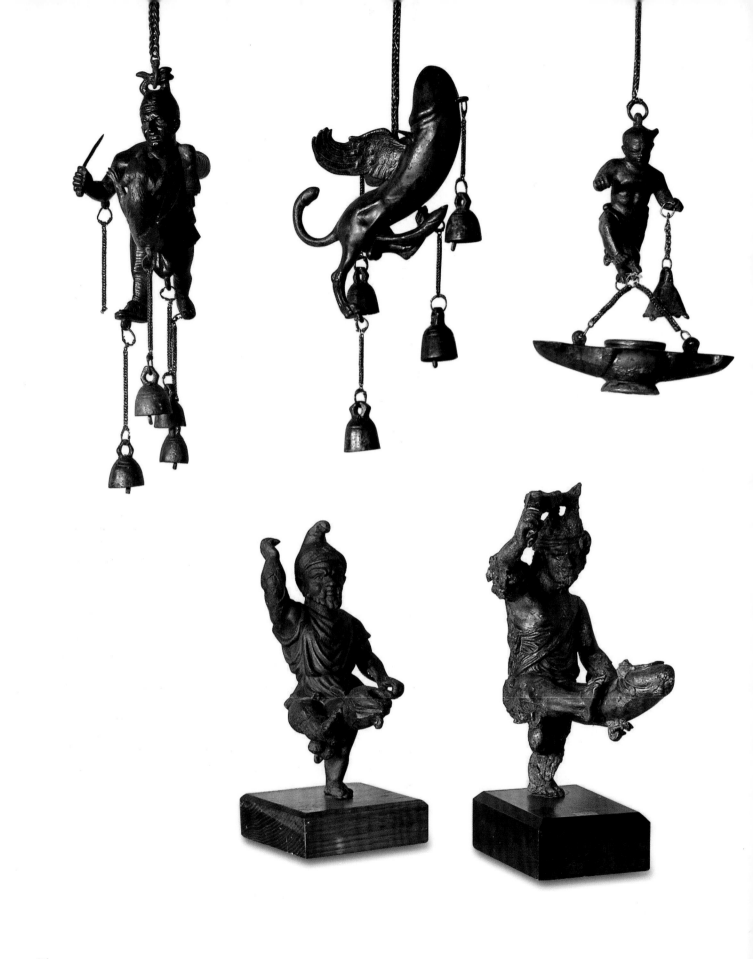

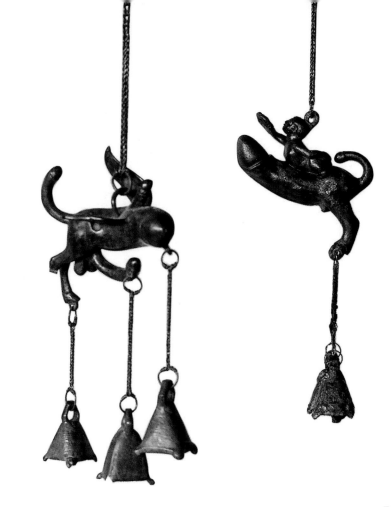

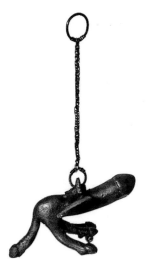

painting they considered obscene, they either destroyed it on the spot or cut it out and sent it to this chamber. The room had been filling up for nearly 250 years. "For twenty years in the 1800s," our guard informed us, "the door to this room was sealed with a wall of mortar and bricks. Sealed by the Minister of Morality."

There were two rickety wooden cabinets chock full of pottery and small bronzes. There was a box full of lamps with sex scenes on them; another with lamps in the shape of an enormous phallus; wind-chimes in the shape of a penis covered with bells, and much more (fig. 7). The guard rushed us, worried that he would be missed from his station in the "normal" part of the museum. On our way out we saw a beautiful marble statue of a leering Pan penetrating an uncannily human-looking she-goat (fig. 8).

7

◄ **Hanging phallic bells** (*tintinnabula*). Although these and many other objects found in the cities buried by Vesuvius could only be seen by permission of the King, clandestine sketches appeared in deluxe publications for wealthy gentlemen. Called the Cabinet of Obscene Objects at its inception in 1819 and closed to the public for most of its existence, it reopened to the public in 2000.

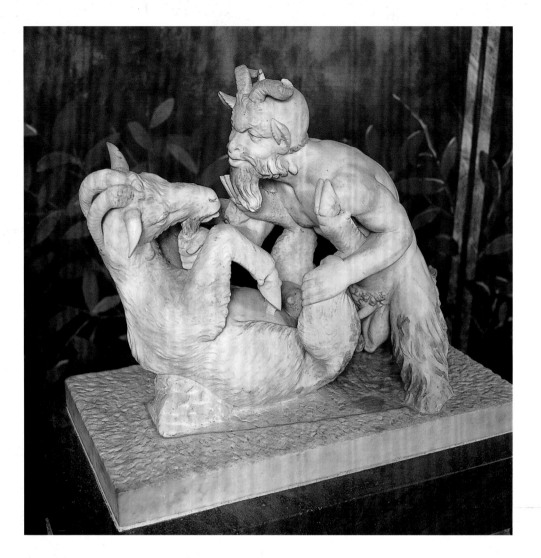

8

▲ ▶ **The most famous object in the Pornographic Collection is the sculpture** of Pan and the She-Goat. Found in the excavations of the Villa of the Papyri at Herculaneum in 1752, it immediately caused a furor. Although the sculptor Luigi Vanvitelli judged it to be "lascivious but beautiful," King Charles (at the advice of his confessor) judged it "worthy to be ground to a powder." Instead, he had it closed up in the royal palace at Portici with orders to show it to no one without special permission. Not even the great Johannes Winckelmann was ever permitted to see it.

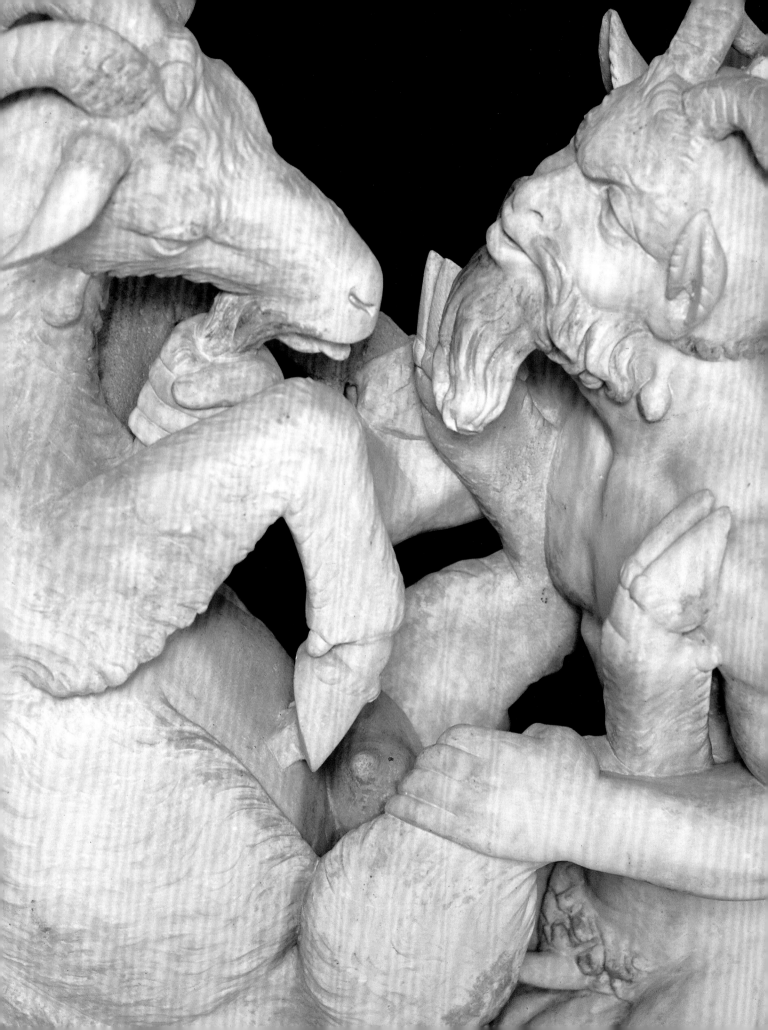

Why Erotic Pictures Belong in an Upper-Class Roman House

Flash forward twenty years. We three— I, my photographer friend Michael, and my Ph.D. student Margaret—are back in the Pornographic Cabinet. We are completing photographs, with permission of the Ministry of Culture, for my book-in-press. The room is, if possible, in worse condition; the paintings are literally—as well as figuratively—dirty: covered with decades of grime. When the guard looks away, Margaret attempts to dust the pictures with a soft cloth. With view camera and strobes (there's still no light in here) Michael shoots one after another, as I measure, take down inventory numbers, and make final notes. My book, *Looking at Lovemaking*, will be the first scholarly account of ancient Roman sexual imagery. Many coffee-table books have come out over the past twenty years, and famous photographers have illustrated the objects in the Pornographic Collection. (Finally, in 2000, the Pornographic Collection, dusted off and remounted, was opened to the public.) But my project is different. I will show where the pictures came from and what they meant in their original placement: mostly in houses in Pompeii. I will rescue them from the charge of obscenity.

What I have found in my research is that these objects, miserably treated today, took pride of place in ancient homes. I have come

9

▶ **Rome, Villa under the Farnesina, right wall of a** bedchamber, 19 B.C. The artist re-created a picture gallery (*pinacotheca*) in fresco, with paintings of various sizes and different styles framed by delicate illusionistic architecture and faux-marble panels.

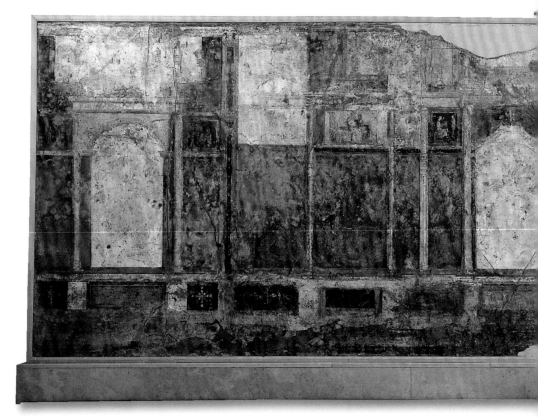

to this conclusion in two ways. I have read all the surviving references in ancient Latin and Greek texts, and I have charted the original locations of most of the paintings that ended up in Naples. The ancient authors reveal that the wealthy prized erotic paintings. Here, for example, is the poet Ovid addressing the emperor Augustus himself, around A.D. 10:

> Even in your house, just as figures of great men of old shine—painted by some artist's hand—so somewhere a small picture depicts the various forms of copulation and the sexual positions. Telamonian Ajax sulks in rage, barbarian Medea glares infanticide, but there's Venus as well—wringing her dripping hair dry with her hands— and barely covered by the waters that bore her. (*Tristia* 2.521–528)

Ovid is describing what had by then become a standard feature of the wealthy Roman house: a picture-gallery. He mentions mythological paintings of Ajax and Medea, but also reminds the emperor that his picture collection—if it was a worthy one—included paintings showing a variety of sex acts. There were Kama Sutra–like paintings detailing all the sexual positions, and at least one painting of Venus, the goddess of love, beautiful—and stark naked.

The historian Suetonius has the emperor Tiberius, Augustus' successor, placing a painting by the famous Greek artist Parrhasios in his bedroom. Its subject? It showed Atalanta fellating Meleager. In the same passage he goes on to say that Tiberius had pictures illustrating sexual positions placed throughout bedrooms used for copulation: "He deco-rated rooms located in different places with images and statuettes reproducing the most lascivious paintings and sculpture, and he furnished them with the sex manuals of Elephantis, so that no position he might order would fail to be represented." (*Tiberius* 44.) The written descriptions or instructions of Elephantis' sex manuals were not enough— nor perhaps as blameworthy in Suetonius' judgment—as the painted images and sculp-ture that illustrated the sexual acts.

Both Ovid's apology for paintings that illustrated sexual positions and Suetonius' indictment of Tiberius for using them show how an ancient Roman might display and use erotic art. Ovid puts the erotic picture into the picture gallery, where the context is that of the man of taste looking at high art. Suetonius has the evil Tiberius using erotic paintings and sculptures as part of an obsessive project to fulfill his immoderate lust. Both authors reveal the widespread existence of erotica and its use both as high art and as practical sexual aids.

Unfortunately, we don't have any of the famous paintings by the great masters from ancient Greece and Rome. Painted on wood or canvas, they all perished in the great fires that swept Rome. What we do have are paint-ings made by incorporating pigments in wet plaster applied directly to the wall. These frescoes have survived burial in the volcanic debris of Vesuvius or in the mud of the overflowing Tiber River in Rome. Even when frescoes are found in fragments, careful work can put the pieces of plaster together like a puzzle. And, amazingly, we find frescoed versions of the very picture galleries Ovid was describing—including the erotic pictures.

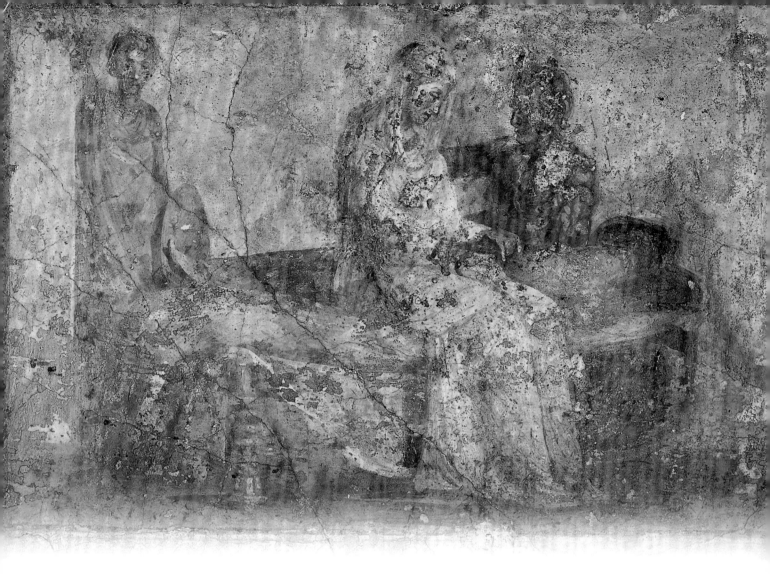

10

▲ **The painting from the upper left shows a reluctant bride,** still wearing her veil and bowing modestly while her nude husband persuades her. Ancient Romans expected bedroom servants to attend them, as they do here— even in intimate moments.

11

▶ **The painting from the upper right shows a passionate woman,** probably a bride, eager to make love. Roman viewers would have recognized the contrast between the reluctant and eager brides, for it had many parallels in poetry and rhetoric.

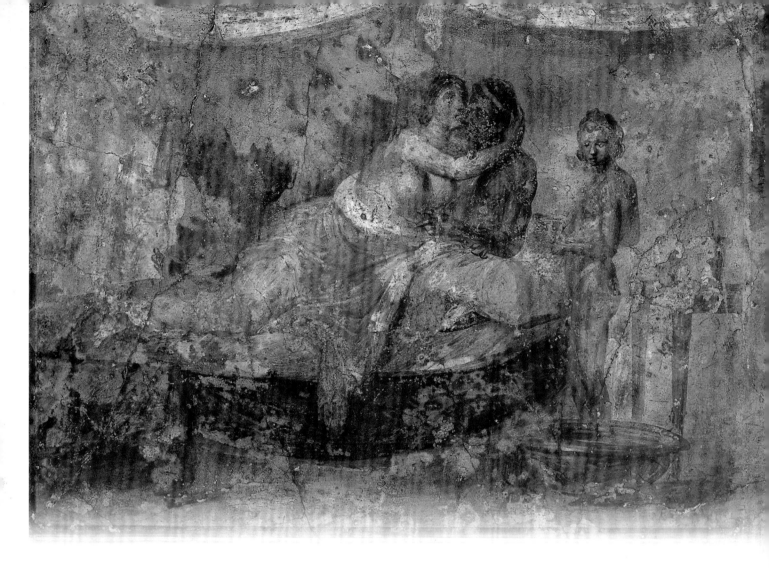

Erotic Pictures
in the Picture Gallery

The finest examples come from Rome itself. The original owners were probably none other than the emperor Augustus' daughter Julia and his son-in-law Agrippa. Fortunately for us, they built their elaborate villa too close to the Tiber, and had to abandon it soon after its construction when a flood filled it with mud. And so it remained until 1879, when construction crews building embankments along the Tiber happened upon it. At the moment they were cutting through the gardens of the Renaissance Villa Farnesina. Archaeologists dubbed their discovery the Villa under the Farnesina. They were able to rescue four rooms and two corridors, all beautifully frescoed. Two rooms re-created, in fresco, versions of the pic-

ture galleries Ovid describes, complete with sets of erotic pictures (fig. 9). Each picture is in a different style: resting on a podium and framed by elaborate columns are two large, white-ground paintings (now faded); in the upper zone are little square pictures with black backgrounds; the erotic pictures are about twice as large as these and painted in a full color range.

Let us examine these two pictures. The one on the left depicts a serious moment between the couple on the bed. Not only is the woman fully clothed from head to foot while the man is nude, but she is wearing a veil, her head demurely bowed (fig. 10). The picture on the right is as hot as the one on the left is cold (fig. 11). The woman

► **A couple on a bed, Pompeii, House of Caecilius Iucundus, A.D. 62–79.**
The artist builds erotic tension by turning the woman's back to us (and her partner) as she reaches back to grasp his hand. We see his gesture and imagine the next move.

stretches out her body on the bed, nude to the waist, as she reaches her arm around the man's neck to pull his head toward her. It seems that she wants to kiss him, but her mouth is at the bridge of his nose. The man, nude to the waist, has his right arm around the woman's neck and shoulder; his fingers are just visible on her right shoulder. His left hand makes an ambiguous gesture: Has he just disrobed the woman or is he about to touch her breast? The artist contrasts the woman's expressive gesture with the man's wooden posture. The eye follows the sweep of her body from her toes, resting on the bed, through her voluminous yellow robe, to her gesture of reaching around the man's neck. He seems disengaged, or perhaps stunned by the woman's passion.

Because the woman appears unrestrained, one scholar decided that she is a prostitute. This is unlikely. The two pictures pair up opposite each other on the wall, and there is a story between them. In one we see the chaste bride, in the other we see the same bride transformed by passion into an eager sex partner. Why did the artist put these two representations of sex—one chaste and tentative, the other passionate and explicit—in juxtaposition? If the paintings portray an upper-class bride, society required her to have sex with only one man (her husband) for the

purpose of producing legitimate heirs. Many Roman writers emphasize that proper married women were supposed to take an erotic interest in their husbands.

There is another clue that the sexy woman is an upper-class bride, not a prostitute: her clothing. Prostitutes did not wear voluminous clothing, nor did they wear veils. By law they wore togas or they dressed for quick sex under the arches of the city. The poet Catullus has them wearing clothing that allows them to "flash" potential clients.

One more thing, before we leave this painting: The couple is not alone. A nude boy servant gazes directly out at you. Elite Romans had many slaves, including many who served them exclusively in the bedroom. Including slaves in sex scenes was a way of signaling your wealth and sophistication.

Here the boy servant has another function. Although he is serving the couple—he has poured water into the large gilded basin and holds a wine vessel—he seems to be aware of you, the viewer, looking at both him and the couple. The boy's gaze is an artistic device designed to heighten your awareness that you are a voyeur,

looking in on the couple's sexual intimacies. The servant belongs there, but you, the viewer, do not. Behind the bed to the left are traces of another figure, who, like all the others in the Farnesina paintings, goes about his business without paying attention to either his owners or the viewer.

The two paintings were meant to be read together. Together they tell the story of how the modest bride became the immodest lover. It is a perfect male fantasy. The slave who looks directly out at you brings you in on the second act of the story. We shall see that many sex scenes, like these two paintings, come in contrasting pairs or even in series.

What this miraculously preserved painted room demonstrates is how erotic pictures fit into a proper picture collection. What is more, they show how erotic paintings taught lessons about sex. Roman women, both unmarried and married, would have looked at them. One thing is certain, these paintings were not hidden away under lock and key.

Not a Brothel: A Middle-Class Banker's House at Pompeii

The excavations on the bank of the Tiber recovered only a small part of what was a very large and luxurious villa. What about the houses of poorer folk living in Pompeii? Did they have erotic pictures too? I was lucky enough to be able to answer this question very concretely through a bit of detective work.

The best picture in the Pornographic Cabinet in Naples, I had discovered, came from the house of a businessman named Caecilius Iucundus at Pompeii. When the excavator, Antonio Sogliano, uncovered the house in the summer of 1875, he found 154 wax tablets recording Caecilius' relatively modest business dealings. Sogliano also found a very beautiful sex picture (fig. 12). Afraid that it would offend, he ordered it cut from the wall and packed off to the

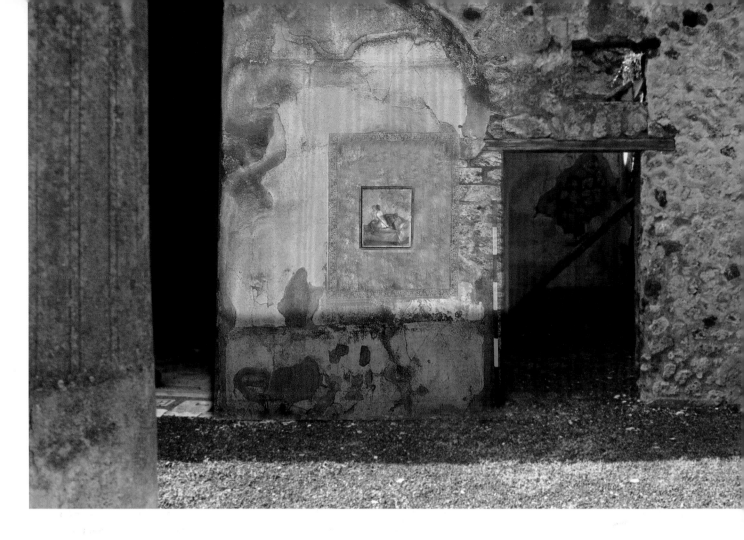

13

▲ **This digital reconstruction puts the erotic painting back** into its original setting, where Caecilius proudly displayed it to all who visited the lavish garden at the back of his house. To the left is a large, richly decorated dining room, to the right a smaller room for intimate entertainment.

Pornographic Cabinet. Paradoxically, the other paintings left in place have now faded beyond recognition. I began to search for drawings, watercolors, and written descriptions that recorded what time and the elements had forever destroyed—and I hit paydirt. Caecilius was so intent on showing he understood fancy folks' ways that he had the painter put the sex picture in the garden portico. Following the clues, I found a hole in the wall marking the spot where the painting had once been. I was able to put the picture back into place in a digital reconstruction (fig. 13).

At first I was puzzled. If Caecilius wanted to imitate the fancy picture galleries of the rich, why did he not place his erotic picture in a room with a number of other pictures? Once again, it was the surviving

architecture and the watercolors done by patient artists back in 1875 that provided the answer.

The front part of a Roman house was where the owner carried out his business. Invariably, we see the same layout: a deep entryway from the street, a high hall called an atrium, and a room opposite the entryway for receiving clients (fig. 14). You can be sure that every morning at the crack of dawn Caecilius was there, standing in his home office and taking care of business. The wax tablets that Sogliano found recorded sums paid by Caecilius to customers for whom he had sold land, animals, and slaves. He also collected taxes levied on the colony of Pompeii.

Romans relaxed and entertained in the rear of the house. Caecilius' house is no

exception: there is a portico surrounding a garden on all four sides, and several suites of rooms suitable for entertaining. The sex picture now in Naples was on the wall between two beautifully decorated entertainment rooms. The larger room created a sensation at the time of its discovery: the frieze with griffins, centaurs, and sphinxes was immediately published in a pattern-book for decorative artists, and the German Archaeological Institute in Rome sent artists to Pompeii to do drawings of the paintings of priestesses found there. There were big mythological pictures as well, today unrecognizable. (The only picture to survive, other than the erotic painting, was one of *Theseus Abandoning Ariadne*—cut out of the wall and sent to the Naples Museum.) Caecilius spared no expense on the frescoes in this room; the artist even applied gold leaf to the frescoes to depict jewelry.

The smaller room had equally fine painted decoration. It has two alcoves for couches set at right angles to each other. The combination of the two rooms, a large room for big parties with a smaller, two-alcoved room next to it, is a feature commonly found in luxury villas. Romans would have called the smaller room a *cubiculum*. Recently, scholars have established that the cubiculum was used for a variety of purposes; it was not just a "bedroom." For instance, it was there that the master of the house would stage business meetings with people above his social level; it was also the proper place to receive friends. Emperors even held trials in the cubiculum. It seems that Caecilius—who probably had no need of a proper cubiculum—was imitating his social betters.

To call attention to his suite of enter-

tainment hall and cubiculum, Caecilius located the erotic painting in the portico between the two rooms. In this setting it commanded pride of place and established a pictorial link between the two rooms.

Let us look at the picture more closely. It is a delicate scene of lovemaking painted with even more care than the Farnesina paintings we just looked at. An elegantly clothed bedroom servant approaches a couple on a bed. The artist used gold

14

▲ **House of Caecilius Iucundus,** plan with the position of the erotic picture marked.

even more lavishly than he had in the picture of Ariadne abandoned by Theseus: for the servant's hairnet and armlet; for the woman's bracelets, earrings, and hairnet. An elegant yellow cloth covers her legs—it, too, decorated with applied gold. (Unfortunately, all of the applied gold—visible at the time of excavation— disappeared because of the

ill-suited procedures used to detach the fresco.) The artist paid special attention to color and the opulence of fabrics throughout; the bed, for instance, has a pink coverlet with blue sham.

Models in high art must have inspired the artist, for this composition is complex. Far from being a frank scene of sexual intercourse, the conceit here is one of the man's desire and the woman's resistance. She holds her hand behind her. Perhaps she is reaching for his penis. He lifts his arm as though in entreaty, but she cannot see his gesture. A nice touch is the way the man's left hand curves up at the wrist, allowing the artist to show how good he is at depicting gestures. You, the viewer-voyeur, see these details but the woman does not. You understand the man's entreaty and the woman's hesitation in a way that the woman—and perhaps her lover also—cannot. As a viewer-voyeur, you have the same advantages as in the Farnesina pictures.

What did this splendid picture mean for Caecilius and his guests? For one thing, it showed that Caecilius knew that rich people's collections had erotic pictures in them. He wanted to imitate them. For another, he wanted his guests to see this expensive picture up close, where it would draw them in. After looking at it, they would go on to the admire the other fine pictures in the rooms to either side of it.

Strictly speaking, Caecilius' sex picture is out of place—an aristocrat would never have put it so up front. But even if he did not follow the rules for displaying the picture, Caecilius did understand how important it was to *have* a fancy sex picture in his house. Every home had to have one.

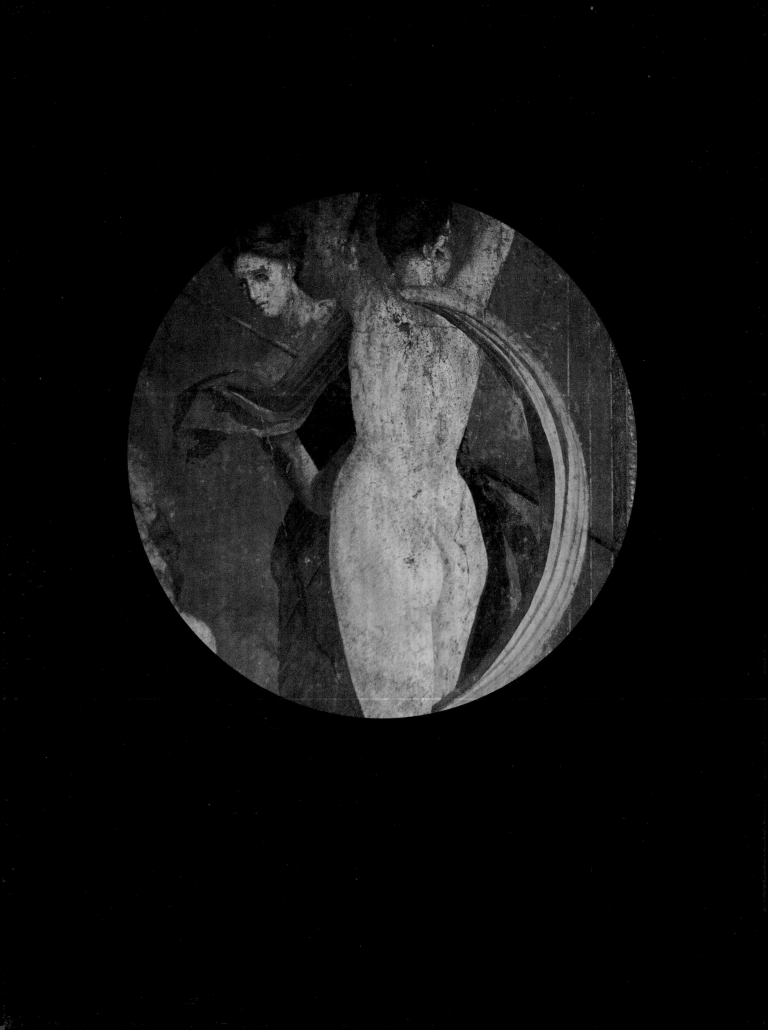

WOMAN ON TOP · WOMEN'S LIBERATION IN THE FIRST CENTURY A.D.

15

▼ **Female prostitutes commonly entertained** elite Greek men at drinking parties as seen in this red figure cup by the Pedeius painter, late 6th century B.C. The painter has emphasized the men's frenzied behavior and the women's debasement.

I ALWAYS BELIEVED that women's liberation was a twentieth-century achievement. Imagine, then, my surprise to hear a most eminent professor of ancient Greek and Roman law, Eva Cantarella, declare that Roman women of the first century A.D. achieved a level of autonomy equaled only in late-twentieth-century Europe and America. Her reasoning was clear and convincing. Roman law, first formulated in the fourth century B.C., gave women the right to inherit. But it was only with the bloody civil wars of the first century B.C. that the law allowed women to inherit personally. Up to that time, guardians spoke for women and oversaw their money and property. But when so many elite men were being wiped out by war, the senators realized that all the money and property would end up in the hands of a very few—including ruthless dictators like Sulla and Caesar. What to do? Allow women to exercise the right they always had—but personally. Allow them to inherit directly the wealth of their family.

The other plank in this platform of liberation was divorce law. There were many kinds of marriages, from a highly formal and unbreakable bond to common-law cohabitation, each kind of bond aimed at a different class and designed to protect property and money in different ways. During the first century B.C., the old kind of marriage that put the woman under the power of her husband disappeared in favor of a bond that kept the woman under the power of her father. The result was that when her father died, the woman was able to inherit her share of her father's wealth.

What is more, marriage customs shifted to allow easy divorce. The man or the woman simply announced that he or she no longer wished to be married. But now, since the woman had control over her own property, she took her money with her. Men who had married for money and prestige quaked at the thought of divorce. If their rich wives divorced them, they would lose wealth. No wonder that we have the poet Martial, at the end of the first century, sardonically commenting: "You ask why I have no desire to marry riches? / Because, my friend, I want to wear the britches." (*Epigrams* 8.12)

▼ ► **Although the
artist emphasizes the**
woman's sexual agility,
the bedroom setting
with its rich furnishing
creates a feeling of
intimacy between the
couple. Interior of
bronze mirror cover
from Corinth, c. 320 B.C.

From Greece to Rome

Of course, the law concerned itself principally with elite women and men, a rather small percentage of the total population. Unlike the laws of modern democratic states, which aim to protect all the people equally, Roman law worked in favor of freeborn citizens and gave preferential treatment to citizens whose families had prestige (those with the rank of senator or knight). The huge slave population had minimal protection under the law, and freed slaves—although citizens—still had obligations to their former masters. Foreigners without great wealth counted for little. Yet no women before or after this century had more power and independence than freeborn women—especially those of the upper classes.

Artists found ways to express women's relative liberation (or lack of same) in the way they constructed scenes of lovemaking. If we survey the sexual art of every other society in the ancient Mediterranean—including famous "democracies" like that of fifth-century Athens—we find that women simply have no power. For example, an Athenian vase painting from around the year 500 B.C. shows professional women entertainers at an all-male drinking party (fig. 15). Although tamer vase paintings

show these same entertainers (called *hetairai*) serving wine, playing musical instruments, and singing, by the end of the party they became sex toys. In this particularly graphic image we see, to the left, a woman fellating a young, beardless man while an older, bearded one penetrates her. The artist has made her position unusually uncomfortable, compressing her body between the force of the two penises she's accommodating. The woman on the right seems equally demeaned. The artist has depicted her mouth distorted with stretch lines as she struggles to take the youth's huge member. We see just the right hand and the feet of the man who enters her from behind as she braces for his rear-entry attack. No liberated women here! The artist depicts these women as sex machines—mere bodies with orifices to satisfy the handsome men.

In Greek art of the following centuries, it is true, we find more romantic and flattering representations of women.

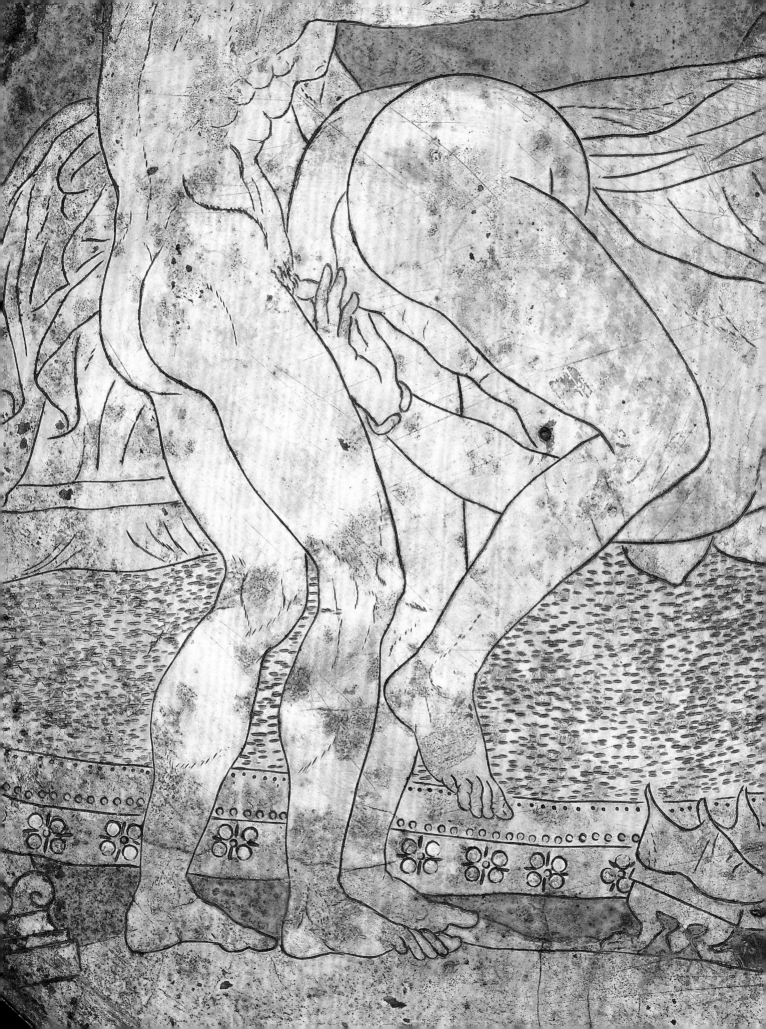

17

▶ ▼ **Exterior of the mirror cover, worked** in relief. The image reminded the owner (most certainly a woman) that passionate sex was a gift of the gods. Here it is the god Eros who flies in to tie a band around the man's head—an honor usually given to victorious athletes and soldiers.

On an object owned by a woman, a bronze mirror cover found at ancient Corinth and now in the Museum of Fine Arts, Boston, the artist has emphasized the woman's beauty even while depicting her sexual proficiency (fig. 16). Against a background showing a bed piled up with cushions and covered with an elaborate bedspread, we see the woman gracefully assuming a somewhat awkward position, raising her buttocks high while bending her torso low. The artist has emphasized her acrobatics: she is supporting the whole weight of her body with her left arm and leg. Even at that, the fingers of her left hand lightly touch the footstool that supports her torso, and while standing on her left leg she lifts her other leg so that she can pass her right arm back to guide the man's penis into her vagina. Her expression is calm—perhaps complacent—while the man seems agitated, his right arm shooting up in the air, fingers apart, even while he plants his feet firmly on the floor to initiate penetration. In contrast with the vase painting, here the woman is taking the initiative. She is in control—a professional.

What sort of woman would have owned the Boston mirror? Scholars have proposed two possibilities. She may have been one of the accomplished and celebrated courtesans, mentioned in inscriptions, who flourished in the city of Corinth between 350 and 250 B.C. Or she may have been a married Corinthian woman who subscribed to the popular ideal of

the time: that a woman should play an active role in achieving sexual pleasure for herself and her husband. On the front of the same mirror cover there is a more conventional representation of a male-female couple on a bed with the god Eros (our Cupid) flying in with a ribbon to adorn the man's head (fig. 17). This divine interloper makes a further statement: that good sex is the blessing of Aphrodite (Venus)—and an ideal to strive for.

If anything, the period between the vase and the mirror cover represents not so much the liberation of women in sexual matters as a shift to one-on-one scenes in art. In place of the orgy typical of fifth-century Athenian vase paintings, we find romantic encounters between couples, both male-female and male-male. This shift reflects changes in social practices, from the stag-club mentality to a "couples" mentality. Although the men at the symposium thought they had a democracy, their democracy was just for them: the elite males. Women were sex toys (hetairai) or baby makers (wives). The new social systems of the Hellenistic period (330–27 B.C.) emphasized the individual over the city-state, and part of the cult of the individual was the notion of one-on-one, rather than group, sex.

But this new emphasis did not create the
liberation of women that we see in first-
century Rome. In art, as in life, women were
still at the mercy of men. Indeed, it was the
accomplished courtesan who could best
achieve relative freedom—but at the price of
selling her body and being branded a whore.
The hetaira's situation was like that of the
famous geisha in eighteenth-century Japan:
she attained great fame but was still a social
outcast. The situation in the Hellenistic
period was difficult for elite women as well,
for although they could gain wealth and
status through good marriage, they could
not control their wealth. Unable to inherit
or pass on their wealth, they remained com-
pletely in the power of men.

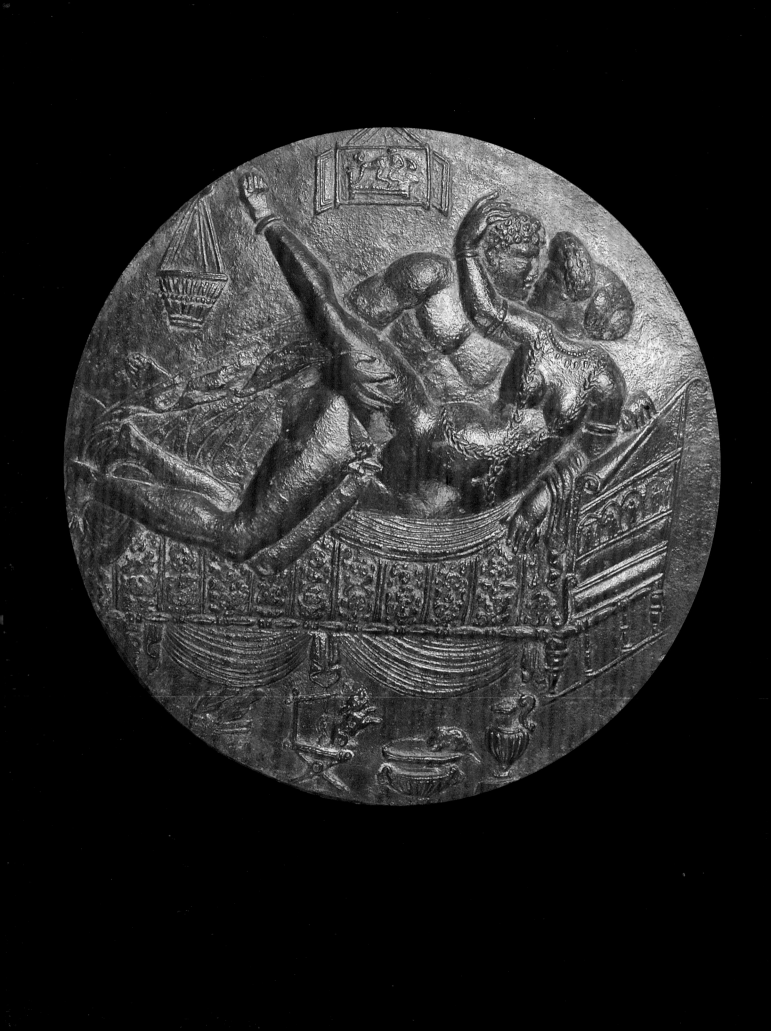

◄ **Exterior of bronze**
hand mirror from Rome,
c. A.D. 69–96. Passionate
lovemaking in an unusually
well-outfitted chamber,
complete with an erotic
painting and the owner's
pet dog.

A Liberated Woman's Mirror

Comparison of the mirror cover from Corinth with the back of a hand mirror found on the Esquiline Hill in Rome reveals how artists—and presumably the woman who owned the mirror—conceived of "modern" sex in the heyday of women's liberation, in the last decades of the first century A.D. (fig. 18). We can be sure about the date because of the woman's elaborate hairstyle. A band of high curls frames her face, with a huge mass of coiled braids extending behind her head. This hairstyle was popular in the period of the Flavian empresses, between A.D. 69 and 96. Although the couple's pose is similar to that on the outer side of the Corinth mirror cover, there is no divine intervention in the form of the Eros flying in with a ribbon.

Instead the artist has done everything possible to make the scene here-and-now. He fills the mirror back with details that emphasize the actuality of lovemaking. The most obvious detail is a little erotic picture, complete with shutters, hanging above the couple. It depicts a man and woman on a bed. The woman, on her hands and knees at the left, looks back at the man as he enters her from the rear. The couple on the bed below the picture are, if anything, more intent on their act. Their gazes meet in profile as the woman curves her right arm around the man's curly head. They're about to kiss, just as the man's penis is about to enter the woman. The bed is the most elaborate representation of this essential piece of bedroom furniture that you will find in Roman erotic art. At the right we see the high scroll of the headboard, or *fulcrum*, decorated on its outer side with figures in arches. Below are four legs. The artist has worked the bed's front face with vertical decorative panels and has tied the sham in a double swag.

Beneath the bed several unusual details may be attempts to personalize the scene and tell us something about the owner. In scenes like this we often find drinking vessels and the woman's slippers on a footstool. But here the artist has also depicted a tiny dog sitting in his own chair, agitated at the sight of a mouse drinking from the water bowl! The dog seems to be the woman's own pet. She instructed the artist to include her pet on the mirror back,

immortalizing him even as she shows
herself in a moment of supreme pleasure,
decked out in her favorite lovemaking
jewelry (chain draped over her breasts
and criss-crossing at her navel; necklace,
anklet, and bracelet).

The other side of the mirror consists of
two pieces riveted together, a reflecting disk
and a filigree border (fig. 19). (The mirror
has lost its handle, and may have also had a
hook opposite the handle to allow it to be
hung on the wall.) Conservators were able
to reconstruct the mirror's bronze filigree
border (fig. 19-1). The signs of the zodiac,
delicately depicted in relief, formed a circu-
lar frame for the reflecting disk. The mirror
itself, a highly polished bronze or silver disk,
fit within the zodiac border. Only one scholar
has attempted to interpret the meaning of the

zodiac, and she omitted its possible relation
to the erotic image on the opposite side—
opting instead for a general cosmological
interpretation. For my part, I believe that the
dominant image—passionate lovemaking—
would have determined the meaning of the
zodiac, not vice-versa. I think that the
woman looking at herself in this mirror
would have understood the zodiac border
as a reference to two kinds of time: the
immediate moment and time in general.

The immediate moment was the sign of
the month and day. Many Roman women
employed astrologers to determine the best
time to perform important activities, and
lovemaking was one of them. If they wanted
to get pregnant, they would consult astro-
logers to find under what sign and on what
day they would most likely conceive.

20

▼ **Pompeii, Villa of the Mysteries,** Room of the Mysteries, c. 40 B.C. Nearly life-size figures of women, along with mythical beings, dominate the room's decorative system. The scenes, excerpted from the pageants of Dionysus, allude to initiation rituals and the preparation of a bride for marriage.

21

▶ **Plan of the Villa of the Mysteries,** c. 40 B.C. The Room of the Mysteries, 5, formed a suite with room 3–4 — probably designed by and for the woman of the house.

The other message that the zodiac conveyed was that time—like the beauty that the mirror reflects—passes quickly. "Seize the day!"—*carpe diem*—was the motto of many a Roman, not just the poet Horace. Make love, enjoy your youth and beauty, luxuriate in the blessings of Venus, for time is short and beauty fades as does youth! The owner would see her own image surrounded by a literal reminder of the passage of time. Turning the mirror over, she would see an image of the best that Venus had to offer. Excavators believed that the mirror was buried along with the owner's ashes. As such, it was a fitting memorial to the woman's beauty and a thank-offering for the sexual gifts that Venus had bestowed during her life.

What is remarkable about the Esquiline mirror is not so much that it shows sizzling sex but that it personalizes it. We see not just the ideal couple making passionate love but also a specific woman's bedroom, complete with her favorite pet. It is this personalization—and domestication—of a woman's sex life that best reflects the liberated woman of the first century. Of course, the mirror is an isolated object found in random excavations, so it cannot tell us the woman's name, where she lived, or her social status. About these we can only guess.

In 1910, explorations beyond the Street of the Tombs at Pompeii uncovered a remarkable room—so remarkable that the excavator declared that it was an "initiation hall" belonging to an important temple (fig. 20).

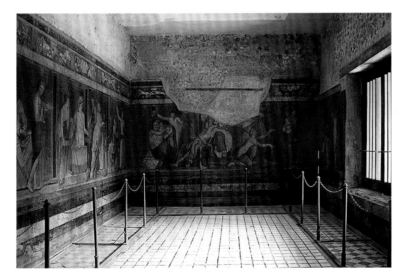

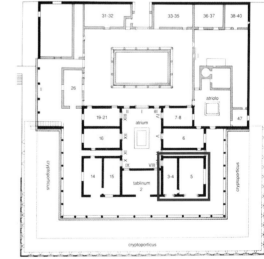

22

◄ The *domina* (the wife of the owner) sits in her corner and gazes out at the rituals unfolding on the other three walls.

23

► The narrative begins on the left wall with a woman dressed in street clothes who seems to ignore the mother attending to her son, who reads from a scroll. A pregnant woman with a laurel crown carries a silver tray laden with cakes. She looks out at the viewer.

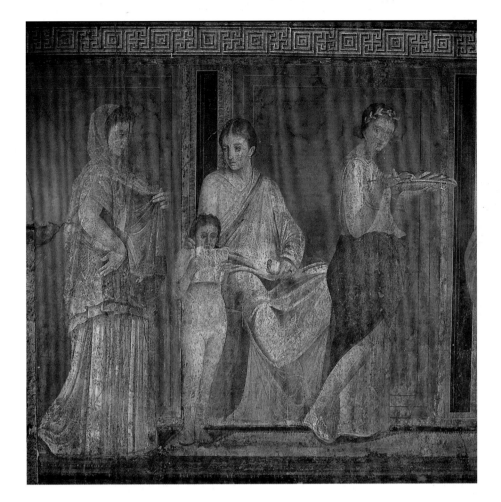

Technical problems, especially poisonous gases trapped within the volcanic material, prevented further exploration, although speculation about the meaning of the frescoes had already begun.

It was not until the 1930s that the truth came out: it was not a cult room of a temple complex but a room in a luxurious private villa (fig. 21 room 5 on the plan). The "Mysteries Room," as it was now called, belonged to a suite located in one corner of the villa, matched by similar suites in the other three corners. But none of the other suites had a frieze running around its walls with life-size figures of women and gods exploring worship, wine, flagellation, and sex.

Curiously, only one scholar, a woman, found the courage to confront this disquieting imagery head-on. It was Margarete Bieber, a German-trained scholar who in her later years taught at Columbia University. In a famous 1939 article, she proposed that the Mysteries Room was designed to prepare young brides-to-be for marriage. It was planned by and for the mistress of the house, the *domina*, who is also pictured in the frieze (fig. 22). The artist placed her on the wall to the left of someone entering the room, where she sits on an elaborate chair, draped in the robes of a married woman, and gazes out at the proceedings on the other three walls.

And what proceedings they are! The narrative starts out directly to the left of the domina, on the left wall of the room. This means that a viewer "reads" the story as she would the lines of text in a book, from left to

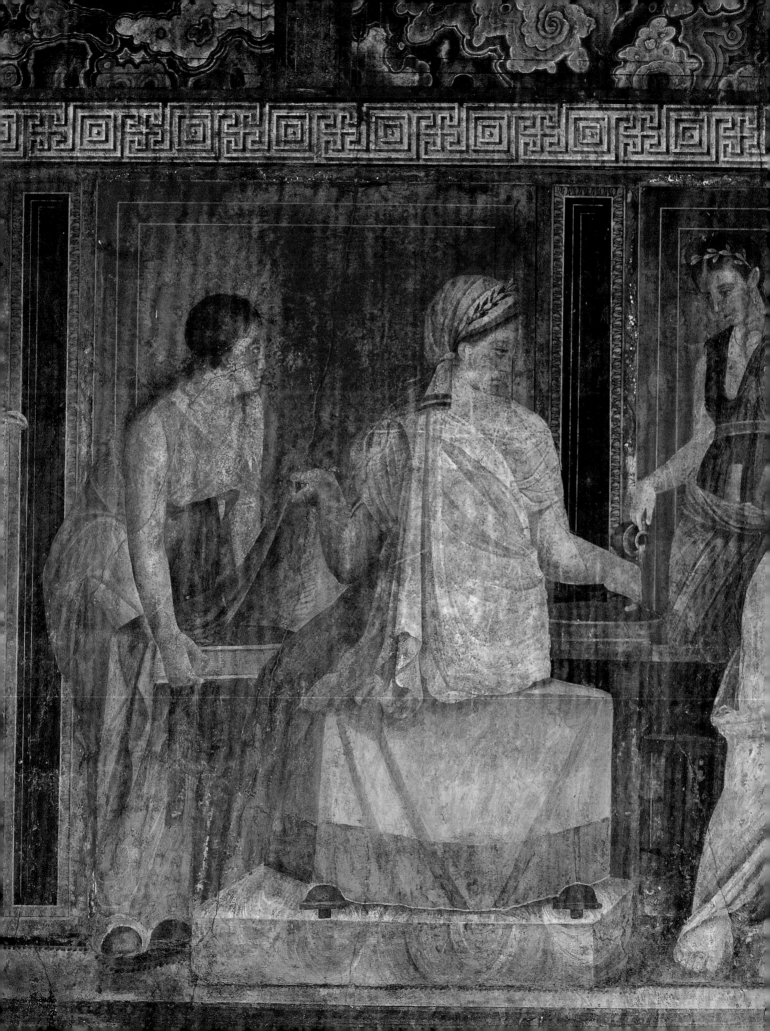

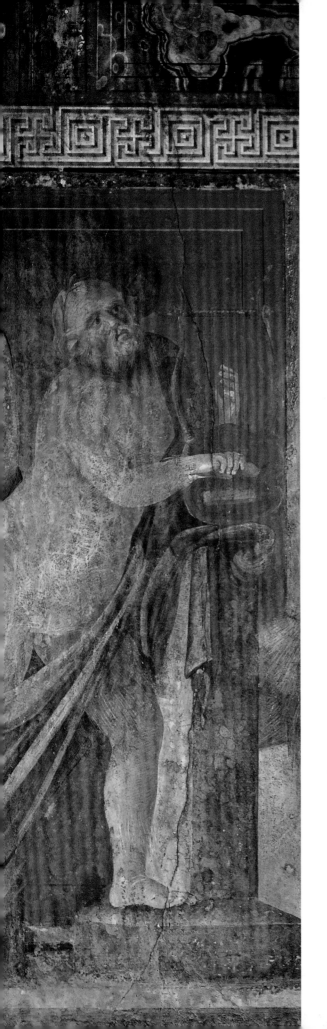

24

◄ **The seated woman
has her back to the viewer.**
A servant pours water on
her right hand while she
draws a cloth out of a
casket with her left. At
right: hairy Silenus plays
the lyre.

right—but around the room. A shallow stage
constructed in perspective runs around the
room, and the background is solid cinnabar
red, the famous Pompeian red—made from
costly mercury imported from Spain.

The story begins innocently enough, with
a woman dressed in outdoor clothing inter-
rupting a naked boy reading from a scroll to
an adult woman, presumably his mother
(fig. 23). A pregnant woman carrying an
offering-tray with cakes is next; followed by
a scene of ritual washing. A seated woman
takes a purple cloth out of a little chest with
her left hand as a servant pours water over
her right hand (fig. 24). The solemnity of
these scenes suggests that they belong to a
ritual; the following vignette, acted by
demigods from the retinue of Dionysus,
confirms this assumption. A hairy Silenus
sings while accompanying himself on a lyre,
while a male Pan observes a female Pan giv-
ing suck to a goat (fig. 25). At the end of the
sequence on this wall is the famous image of
a startled woman (fig. 26). Although it is not
clear what has frightened her, her gaze and
gestures make the viewer search the back
and right-hand walls for clues. Could it be
the flagellation scene in the opposite cor-
ner, where a winged demon whips a woman
who cowers in her friend's lap (figs. 27, 27-1,
and 28)? Or is it the scene of the unveiling
of the phallus (fig. 28)? One scholar pro-
poses that the phallus is not being unveiled
at all, but that it has spontaneously come to

25

◄ **Pan playing his pipes**
glances at a Panisca
giving suck to a goat;
the startled woman;
Silenus with two Pans.

26

► **The startled woman
is the most mysterious**
figure of all, since it
is not clear which
scene—whether on
the back or right wall—
has frightened her.

life—erected—while the attendant struggles
to keep it covered. A mosaic found in
Algeria supports this interpretation, where
one woman unveils the phallus and another
woman jumps back in surprise.

Bieber's interpretation, that the women
in the frieze are taking part in a ritual of
initiation intended for the bride-to-be,
finds its strongest support in the final
image of a young woman dressing her hair,
tucked in the right-hand corner of the room
(fig. 29). It turns out that a young woman
about to be wed had to comb her hair in a
special hairdo, and here a servant helps her
while two cupids look on, one holding up a
mirror. The human beings in the frieze,
with the exception of the young boy reading,
are all women of various ages; the demigods
all belong to the retinue of the god Dionysus.
And Dionysus himself appears in the most
important spot in the room, directly oppo-
site someone entering. Although he has
many guises, here it is the well-known
image of the drunken Dionysus collapsing
into the lap of his mortal love, Ariadne
(fig. 30). For the Roman woman, it is a
scene of divine salvation through love, since
Dionysus fell in love with Ariadne after the
Athenian hero Theseus had abandoned her
on the island of Naxos. The god's love gives
the mortal woman immortality.

Many women belonged to the cult of
Dionysus. It is astonishing that the mysteries
of Dionysiac initiation—a cult that endured

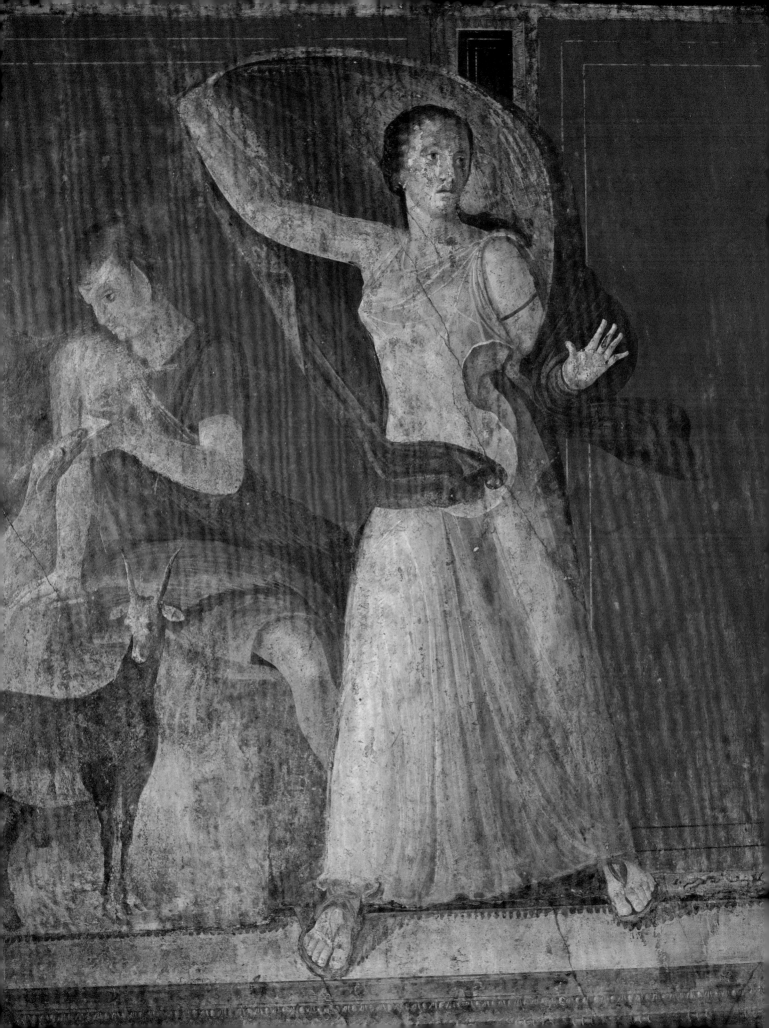

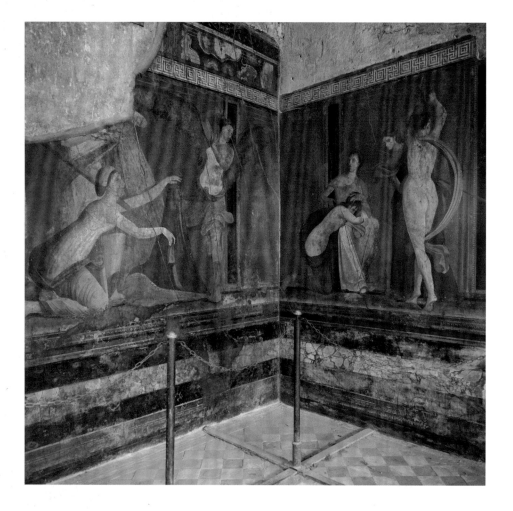

27

◄ **Across the right-hand** corner of the room, a female demon whips a half-naked woman.

27-1

► **She cowers in another woman's lap.** Yet immediately to the right a nude woman (the same woman?) dances ecstatically, playing cymbals.

for over a thousand years—were never divulged. They remain mysteries despite the concerted efforts of scholarship. What we get are hints in both ancient texts and artwork. The Mysteries room is perhaps the most tantalizing of all these hints, with its range of emotions—from terror to ecstasy— and its sequence of revelations that we cannot quite understand. What are the words the boy is reading? What song does the Silenus sing? What does the phallus signify? Why does the demon beat the woman?

One thing is certain. Whoever commissioned this expensive and elaborate decoration—almost certainly the woman of the manor—*wanted* to tantalize the viewer. She could not have the artist show all of the secret rites, but just those parts that

the followers of Dionysus presented in the public cult pageants. (We read, for instance, of the Dionysian processions at Ephesus, in which a huge phallus was paraded through the streets.) Only successful initiates knew the precise meanings of the images. And if there is a religious dimension, there is a sexual one as well. Dionysus himself sets the theme of love, a love for a mortal woman that promises salvation to all mortal women who love him as Ariadne loves him. The wine that makes the god drunk, that the Silenus and Pans drink, must also engorge the phallus and fuel both the sado-masochistic flagellation and the ecstatic dance that follows it. Yet when the viewer has taken it all in, her eye returns to the three images of calm and stability: Dionysus and Ariadne, model lovers;

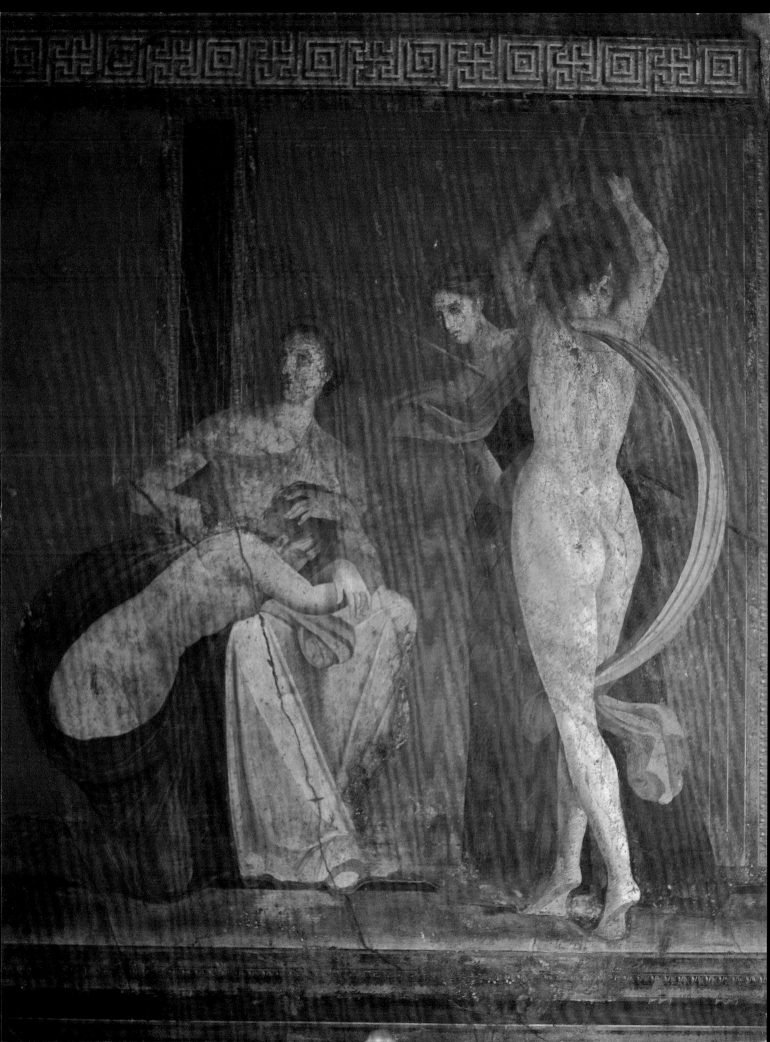

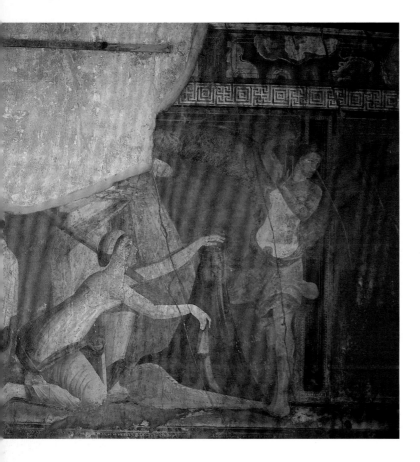

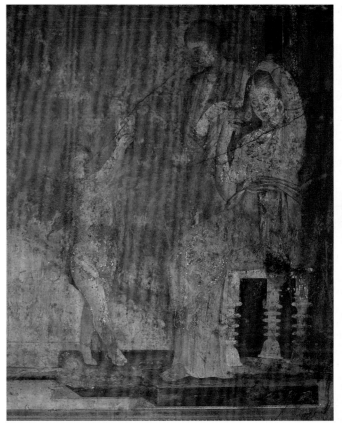

the married woman who surveys it all; and the bride preparing herself for the mysteries of first sex and love.

Few women before or since could decorate their houses with imagery that so frankly expressed the joys and torments of sexual love—and its transformation into divine salvation. The Mysteries frieze dates to about 40 B.C., making it an early expression of the liberation that the Esquiline mirror expresses purely in human rather than religious terms. If the Esquiline mirror expresses one woman's unabashed joy in the pleasure of sex, the Mysteries frieze frames women's sexuality in mystical and religious language. In both cases, women are the principal actors as well as the primary audience. In this way, these two very different works of art encode a similar social phenomenon, that of the liberated Roman woman.

28

◄ **A woman kneels before a large phallus** in a basket (the *liknon*). With her right hand she draws up the purple veil, but with her left she pats its tip.

29

▲ **A maidservant helps the young woman** arrange her hair in the special hairdo reserved for brides, while a winged cupid holds up a small hand mirror.

30

► **The focus of the room is the drunken** god Dionysus, passing out in the lap of his beloved Ariadne. This time-honored composition appears in many terra-cotta votive statuettes found throughout the ancient world, because it reminded women devotees how the love of the god for Ariadne, a mortal woman, brought her immortality and made her a goddess.

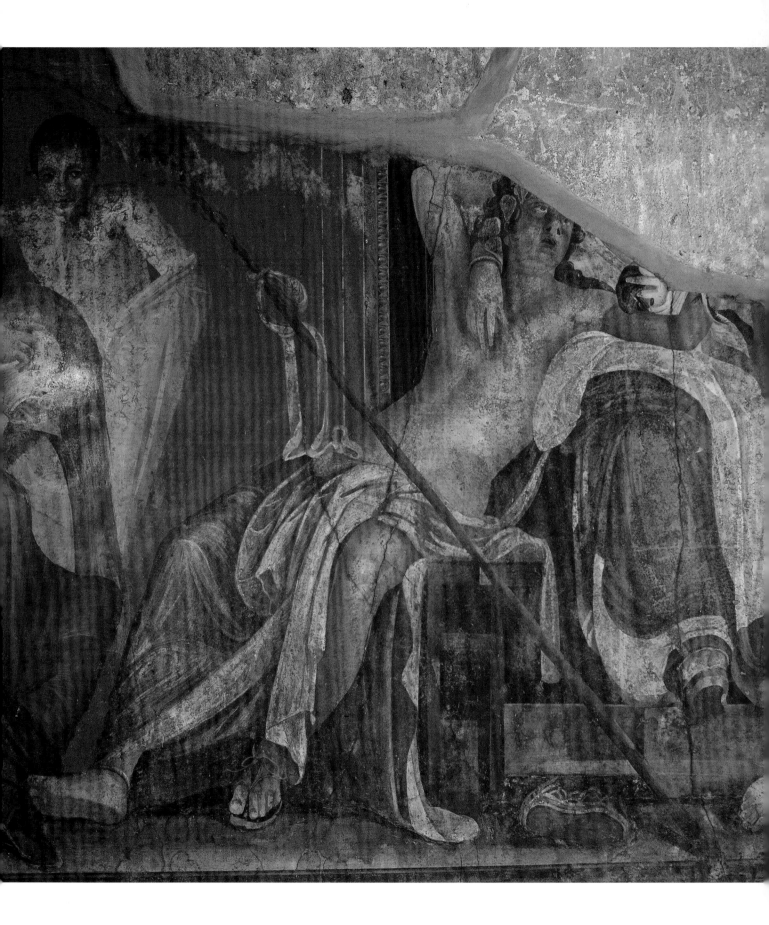

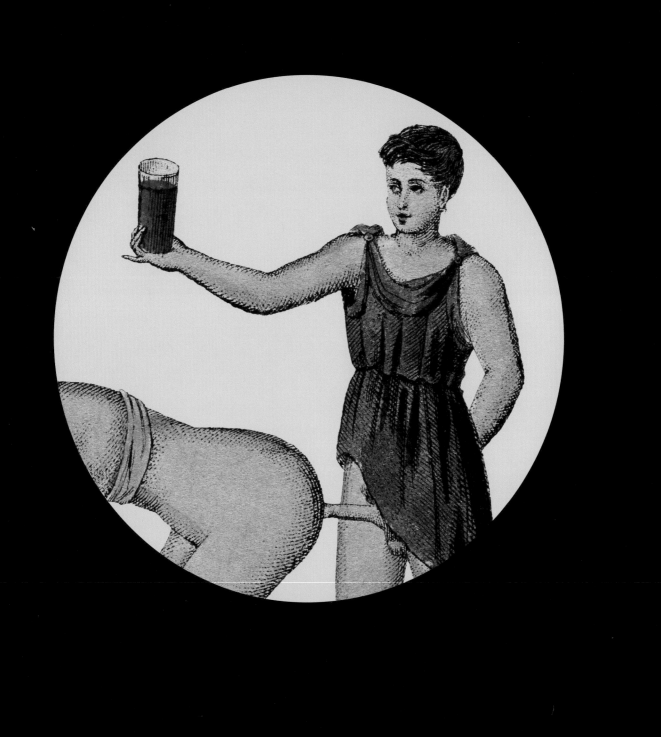

SEX IN WHORE-
HOUSES, SEX ON
STAGE

The Grand Lupanar

THE YEAR IS 1862. For some time now, Pompeii has been all the rage, and excavations are continuing apace. The Pompeii of the Romantic imagination is a city of high-minded but terribly unfortunate Romans whose lives were snuffed out by a catastrophe. Then they uncover Pompeii's principal whorehouse and dub it the Grand Lupanar (after *lupa*, one of the Latin words for "whore").

A furor arises about this "obscene" establishment, for everything about the building addresses the business of sex. It is a tiny, two-story structure occupying a triangular plot at the intersection of two narrow back streets (fig. 31). The interior on the ground floor consists of a broad corridor, with five cubicles opening off it (fig. 32). Each cubicle has a raised masonry platform that served as a bed—with a pillow also in masonry (fig. 33). Above the doorways excavators find six pictures, each

31

▶ **Pompeii's only multi-room brothel** occupies a triangular lot at the meeting of two narrow streets. The owner increased the size of the upper-story rooms by putting the access corridor on a balcony.

32

▼ **Seen from the eastern doorway, the** layout is clear: A wide corridor gives access to three cubicles on the right, a latrine at the back, and two more cubicles on the left. Rectangular openings over the right-hand cubicles let in some light and air.

33

▶ **Each cubicle has a masonry bed** with a masonry pillow, but no traces of a proper door. Above the entrance is an image of rear-entry sex taking place on a conventional wooden bed with bed linens.

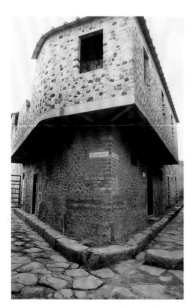

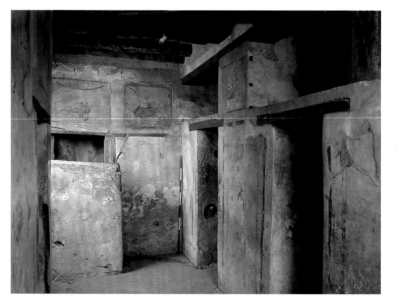

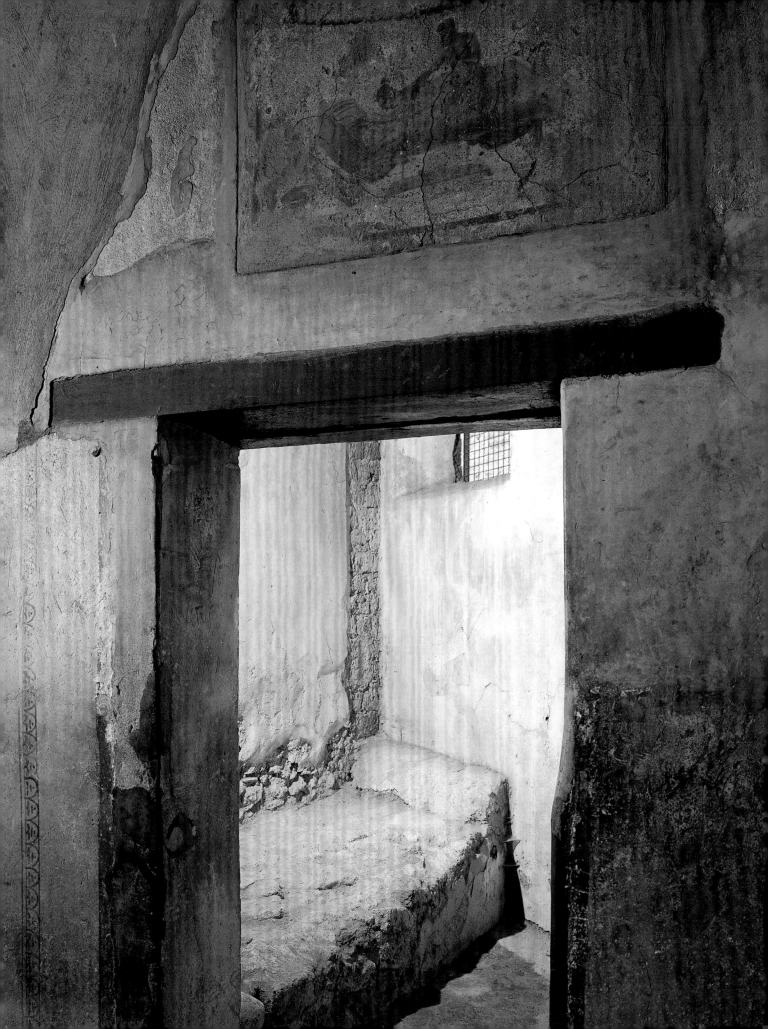

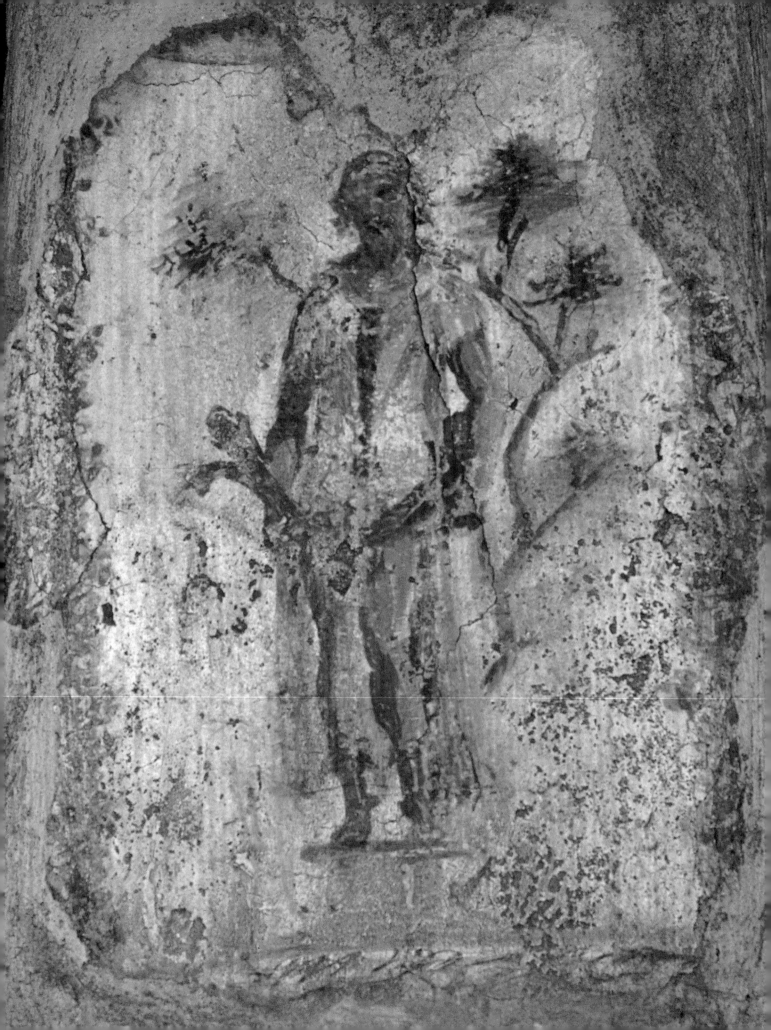

showing a man and a woman having sex.
In the furor, officials discuss whether the
public should be allowed to see them. But
scientific research continues, as experts
record and begin to translate the graffiti
covering the walls of the cubicles. They
even find the impression of a coin minted
in A.D. 72 that someone pressed into the
still-wet plaster, proof that the paintings
were fresh at the time of the eruption.

Today the Lupanar is always crowded
with tourists eager to see a real ancient
whorehouse. It is noisy and filled with
laughter. You can hear the same predictably
suggestive quips in every language of the
world. Cameras flash and videocams hum
as tourists think of creative ways to capture
their experience on film. I wonder how
many men have photographed their wives
or girlfriends posing on one of the hard
cement couches.

In today's scholarly world, prostitution
in ancient Rome is a hot topic. It was only
after the sexual liberation movements of the
late 1960s that study of ancient sexuality
became a valid scholarly pursuit. Translations
of the Latin and Greek sexual vocabulary,
feminist work on the condition of women in
antiquity, and the open publication of texts
and images previously censored helped open
up the topic of sex-for-sale.

But at Pompeii, controversy still rages
about what it means when you find erotic
pictures in a building. Until recently, every
time an excavator found an erotic painting,
he declared that the building was a bordello—
or at least that this room in the house or
tavern was used for prostitution. By 1986,
when the erotic pictures of the Suburban
Baths were discovered (see pages 115–133),
the number of supposed whorehouses had
soared to thirty-five—or one brothel for
every seventy-one men in Pompeii. As we
have seen in the case of the banker Caecilius
Iucundus, the erotic picture in his house
was a sign of his sophistication as a picture
collector, not an advertisement that he had
made the most important rooms in his house
into a bordello.

With the Lupanar, there is no mistaking the
fact that it is a whorehouse, but the pictures
themselves are far from transparent in their
meaning. For one thing, we have to think of
them in terms of their intended viewers: men
of the lower classes. Romans with enough
money to own slaves had little reason to fre-
quent brothels. They purchased slaves to
fulfill their sexual desires. There was no
stigma attached to the sexual use of slaves,
since they were the property of the owner.

And the prostitutes? There are many
graffiti that advertise prostitutes, and they

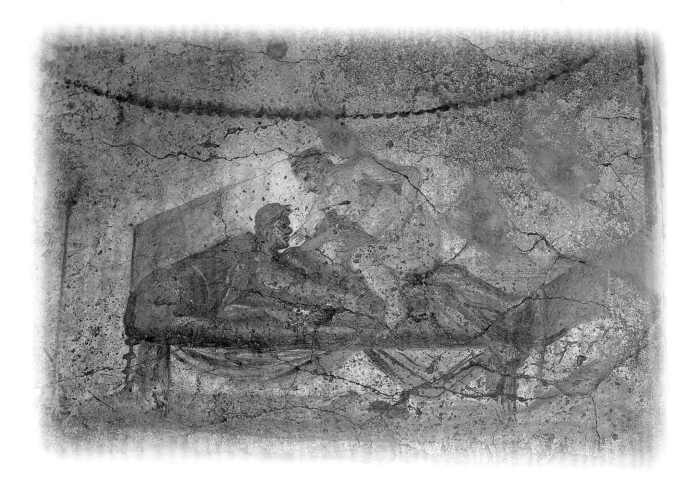

36

▲ **The artist shows the woman gazing longingly at the man,** and has included a lamp on a lampstand to the left. Since there were no beds—perhaps no mattresses—in the Lupanar, the painting is not a record of what went on there but an attempt to pretty up the harsh realities of the establishment.

37

▶ **Another "beautiful couple"** in a luxuriously appointed bed.

appear in every type of building from the houses of the wealthy to streetside shops. Analysis of the names of the prostitutes reveals that they were all slaves (both male and female). And their owners were usually ex-slaves. The prices for these prostitutes' sexual services ranged from 2 *asses* (the cost of a cup of common wine) to 16 *asses*. At Pompeii, prostitutes were readily available and fairly inexpensive.

Knowing that the clients in the Lupanar were relatively poor and that the prostitutes' services cost little, the painted decoration of the interior—and especially the erotic pictures—seems aimed at prettying-up the harsh realities of the rough-and-ready sex that went on there. The artist decorated the rude corridor with white panels defined by carpet borders that frame little winged creatures at their centers. The erotic pictures appear above the level of the lintels over the openings to the cubicles.

Presiding over the north wall is the protector-god Priapus, standing on a pedestal (fig. 34). He is there to protect the Lupanar and its clientele, just as he protects visitors entering the House of the Vettii (see fig. 3). But this Priapus has two phalluses instead of one—a visual joke about how to double your pleasure in sex.

In the erotic panels the artist—despite his modest abilities—looked to models in high art in his attempt to elevate the tone of the establishment. Take, for example, the painting on the west wall, above the entrance to the latrine (fig. 35). The couple are not even engaged in sexual intercourse. Instead, they are contemplating sex, for they are looking at an erotic picture with shutters perched at the upper left. Unfortunately, paint losses are such that only its outlines are visible. The man, naked and resting against the headboard, gestures toward the picture with his right arm, while

the woman, fully clothed in a long green dress, stands beside the bed. Her head is in profile to show off her hairdo—the piled-up curls popular in the seventies A.D.

Humble as it is, this painting represents a fantasy where the man and his sex partner have the time—and sophistication—to contemplate an erotic picture before getting down to business. As we have seen, such pictures belonged in the rooms of a sophisticated art collector; they could also be part of the furnishings of luxurious bedrooms, like the one depicted on a woman's mirror (see fig. 18). But here, where a tumble with a prostitute cost little—and the tiny cubicles offered few comforts—the painting is little more than wishful thinking.

Yet in all of the pictures the artist tried to represent luxurious, comfortable lovemaking where beautiful women give themselves to handsome men. It is straight, upper-class sex, with the men penetrating the women in the usual positions. In the

best-preserved of the pictures, the artist depicted an elaborate bed, complete with foot- and headboard, ample bolster, and bedcovers swaged from the bottom of the mattress (fig. 36). He kept a space at the left edge of the picture for a lampstand, an accessory typical of a well-appointed bedchamber.

The couple's pose and facial features reveal nuances that are surprising in a brothel painting. Rather than showing intercourse, the artist represented an ambiguous moment. The man's pose is quite relaxed. He reclines on his back but raises just his head, not his torso, toward the woman. She straddles his outstretched legs, crouching to rest her buttocks on his left thigh. She leans forward sharply to gaze at her inattentive partner. Her profile is well-enough preserved to show that the artist wanted her to be a sober beauty of classical profile, whereas the man has an unclassical face, with convex forehead

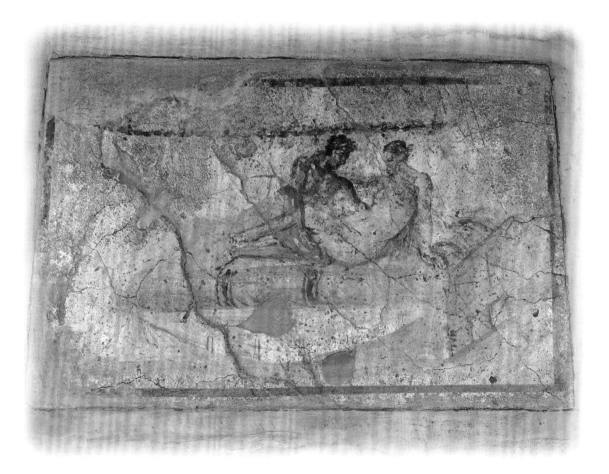

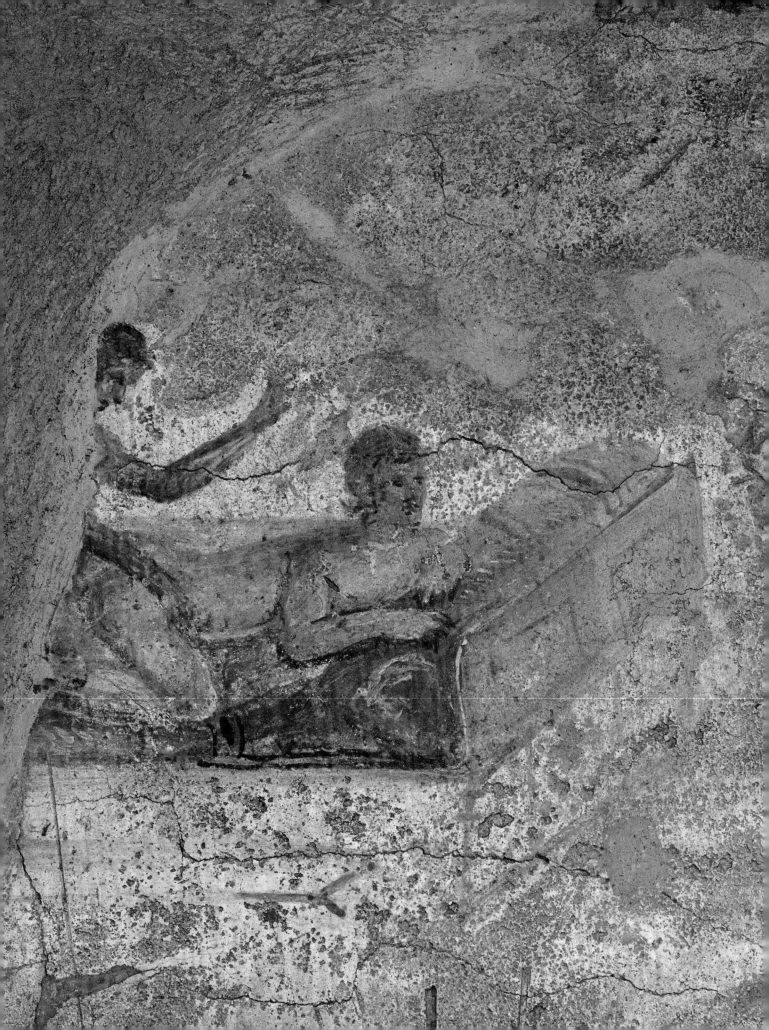

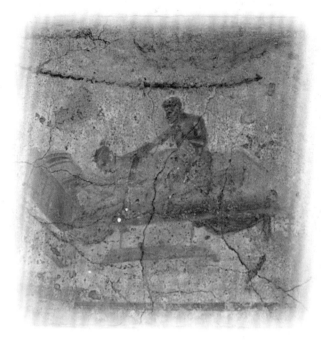

38

◄ **Respectable Romans considered rear-entry sex** to be the province of prostitutes and overly sexed women. There are three such pictures in the Lupanar.

39

▲ **The man reclines, his left arm drawn up in the** gesture of erotic repose, while the woman leans back upon his penis.

40

▲ **The woman crouches, her** back to the man.

and short, curved nose. The woman's pose suggests a lull in lovemaking, or perhaps the woman's attempt to engage the man's attention. Here in the Lupanar, where we would expect the paintings to show explicit sexual action, this painting illustrates amorous dalliance—a fantasy in light of the realities of the establishment.

The most beautiful of the paintings presents a tall, slender woman with a small, elegantly coiffed head and her handsome lover, his head crowned with a garland (fig. 37). Once again, the couple's eyes fail to meet. The woman seems to be absorbed in her own reverie while the man inclines his head forward as if to concentrate on his act of penetration. The artist has mastered the technique of depicting the details of the couple's faces, hair, and bodies in an impressionistic style, using daubs of paint to represent highlights. His attention to such details seems to be another way of encoding upper-class luxury for the clientele of the Lupanar.

The other three legible paintings, perhaps by the hand of another, less experienced artist, lack such details and refinements. They portray variations on rear-entry sex, positions that give the artist few opportunities to distinguish between the man's and the woman's mental states (figs. 38, 39, and 40).

The Lupanar is a remarkable time capsule where every element—architecture, graffiti, and painted decoration—tells us what a brothel for poor, lower-class clients was like. Yet even so, it would be a mistake to see the paintings as mere illustrations of the services the clients would receive. For one thing, the artist put his lovers on pretty beds with covers in rooms furnished with erotic pictures and lampstands. For another, he created scenarios that emphasized the preliminaries to lovemaking and that explored the different emotional states of the man and the woman. These are artistic inventions that point to situations far removed from the realities of the Lupanar and in so doing they represent fantasies of upper-class sexual luxuries for viewers who could not afford them.

Pictures of Sex Shows
in the Inn of Mercury

Another scandalous set of sex pictures, four in all, emerged from the ashes of Pompeii in 1823, but the building was clearly a tavern, not a brothel (fig. 41). (Excavators dubbed it the Inn on the Street of Mercury because it's directly across the street from a fountain decorated with a bust of the god Mercury.) A big street-side counter for selling food and drink takes up the street corner *a*; room *b*, where the sex pictures were found, was set up for customers who wanted to sit at tables to drink, eat, and play dice. In fact, that is just what the other nine pictures, most of them still preserved, show (fig. 42). On the right long wall, for example, we can still make out a scene of men playing dice, a man asking a servant for water, and a group of travelers sitting beneath a rack hung with sausages and hams. But the pictures to the far left and right are gone, as are the pictures to the left and right sides of the back wall. This is where the French artist César Famin saw and recorded two images of outrageous sexual acrobatics. They were published, just fourteen years after their discovery, in a

luxury volume called *Musée Royale de Naples. Peintures, bronzes et statues érotiques du Cabinet Secret.* It rapidly sold out, evidently to wealthy gentlemen collectors. But shortly thereafter the sex pictures were gone, deliberately destroyed by some prude who knocked the very plaster off the wall. Famin's engravings appeared in 1841 in a volume edited by the moralizing M. L. Barré, but subsequent editions erased the men's huge penises (fig. 45).

What is puzzling about the sex pictures is the company they keep, side-by-side with innocent pictures of tavern life. Take, for example, the so-called *Tightrope Walkers* (fig. 43). It was originally on the back wall, opposite the main entrance to the room, where today only the legs of the man on the right and a head remain. The woman bends deeply at the waist to perform several feats simultaneously. As she bends over to grasp the neck of a wine jug with one hand, while raising her glass to drink with the other, her companion seizes the opportunity to enter her with his huge penis. He seems to be toasting the event as holds his glass aloft.

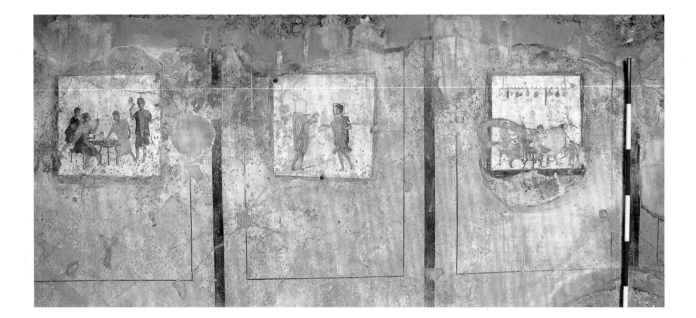

41

◄ **Pompeii, plan of the Inn on the Street of Mercury.** Discovered in 1823, little dining room b was decorated with scenes of tavern life— including several outrageous sex scenes.

42

▶ **Today, three scenes of tavern life** survive (from left to right: men playing dice, a customer asking for wine, and men eating), but the sex scenes are long gone— destroyed by a prude.

43

▶ **In 1827, the artist César Famin recorded two of the sex scenes.** One scholar dubbed this acrobatic painting *Tightrope Walkers*, and claimed that the man's penis was Famin's invention. Famin made one error: He misunderstood the shadow lines beneath the fig- ure's feet as ropes, and tied them to the low table.

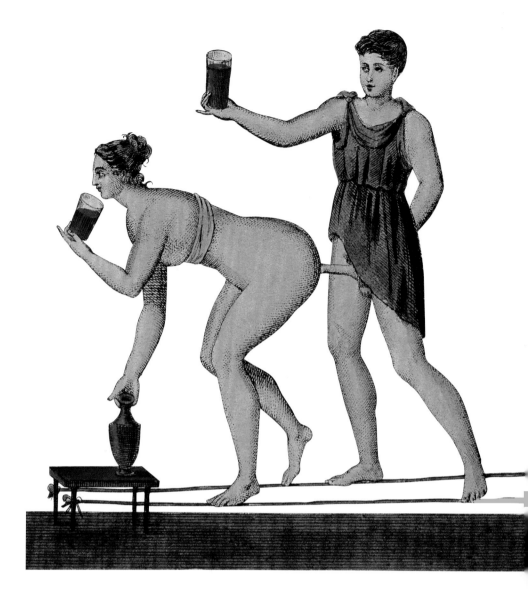

Because the original is destroyed, it's impossible to verify the details of Famin's engraving, particularly the parallel ropes that appear beneath the couples' feet. The most likely explanation is that this area of the painting was not entirely clear, and that what the artist interpreted as ropes tied to a table were merely the cast shadows that reg- ularly appear in Pompeian paintings as thin lines behind the figures' feet. Ancient tightrope walkers never used two ropes rather than one, and tying the ends of two ropes to an ordinary table would not sup- port the performers' weight.

And performers they are—for what we have here is a scene described in literary sources but pictured only here: the sexual acrobatics from the popular theater. Performances of outrageous sexual acts, known as the nude, or obscene mimes, had long been part of the theater—little skits sandwiched in between tragedies and comedies. The *nudatio mimarum*, as they were called, originated in fertility cults, but by the second century B.C., they had become outlandish explorations of sexual play. For the owner of the tavern and his customers, picturing sex-acts from the popular theater was equal to showing scenes of eating, drinking, and dice-playing. They were just another reminder of the little pleasures that enhanced their lives.

Famin recorded one other sex picture from the walls of room *b*. It is less acrobatic

44

▶ **The other painting from the Inn on the Street of** Mercury, like *Tightrope Walkers*, recorded a scene from the sexual farces that everyone saw on stage.

45

▼ **Barré republished Famin's engravings,** but in many editions he removed the men's penises.

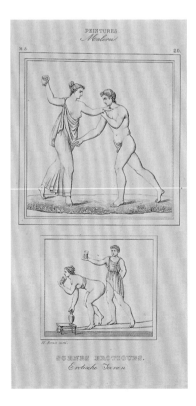

than the *Tightrope Walkers*, but it shares one sensational feature: the huge size of the man's penis (fig. 44). Although it is possible that the draftsman exaggerated the size of the men's penises in both drawings, I believe that he recorded the paintings faithfully. It seems logical that male sexual acrobats would have to have large penises so that the spectators could see the act of penetration—even from the back row. We know that comic actors wore huge leather phalluses for certain roles; in the nude mime there was no faking it.

What is more, despite the avowed Roman preference for men with small penises in high art and literature, men with large penises are the focus of comedy and satire. In Petronius' comic novel, the *Satyricon*, a huge crowd of bathers gathers around Ascyltus to admire his enormous penis (Petronius, *Satyricon* 92). They applaud him, as do the bathers in Martial 9.3: "If from the baths you hear a round of applause, Maron's huge dick is bound to be

the cause." Here in the tavern, where the artist included the erotic paintings as part of a compendium of life's pleasures, he emphasized not only the sexual acrobats of the theater, but also the men's super-penises. His aim was to elicit a combination of dumbstruck admiration and laughter from the customers.

A Tavern with a Playroom?

Many tavern owners regularly rented out their waiters for sexual purposes. But if customers in the Inn on the Street of Mercury wished to have sex with one of the male or female waiters, the only available space was little room *d*, where the artist tried to produce "proper" decorations like those you found in middle-class houses. The room is decorated with faux marble and has mythological paintings—not pictures of

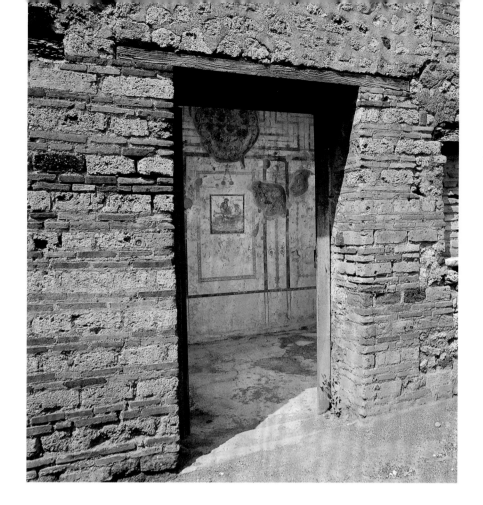

46

▶ **Tiny room f'**
(10 ft. 5 in. × 8 ft.;
3.20 × 2.45 m) is all that
remains of the House of
the Restaurant because
the excavator put a
modern roof and secure
door on it to keep it from
offending visitors.

47

▼ **Pompeii, plan of the
House of the Restaurant.**
The rooms marked a'
through f' represent the
remodeling that made
this part of the house into
a tavern with a playroom.

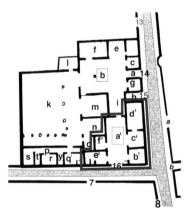

lovemaking—on its walls. Not so the little
room of the so-called House of the Restaurant
at Pompeii, which is decorated in its entirety
with sex pictures (figs. 46 and 47). A glance
at the plan shows that there were really two
houses here: one, a large house entered at
number 14 with a big garden (k) at the rear,
and a smaller house with its entrance at 16.
Sadly, the rapid excavations of 1877–78 left
only ruined walls behind—except for little
room f', since officials made sure that it
received a modern roof and a heavy door to
protect the morals of the curious.

August Mau, the famous scholar of Pompeii
and member of the German Archaeological
Institute in Rome, provided the only exten-
sive description of the house at the very
moment of excavation. It is to him we owe the
nickname House of the Restaurant, for Mau
decided that this was a little house that went
wrong—converted to a combination tavern-
brothel when the artist created the erotic pic-

tures in room f'. But reading Mau's account of
the rich decoration of the other rooms, where
a viewer saw standard mythological pictures
and elaborate decorative motifs, I began to
doubt just what message the owner was trying
to send to his clientele. To the modern visitor,
who sees just the ruined, blank walls of the
rest of the house and then suddenly sees the
"sex room," it looks very much like a brothel.
But to the ancient visitor, f' was just one room
among six.

Four of the five original paintings still
survive. They are set into a simple yet
elegant decorative scheme on a white
ground, and although they emphasize posi-
tions rather than the niceties of bedroom
decor, they are not without nuance. In the
centerpiece on the west wall, opposite the
door, the woman reclines in a pose meant
to emphasize her gracefulness and beauty
(fig. 48). The gesture of her right arm,
crooked over her head to frame her face,

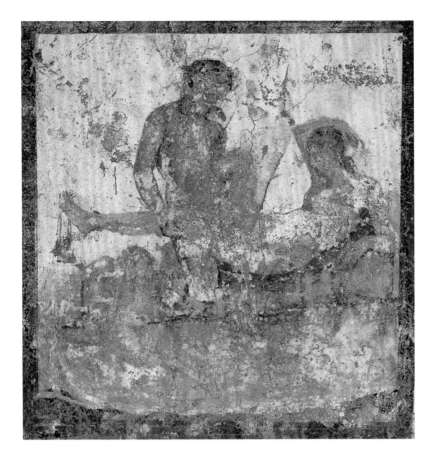

signifies both repose and sexual readiness.
The man kneels on the bed and parts her
legs to enter her.

The two sex scenes on the north wall float
within large vertical panels, defined by gar-
lands rather than by the double frame that
defines the west-wall image as a picture. In
the left-hand image, the man kneels facing
right as does the woman, but she is crouch-
ing down, supporting her upper torso with
her right elbow while she raises her buttocks
to receive the man's thrusts (fig. 49). The
couple is not unbeautiful, although paint
losses unkindly erased the woman's mouth
as well as much of the man's classically pro-
portioned head. Note the large pillow, bed-
spread, and sham—all decorated with a
striped pattern. There is a headboard but no
indication of the legs of a bed. Perhaps this
was a masonry platform, like the ones in the
Lupanar, rather than a wooden bed.

The right-hand image underscores
the difficulty of interpreting sexual body
language from a distance of 2,000 years

(fig. 50). The woman kneels facing the man
and straddling him, so that her genitals are
near his. She leans back and inclines her
head—perhaps coyly, perhaps intimidated
by the fact that the man is waving his hand
toward her face. Paint losses make it impos-
sible to understand what the woman is doing
with her left hand. She is either grasping the
man's penis or touching her own genitals.
One scholar has suggested that she is mastur-
bating, since a Roman moralist specifies the
left, or unlucky, hand for this unseemly act.
In this scenario the man's gesture is one of
disapproval of the woman masturbating. Yet
it is equally possible that the woman is guid-
ing the man's penis into her vagina. In the
end, it is unclear what the man's gesture
means, since although his right hand seems
to say "stop," the rest of his body seems quite
relaxed. Perhaps his gesture expresses his
amazement and delight.

On the south wall, only the left-hand
panel remains (fig. 51). The woman, in
profile, kneels straddling the man's hips

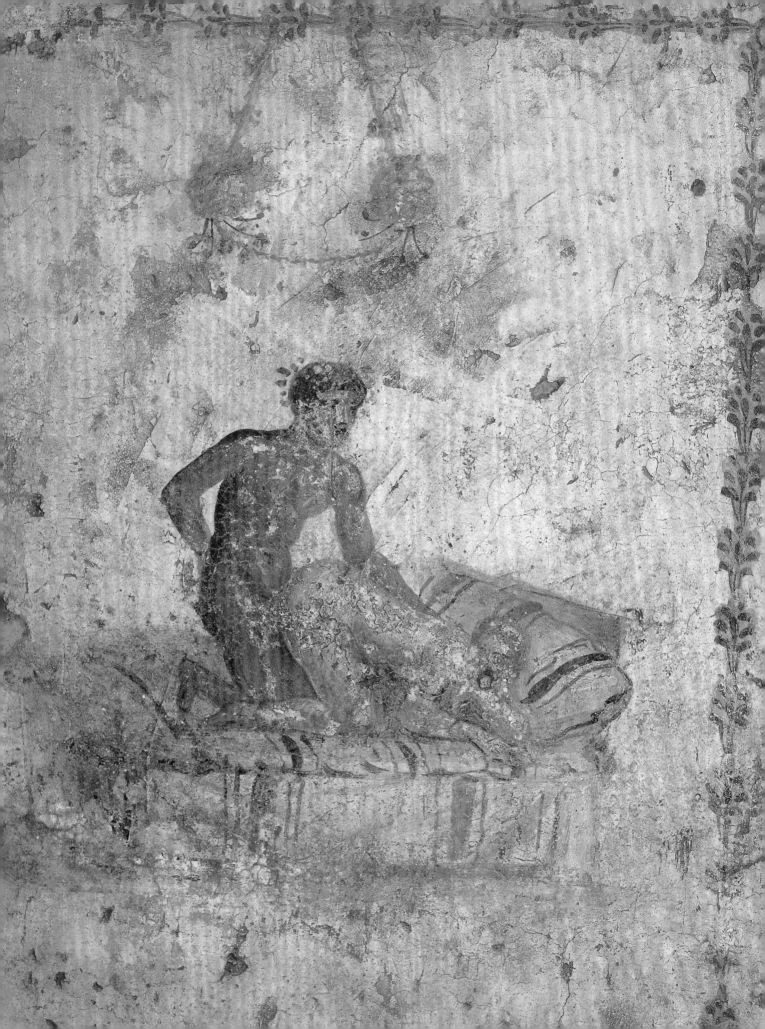

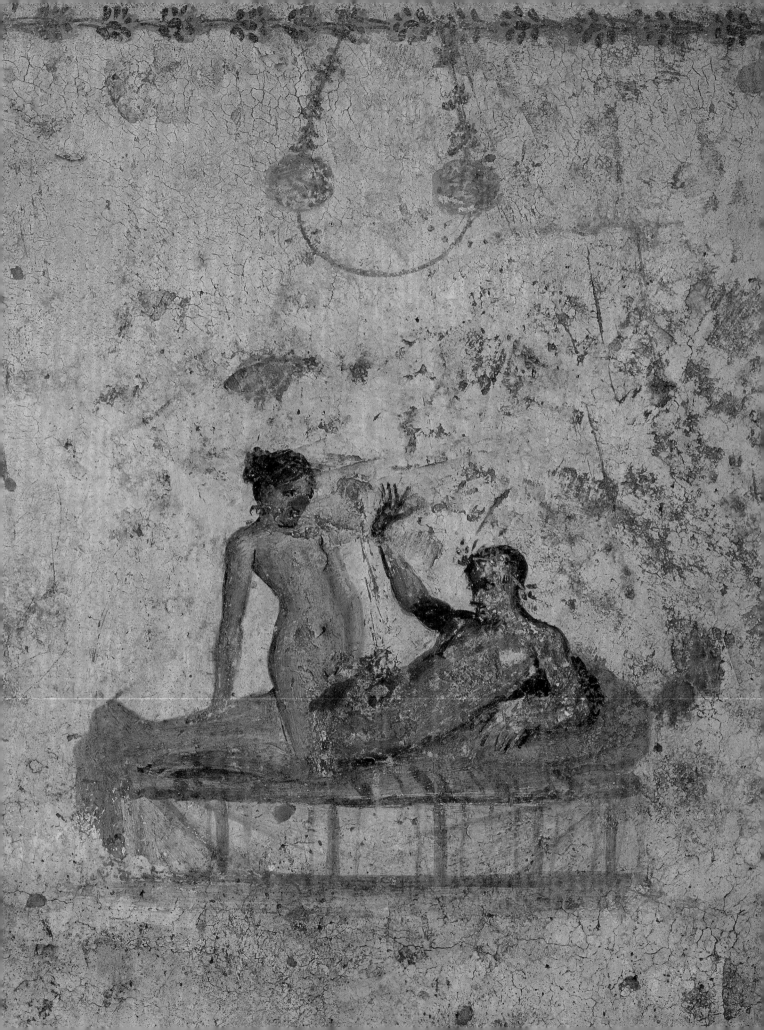

50

◀ **Paint losses make it impossible to know what** the woman is doing with her left hand. Some scholars believe that she is masturbating rather than reaching for the man's penis—thus explaining the man's gesture—surprise? disgust? Elite Romans were supposed to masturbate with the unlucky (or unclean) left hand.

51

▶ **An eager woman with** an elegant hairdo typical of the 70s A.D. tenderly kisses her partner.

as she leans forward to kiss him. He is reclining, his head resting on the pillow as he supports his upper torso with his left elbow. Even though this is the worst preserved of the paintings, it is perhaps the most tender, emphasizing the kiss as either prelude or accompaniment to the sex act. The artist tried to make the woman's profile attractive and paid special attention to her coiffure, the hair pulled back from the forehead and gathered in curls at the back.

At the time that Mau decided that the House of the Restaurant was a house-to-brothel makeover, he could not have predicted that a much fancier house with a room decorated much like this one would emerge from the ashes fifteen years later. This was the famous House of the Vettii, where we began our story. Like room f', the "cook's room" in the House of the Vettii has simply painted male-female sex pictures on a white background—yet the House of the Vettii was certainly not a brothel (see fig. 1). The main difference is that, unlike the "cook's room," hidden away behind the kitchen, f' is highly visible from the atrium.

Like the House of the Vettii, the House of the Restaurant boasted some fine paintings in its other rooms, several of such high quality that the excavator had them cut from their walls and sent to the Naples Museum.

If only the House of the Restaurant had gotten modern roofs to protect it, like the House of the Vettii, perhaps we could understand how the sex pictures of little room f' fit in. Mau based his notion that the House was a "restaurant" on what he identified as a stone wine-heating stove to the right of the entry; today it is a heap of rubble, and the only other person to report on the house, the excavator Antonio Sogliano, identified the same heap of rubble as a staircase to the upper story. All the other evidence is gone. If sex was sold in the House of the Restaurant, it was not served up in the production-line fashion suggested by the narrow rooms of the Lupanar. This house-to-tavern makeover offered clients several nicely decorated dining rooms and a special room with erotic paintings that could be used for the occasional tryst. It was a tavern with a playroom. 🍆

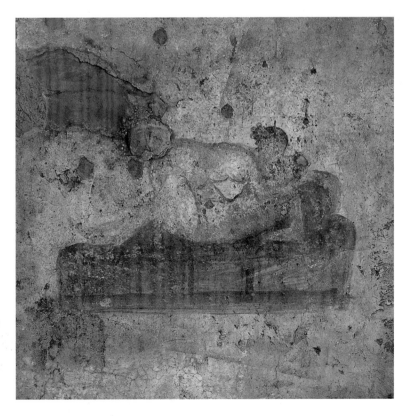

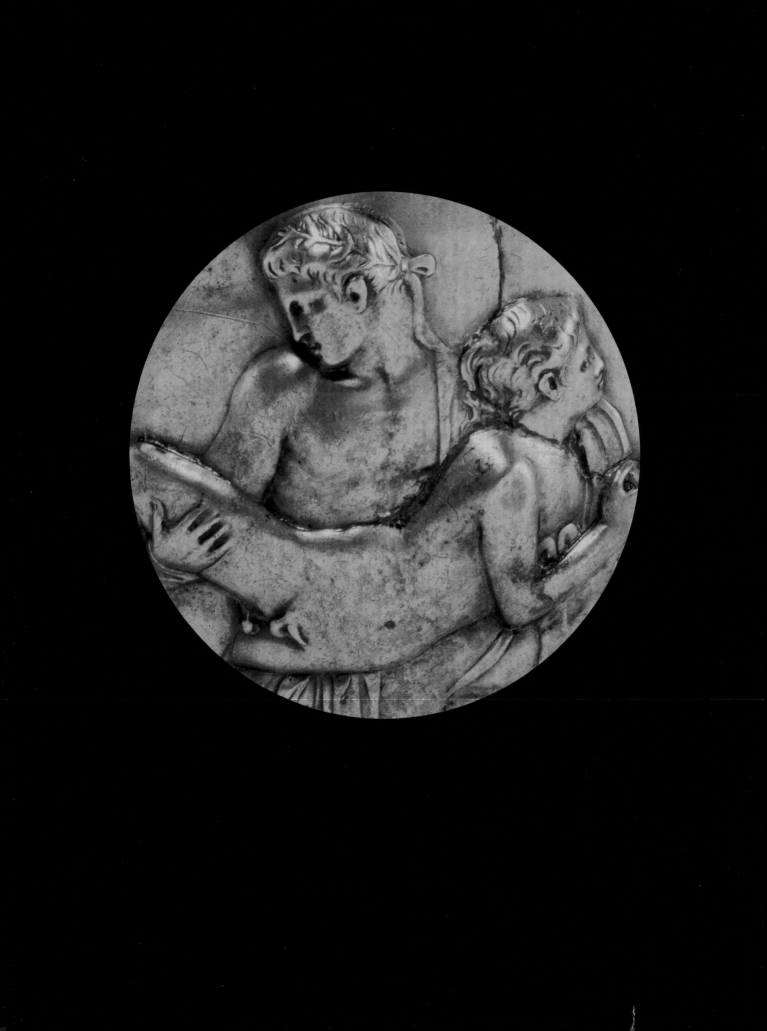

GAY SEX

IN BI AND

STRAIGHT

COMPANY

BESIDES THE EROTIC PAINTINGS on their walls and in their picture collections, Romans prized drinking cups with sex scenes on them. I remember my astonishment when I first saw a photograph of the Warren Cup (figs. 52 and 53). On one side a young man is lowering his buttocks onto another man's penis with the aid of a strap while a young voyeur looks on. On the other side a man is having anal intercourse with a young boy. The detail is astonishing, especially if you consider that the cup is only six inches tall. Today the Warren Cup is proudly displayed in the British Museum, bought from a private collector reportedly for the sum of three million dollars. Yet ten years ago, when I first began to study it, the Warren Cup did not even have a name (I named it), and it was virtually unknown, hidden away in a Swiss museum. The reason? Scholars could not bring themselves to believe that such hard-core images of gay sex could have existed in ancient Rome. They thought it was a fake, designed to titillate Victorian gentlemen collectors like E. P. Warren, who acquired the cup in the late 1800s.

I tracked down the owner who had lent it to the Swiss museum, and arranged to see the cup in person. In the meantime, a specialist in ancient silver had cleaned it and examined it. He said he found no indication that it was a nineteenth-century creation, but would not say more. Nor did I. Although everything about its construction and condition convinced me it was genuine, I needed more proof. Time for some detective work.

"Bisexual" Bowls

My first task was to find out whether there were comparable scenes of hard-core gay sex on vessels that came from documented excavations. It did not take much sleuthing to find many male–male sex scenes that I could date to the same period as the Warren Cup, between A.D. 1 and 30. I found a whole range of images of gay sex on a variety of vessels of the period. There were very expensive ones in silver and cameo glass, and cheap, mold-made terracotta imitations produced for poorer folks. One of these cheap terra-cotta bowls, produced in the ancient Roman town of Arretium (today's Arezzo) in Tuscany, has a "bisexual" composition. It alternates images of straight sex with gay sex. Visitors to the Museum of Fine Arts, Boston can see

52

▶ **The Warren Cup, side A. Two men make love while a boy** peers through a door to look on. Considered too explicit to exhibit when it came on the art market in the 1950s, today the cup takes pride of place in the British Museum, London. The hairstyles date the cup to A.D. 15–30.

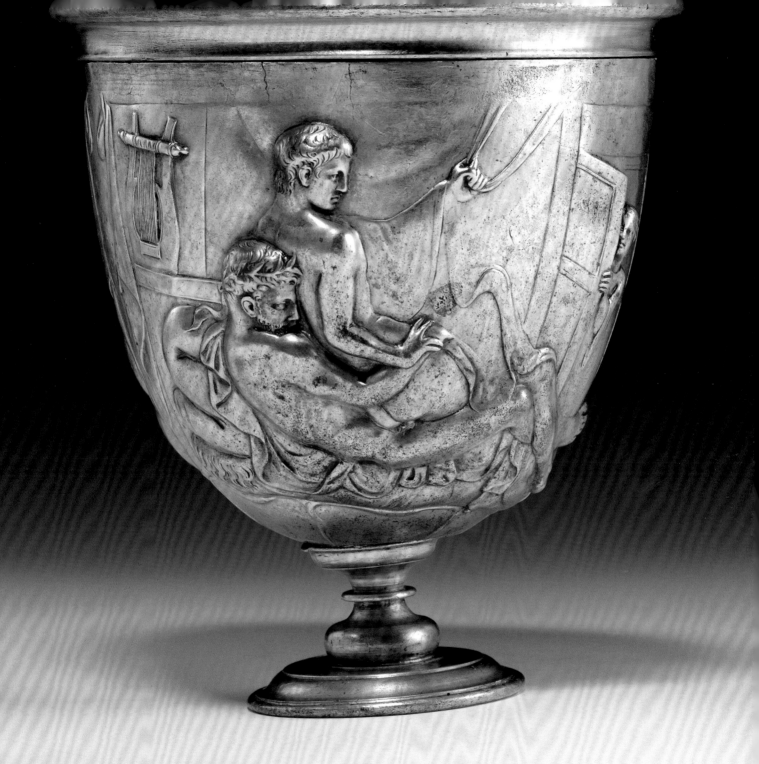

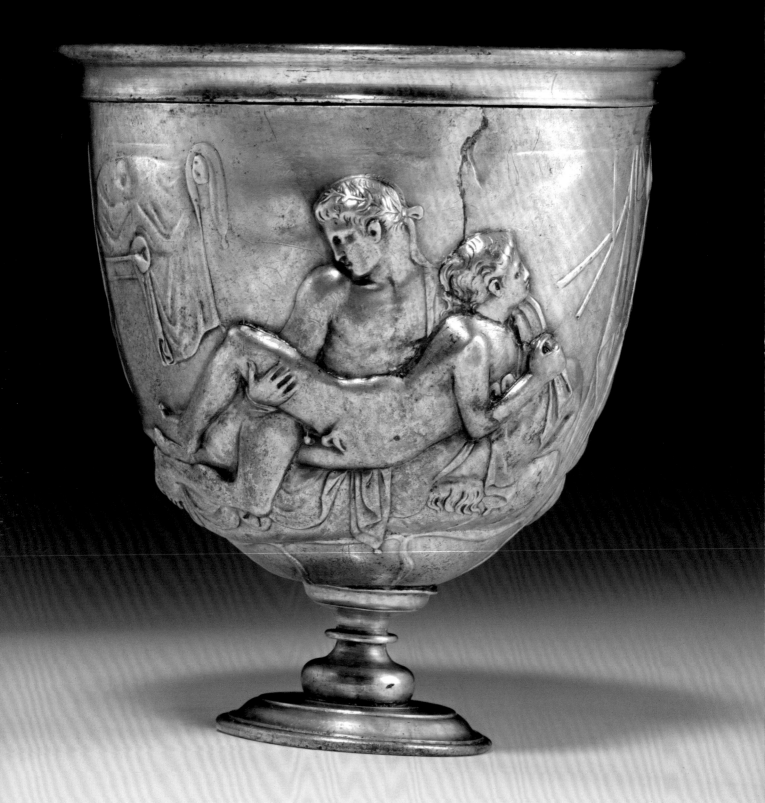

two versions of this composition, both gifts of E. P. Warren, original owner of the Warren Cup (figs. 54 and 55). There were originally four scenes of couples having sex on a bed. Only two are preserved on each of the Boston examples. A statue of Eros, winged god of Love, stands on a fluted column separating the scenes.

The male-female sex scene is the most explicit one that you will find among all the erotic scenes on Arretine ware. The composition emphasizes the act of penetration. The woman's back is to the man as she leans forward to squat down on his erection. The man calmly rests one elbow on the pillow and the other on her back as he watches his penis going into her.

The gay sex scene is a romantic encounter between a man and a boy on a bed. The man

looks into the boy's eyes as he prepares to enter his anus. The man grips the boy's right thigh and plants his knee behind the boy's right knee. The boy grasps the man's arm just below the elbow. Is he resisting the man's entry, or is he pulling him in?

These are but two examples of a whole group of erotic cups and bowls produced in Arezzo during the Augustan age (30 B.C.–A.D. 14). These "bisexual" cups and bowls helped me to establish that ordinary people prized beautiful images of explicit straight *and* gay sex. Arretine ware was an affordable substitute for silver and gold vessels. It was also widely exported, and examples have turned up in excavations as far away as Great Britain and Turkey. Since ancient buyers could choose the imagery on their Arretine pottery, we have to ask why they wanted the

53

◄ **A man penetrates a boy.**
The Warren Cup, side B.

54

► **A "bisexual" decoration:**
A woman squatting on a
man's penis alternates with a
scene of a man penetrating a
boy. The figure of a cupid
standing on a column separates
the scenes. Terra-cotta bowl
from Arezzo, A.D. 1–30.

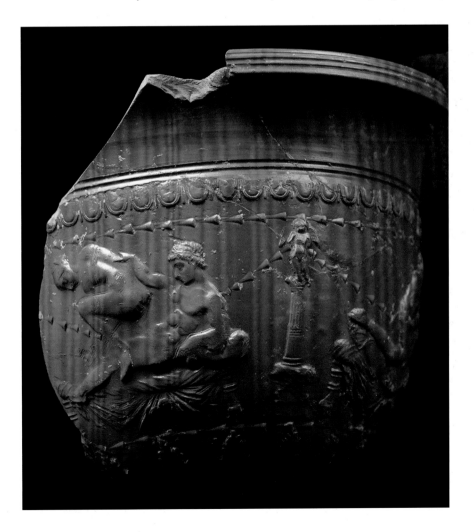

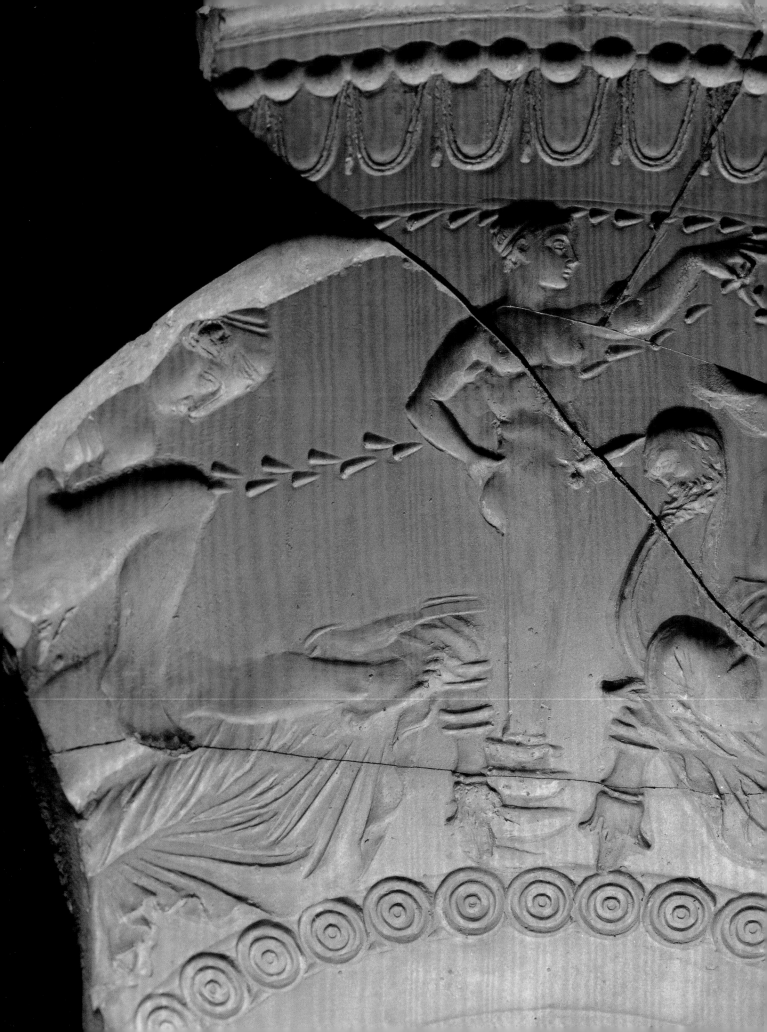

◄ **This mold for another bowl
with bisexual decoration has a**
herm of Priapus—complete
with huge erection—daintily
holding up a garland as he
looks at the man and the boy.

erotic scenes. The answer seems simple: if
they were going to buy low-cost imitations
of the fine silver vessels that rich people
had, they had to have the same imagery—
and erotic scenes decorated expensive
objects like the Warren Cup. After all, the
reason that ordinary consumers bought
Arretine ware was that it did such a good job
of imitating the style and subject matter of
aristocratic silver.

And imitate it does, if we just stop and
look at the correspondences between the
man-boy sex scene on the Boston mold and
the version of that scene on the Warren Cup.
In both cases the artist has clearly distin-
guished the boy from the man by making
the man much bigger and more fully devel-
oped. But on the Warren Cup the artist has
tried an elegant variation on the standard
rear-entry motif by turning the couple's
heads away from each other. Rather than
gazing at his partner, the man looks to the
viewer's left, his head slightly lowered. The
boy, in turn, leans on his flexed right elbow
as he props himself up on the pillow and
gazes up into space. The man supports him-
self on his right knee while parting the boy's
thighs with his right hand. His left leg
extends beyond the edge of the mattress, his
toes touching the bottom of the framing

▼ **The boy being penetrated
on side B of the Warren Cup**
wears a hairstyle—with long
locks flowing down the nape
of his neck—that only foreign
or slave boys wore. This detail
helped authenticate the
Warren Cup.

57–58
▶ **The "bisexual" decoration
shows a man making love to a**
girl on one side and a man
penetrating a boy on the other
side. The boy wears his hair
in the same style as the boy on
the Warren Cup. Cameo-glass
perfume flask recently found
in Ostippo, Spain.

drapery. Despite all this elegant twisting
and posing, the act of sex is quite explicit:
the artist has represented one of the man's
testicles directly behind the boy's, indicat-
ing that he is already inside him.

Authenticating
the Warren Cup

This scene on the Warren Cup also has an
anomaly that provided the evidence I
needed to prove that the cup was genuine.
The boy has an unusual hairstyle (fig. 56).
Like the other figures on the cup, he has
short-cropped hair combed in the typical
Augustan style. But he also has a long lock of
hair at the nape of his neck. I could not find
this feature on the Arretine cups, or any-
where else, until I happened upon an
extremely rare and beautiful perfume bottle
in a Swiss private collection. There it was!
On one side, a man penetrating a girl (fig.
57); on the other, a man penetrating a boy—
and the boy has an even more pronounced

"neck lock" than the one on the Warren
Cup (fig. 58). What is more, this bottle was
found in excavations at Estepa, Spain (near
Seville), shortly before 1986.

This was just the kind of evidence I was
looking for. The fact that the boy wears the
same long lock of hair on both the Ortiz
flask and on the Warren Cup was proof that
the Warren Cup was authentic. No forger
working in the nineteenth century could
have known about this feature—since the
first time archaeologists saw it was when
they dug up the Ortiz bottle in the 1980s. If
a forger had made the Warren Cup, he never
would have included an anomaly like the
long lock, since at that time it was unknown
in the repertory of Augustan-period silver
and ceramics. In the nineteenth century,
the only known images showed men and
boys with uniformly short hair.

Since the discovery of the Ortiz bottle—
and my authentication of the Warren Cup—
the long lock has been explained. Literary
sources show that slaves—and especially
young male slaves used for sex—often had
long hair. As several scholars have recently

pointed out, there was no specific class of male slaves whom the Romans considered to be exclusively "sex slaves," just as there is no universal term in Latin for a sex slave. But the primary kind of work that especially beautiful young slaves between the ages of twelve and eighteen did was to serve their masters (and perhaps also their mistresses) sexually. Ancient writers praise the beauty of their smooth slave boys, at the age just before their beards start to grow in. They wax eloquent about their long, flowing tresses and their hairless "rosebuds" (anuses). The artist who made the Warren Cup, like the artist who made the Ortiz bottle, was marking the boy as a slave. His lock is a conservative Augustan version of the more ample flowing tresses worn by male slaves used for sex. The hairdo is a combination of the short bangs in front with the provocative lock behind—much like an American male hairstyle popular in the 1980s.

A fragment of a more elaborate cameo-glass vessel than the Ortiz perfume bottle takes pride of place today in the same room of the British Museum where the Warren Cup is displayed (fig. 59). Although it does not show the lovers' heads, the composition is nearly identical to the man-boy scene on the Ortiz bottle. What is remarkable about the fragment is the artist's use of color, reminding us why cameo glass vessels were so expensive in antiquity. Where the Ortiz bottle uses two colors, the British Museum fragment employs five. In both cases, the procedure was long and difficult. A master glassmaker created a glass "blank" in the shape of the vessel, with the differently colored layers carefully annealed to each other. He then turned the work of carving the relief decoration over to a gem cutter, who expended considerable time and effort in removing the unwanted layers, carving the figural and decorative motifs and polishing the surfaces. He used the same tools and techniques needed to cut semiprecious stones. In the British Museum fragment, the gem cutter carefully revealed the five layers, beginning at the deepest layer with opaque white and progressing through translucent deep green, opaque white, deep green again, and opaque red.

From extremely expensive luxury items in cameo glass and silver to the mass-produced Arretine cups, we see how standard the image of man-boy lovemaking was. In fact, early on, scholars noted that to compose such images, the artists simply took a scene of a man penetrating a girl and made the girl into a boy by removing the breasts and adding the testicles

The "Rules" of Gay Sex— and How Romans Broke Them

The other side of the Warren Cup has even more to tell us about ancient Roman attitudes toward what we call "gay" sex. Here the artist has framed the sex scene with a lyre on the left and a doorway to the right. The young man on top, who holds on to the strap, is clean-shaven. Flowing drapery conceals the arm that holds the strap, but parts to reveal this man's right hip and buttocks, where we see his partner's penis entering his anus (fig. 60). The man beneath him has a close-cropped, curly beard and wears a laurel wreath tied with a ribbon at the back of his head.

The couple is not alone. To the right, a boy opens one of the battens of the door— either to peer in or to glance back while quietly exiting (fig. 61). He has close-cropped curly hair and wears a simple tunic. Both the boy and the door are quite small in relation to the couple on the bed.

An ancient viewer who drank from this cup would have noticed that the young man on the top is about the same size as the man on the bottom. He is fully developed—not really a boy—so that he is more or less an equal of the man who penetrates him. We are actually more comfortable with this scene than we are with the scene on the other side—of a grown man penetrating a

and penis. All the rest—the poses, the romantic gaze—stays the same. This kind of interchangeability between boy and girl as object of a full-grown man's lust is mirrored in ancient Roman poetry, where the poet switches from singing the praises of his girl-love to those of his boy-love with a regularity that is astounding to us. Our modern notions that a man is either "straight," "gay," or "bi-sexual" couldn't be further from the mind-set of the ancient Roman man. His role was to find sexual pleasure by inserting his penis into the vagina, anus, or mouth of a beautiful sex object. Like all Romans, he worshiped beauty in both male and female bodies—and strove to have sex with beauties of both sexes.

▶ **Flowing drapery and the
men's delicate gestures**
frame the focus of the
scene: the penis of the
man on the bottom
entering the anus of the
man on the top.

barely pubescent boy. Why? Because in our culture, if we think of male-male sex at all, we would rather it was sex between consenting adults—not men having sex with boys. Our laws reflect this convention, making the legal age of consent for the younger partner around eighteen years of age. So, speaking from the point of view of our culture, the scenes of man-boy sex that abound on Roman cups are pedophilia, a grave crime. Not so for the ancient Romans, who followed a different set of rules about male-to-male sex. Inequality in both age and social status was the rule—not the exception.

Along with the wealth that poured into Rome in the century before Augustus came to power (about 130–30 B.C.) came a craze—especially among the rich—to import Greek art, customs, and people into Rome. Wealthy Roman gentlemen adopted the fashion of buying slaves to satisfy their sexual whims. Upper-class people took it for granted that the elite male would have his pretty boy toy to make love to. He would also have his female love toys—all under the same roof with his wife. But it is important to remember that these sexual habits—shocking to us, perhaps—were not problematic for the Roman elites, since it was love between unequal partners. And, legally speaking, it was sex between the owner of the property and his property. Considering that a beautiful boy or girl slave cost about as much as a Mercedes, not to have inter-

course with your slave would be like buying a Mercedes and never driving it.

The law also sanctioned another kind of sex between males, the kind provided by homosexual prostitution. Male prostitution was a legal institution. These men paid taxes on their earnings and even celebrated their own holiday like female prostitutes. There were two chief differences between male and female prostitutes. Where the female prostitute was generally of the lowest class and sold her services quite cheaply, male prostitutes were young and often sold themselves for high prices. Many young male prostitutes became quite rich, since to buy the sexual services of a beautiful boy was a luxury. The moralist Cato laments that his fellow Romans were willing to pay a prostitute the money it would take to buy a farm. But what bothered him most was that the elites were impoverishing their estates by chasing after expensive luxuries. Whether they did so with boys or with other luxury spending (such as buying caviar from the Black Sea) did not matter to him. It was the spending, not what they spent it on, that annoyed Cato.

In Roman thinking, what we call "gay" sex carried no stigma. It was fine for a freeborn, elite male to insert his penis into the body of another, whether that other be male or female. The important thing was that the other person had to be of a lower social class. The Roman elite man must not have sex with

▶**Who is the young boy?**

A voyeur? The man's next
sex partner? A stand-in for
the viewer?

another freeborn male—boy or adult. It was
easy to know the social status of people in
Roman times because of their dress. A free-
born boy, who was off-limits for sex, wore a
golden amulet around his neck and a special
toga. The playwright Plautus summed up the
rules in one of his comedies; he has a slave say
to a freeborn man: "Love whatever you want,
as long as you stay away from . . . free boys."

Besides prescribing the inferior status of
the love object, the whole of Roman litera-
ture—from poetry to the law—makes it clear
that the elite man's role must only consist in
inserting his penis into the love object.
Words such as *pathicus* and *cinaedus*, mean-
ing a man who liked to be penetrated, car-
ried a great stigma. And it is especially here
that the Roman mind-set about what we
called "gay" sex is difficult for us to grasp:
the "active" or insertive position carried no
blame, but the Romans scorned and some-
times penalized freeborn men who willingly
had sex in the "pathic" or receptive posi-
tion. This scorn applied automatically to
slaves and even ex-slaves, since everyone
simply assumed that their masters had used
them—that is, penetrated them sexually.

Seen from the Roman point of view, the
image of two nearly equal sex partners on
one side of the Warren Cup is a good exam-
ple of an artist breaking the rules. Nothing
in the body size, facial type, or hairstyles
(aside from the "active" lover's beard and
laurel wreath) differentiates the two men. If
we did not know the Roman legal writings
against two males of the same age and class
having sex, we would be inclined to read this
image as modern "gay" sex: reciprocal sex
between adult men.

Why did the artist break the rules? One
scholar proposed that the Warren Cup was
showing two princes of Augustus' family
caught in the act. In his interpretation, the
cup is political satire. The only problem is
that the scene on the other side of the cup,
as we have learned, is quite standard: an
adult man and a boy sex slave. Furthermore,
elite men did not wear beards at this time
in history.

I believe that the person who commis-
sioned the artist of the Warren Cup was
interested in recording not what the law
said but what real men—elite or not—
actually did. Someone with enough money
to have a silver cup custom-made could
order up any image he wanted. I think
this someone was an elite man who as an
adult identified with the sexual pleasure of
both penetrating and being penetrated.
Although he had no word to label this iden-
tification (the Romans had no words corre-
sponding to our modern concept of "gay" or
"lesbian"), he enjoyed looking at this scene
of equal, reciprocal, male-to-male sex.

After-Dinner Sex Talk

I can go further and suggest that it was not just
the owner, but also his friends and dinner
guests, who enjoyed the sex scenes on the
Warren Cup. Romans entertained a great deal,
and we have numerous of accounts of long
dinner parties that started with many food
courses followed by hours of wine drinking.
Of course, musicians and dancers entertained
the guests, but the host also expected his or
her guests to talk about the art on the walls or
about the images on the table silver. I can well
imagine the Warren Cup—perhaps part of a set
that showed other sexual combinations—as a
conversation piece.

An ancient Roman would, like us, have
appreciated the fine workmanship and detail.
But I think the big topic of conversation

would have been the relative pleasures of different kinds of male-to-male sex. After all, the artist has really emphasized two kinds of lovemaking. Turning the cup in his or her hand, a knowledgeable Roman would have noticed the differences between the conventional scene of a man and a boy and the unusual scene of two adult men in the act of using the strap for sex. I think our viewer would have commented on the differences between penetrating a very young boy—a virgin—and penetrating a proficient sex slave who knew how to use the strap. He or she might have noted the humor built into the strap scene, since the artist shows the man on the bottom exerting himself to keep from being crushed by his partner. In this position—again something a Roman would have enjoyed commenting on—the man on the top (who is playing the "bottom," or the person being penetrated) actually has the reins. He controls the thrusts of the man who is penetrating him. The boy who opens the door to enter or to watch might become part of a story that our viewer could make up: he is an apprentice sex slave, learning how big boys make love; he is the next partner for the bearded man; or he is a stand-in for you, the viewer!

One thing is certain. The ancient Romans saw the Warren Cup as a beautiful sexual fantasy, not as something to hide away or be repulsed by. The care the artist has taken to make all the lovers beautiful (true even on the modest Arretine vessels) expresses the Roman belief that sex with beautiful men, women, girls, and boys was a great gift of the goddess Venus. If we are shocked or repulsed by the Warren Cup, it is because we have a completely different set of attitudes about sex and how society controls sexual activity.

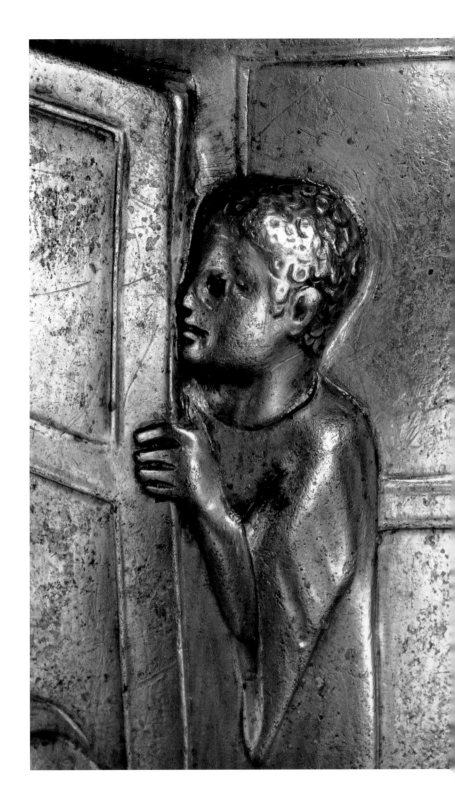

"Leopard" and his Lover

Aside from famous Old Master paintings, cut gems were the most expensive kind of art you could buy in Roman times. In the Royal Coin Cabinet in Leiden there is a large agate gemstone ($1\frac{1}{4} \times 1\frac{7}{8} \times \frac{1}{8}$ in.; $3.1 \times 2.15 \times 0.4$ cm) that pairs an unusually sexy image of two men copulating with a tender poem addressed to one of them (fig. 62). The poem, written in Greek, says:

> Leopard—drink,
> Live in luxury,
> Embrace!
> You must die, for time is short.
> May you live life to the full,
> O Greek!

The poem combines a command to enjoy wine, luxury, and sex with a *memento mori*—a common notion in Greek and Latin poetry. One must seize the day (*carpe diem*), take life's pleasures when they offer themselves, for soon both pleasures and life itself will be gone. So who was "Leopard?" "Leopard" was most likely the special love-name of one of the men pictured on the gem. Since the poem is addressed to Leopard, it is likely that the gem was a love-gift for him. What is more, the image is even more transgressive than side A of the Warren Cup, for both partners are clearly adult men (not a man and a boy). And, quite unusual for scenes of anal penetration, the man being penetrated (the "bottom") has a huge erection.

The artist constructed the couple's unusual pose so that the viewer could see the erect penis of the man being penetrated. He had to raise up the torso of the man on the bottom to leave a clear space to show his penis and testicles in profile. He used foreshortening to make the right side of the man on the bottom larger than that of the man on the top, so that the viewer can read relative body size as spatial depth. The next layer in, represented by the penetrator's torso and right leg, reads as spatially farther

away. This man's left leg, represented by the tip of his knee next to his partner's erect penis, is also the smallest and therefore farthest back in space.

The result, in both image and text, is a unique representation that shows sex between physical and sexual equals; the artist has emphasized both the tenderness in the couple's mutual gaze and—quite exceptionally—the sexual excitement of the man being penetrated. And he is a man, not a boy, for the artist makes him no smaller nor any less endowed than the man who penetrates him.

If the Leiden gemstone is unique, I doubt that the sentiment it expresses was unique in the Roman world of the first century B.C. It gives us insight into the sexual mentality of the individual who commissioned it and gave it to "Leopard." Of course, "Leopard" could be either the man on the top or the one on the bottom. Either way, the image insists on a kind of *reciprocal* sex between two men that went counter to usual artistic and literary constructions of the time, where artists almost always made the male being penetrated a flaccid boy, not an erect adult. Like side A of the Warren Cup, it is a case of an artist creating an explicit and extraordinary (if not to say transgressive) image of male-to-male sex. I like to imagine both men looking at the gem, taking turns holding it in their hands and reading the poem. The gem—even more than the Warren Cup—prompts the person contemplating it to imagine the pleasure that both men are experiencing, the pleasure invoked by the Greek word PERILAMBANE ("Embrace!"). The artist has captured the couple's mutual excitement at the moment of penetration as they embrace and gaze into each other's eyes. This, at least for the owner and viewers, was one important way to "live life to the full."

62

▶ **This beautifully detailed agate gemstone from the 1st century B.C.** personalizes the sex act in two ways: It shows the man with an unusually large erection being penetrated and it records a tender poem meant for the man who received the gem as a gift.

THE OPPOSITE

OF SEX · HOW

TO KEEP AWAY

THE EVIL EYE

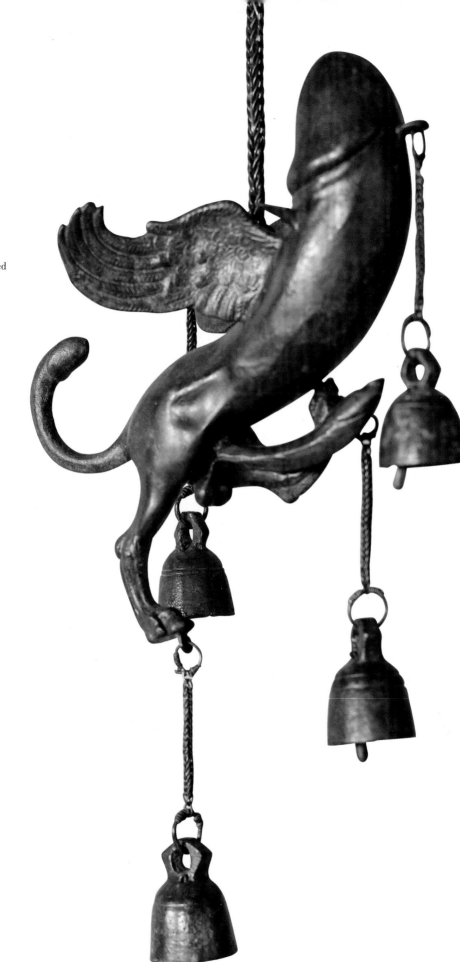

63

▶ **Bronze phallus with bells** *(tintinnabulum)* from Herculaneum. Combining the male organ with bells doubled its protective power.

ONE OF MY MOST MEMORABLE cross-cultural experiences occurred in Sicily thirty years ago. I was traveling around the island with a Sicilian friend, who was eager to show me the sights. Imagine my surprise when an empty hearse drove by on a crowded city street, and all the men unabashedly reached down to their crotches and touched their testicles through their trousers! What I did not notice at the time was that all the women were surreptitiously looking for a piece of iron to grasp. This was my first encounter with what scholars lump together under the term "apotropaia," practices and images meant to keep away evil. As my friend explained, fertility (male fertility, obviously) drives away death (the empty hearse). Women, not having male fertility, grasp what is strong (iron).

I have since learned that the belief in the power of male fertility to avert evil goes far back in the ancient Mediterranean. Where our culture associates any open display of male genitals with obscenity and pornography, ancient Romans regularly felt it was their *duty* to put up phallic displays where danger lurked. They were unusually inventive in creating artworks that presented the male genitals as good-luck charms. These displays, strategically placed in streets, businesses, houses, baths, and tombs, were never about sex as we understand it. They were about protection.

Amulets and Bells

Ancient Romans believed that the male organ (called the *fascinum* from the word *fas*, "favorable") was a talisman of fertility and prosperity that could also ward off evil spirits. Noise was also a powerful charm (babies and domestic animals often had bells, called *tintinnabula*, strung around their necks). This explains the many bronze phalluses with bells dangling from them that we encountered briefly in chapter 1 (see fig. 7). A particularly inventive phallic *tintinnabulum* found in Herculaneum in 1740 has the hind parts of a lion, wings, and four bronze bells (fig. 63). It would have hung in the house, wherever the owner wanted special protection from malevolent spirits.

People also wore small amulets made of coral and amber on their persons. Many are phalluses, but you also find another powerful sexual talisman representing the hand with thumb between index and middle finger—the image of a penis in a vagina.

64

▼ **Whoever carved this phallus into the hard black basalt** paving blocks on Pompeii's main street wanted to bring good fortune to all passerby.

65

▶ **Until its installation in the new Pornographic Collection** in 2000, photos of this phallus, standing alone, made little sense. It was found in 1880, set into the wall of a building at Pompeii, with an enigmatic inscription carved on a marble plaque just below it.

Street Phalluses

In the Roman city, look for the phallus and that is where the danger was. Following this rule, it is clear that the Romans considered the crossing of two streets to be a potentially dangerous place. A*ediles,* minor officials in cities throughout the empire, were responsible for the safety of streets, and often they erected altars at the crossroads in honor of the spirits who guarded them (the *lares compitales*). Another popular way of safeguarding streets was to place a phallus there.

You find the phallus carved into the basalt block of Pompeii's main east-west street, in modern times called the Street of Abundance (fig. 64). Excavators also found many large stone phalli set into the walls of streets and alleyways. They removed them to storerooms or to the Pornographic Collection of the Naples Museum, lest they offend tourists. Only recently did conservators at the museum attempt to re-create their original effect by setting two of the phalli into a wall for the reopening of the Pornographic Collection in 2000. One of these, found in 1880 with much of its red paint still adhering, had a carved marble plaque bearing the words HANC EGO CACAVI, "I shat on this one" (fig. 65). No scholar has been able to offer an explanation for this strangely permanent record of a good-luck bowel movement.

Elsewhere in Pompeii you find terra-cotta plaques set into streetcorners. Although guides will tell you they were signs pointing to whorehouses, it is much more likely that they were talismans to bring good luck to passersby (fig. 66).

Businesses along the street liberally sought the good fortune that phallic images

brought. A masonry
cauldron at the entrance to
a cloth-treating shop on the
Street of Abundance presents the
phallus in two forms (fig. 67). The
artist created a little temple out of stucco
and paint on the side facing the street. It
houses a winged phallus. On the side of the
cauldron (visible in the 1911 excavation photo,
today nearly gone) was a second, much larger
phallus pointing toward the street.

　　Above the oven in his bakery, the proprietor
placed a particularly famous plaque, found in
1814 and removed to the Pornographic Collec-
tion five years later. It bears the legend: HIC
HABITAT FELICITAS, or "Here dwells happiness"
(figs. 68 and 69). Although it does not take
much knowledge of Latin to understand the
words, it is clear that in this setting the baker
was not thinking of the happiness of mere sex-
ual arousal but rather the good luck that phallic
fertility and power brought. His concerns (and
reasons for placing the phallic plaque over his
oven) were that his bread rise and that his
business prosper. The British scholar Sir
William Gell published the only image that
records the plaque's original setting (fig. 69).

66
◀ **Dangerous intersection.**
This terra-cotta phallus
plaque banished evil spir-
its from the street corner.

67
▶ **Doubling your luck.**
An excavation photograph
of 1911 shows a masonry
cauldron at the door to a
cloth-treating shop along
the Street of Abundance in
Pompeii. A winged phallus
in a little temple faces the
sidewalk while a larger phal-
lus in relief decorates the
side of the cauldron.

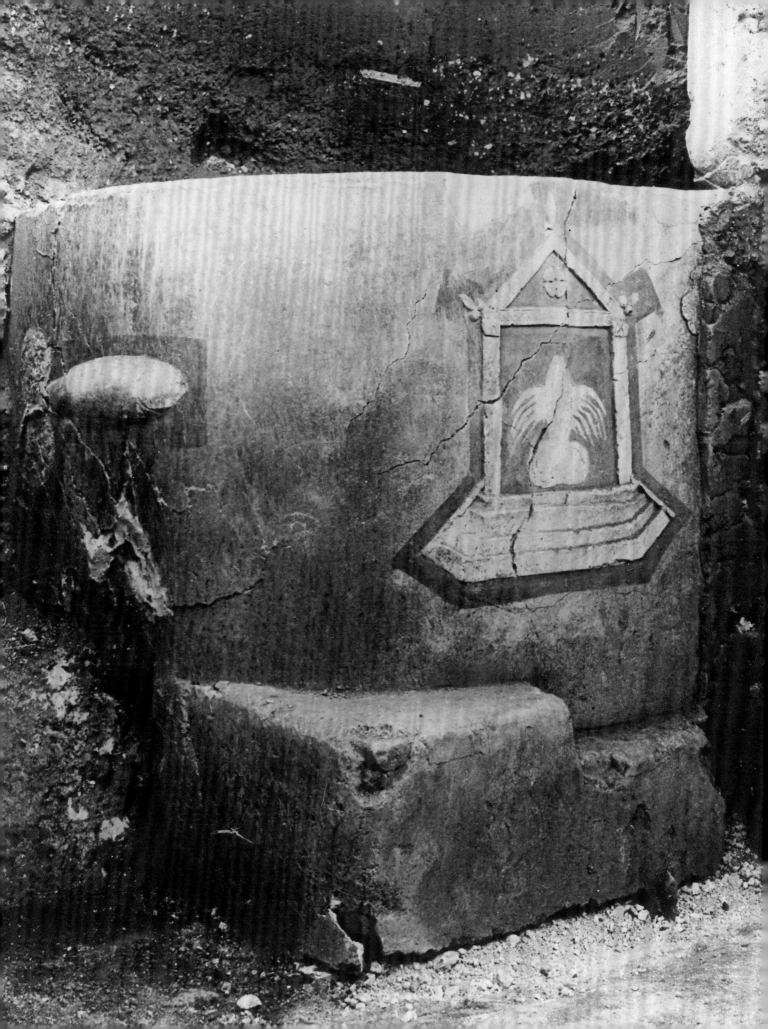

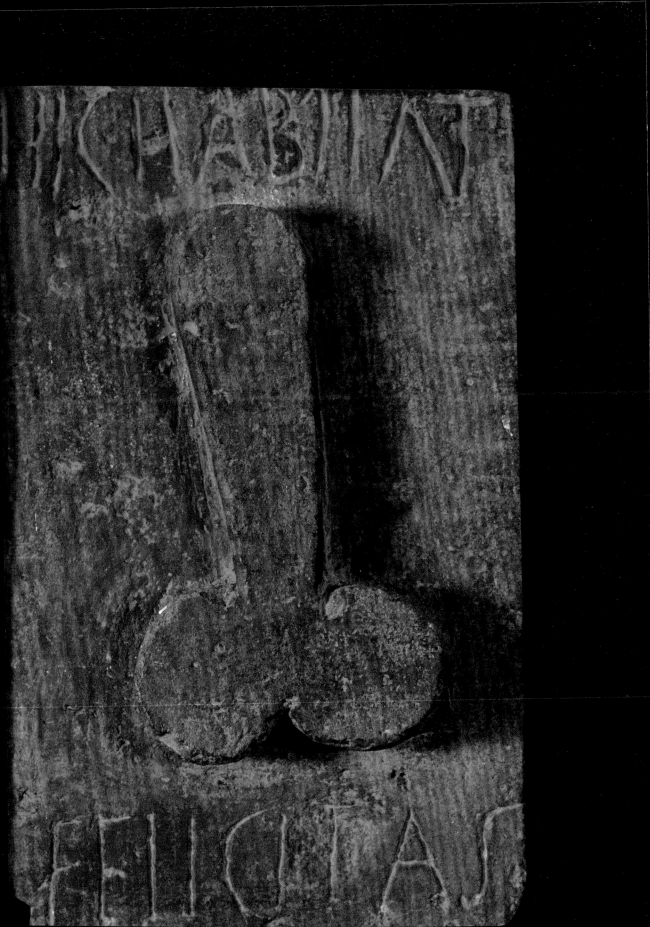

HIC HABITAT

FELICITAS

68

◄ **Not about sex.**
Terra-cotta plaque
from Pompeii with
legend HIC HABITAT
FELICITAS ("here dwells
happiness"), designed
to make the bread rise.

69

▶ **Sir William Gell's
drawing from 1814**
shows the plaque in
its original position
above the opening of
the oven—before it was
removed to the Cabinet
of Obscene Objects.

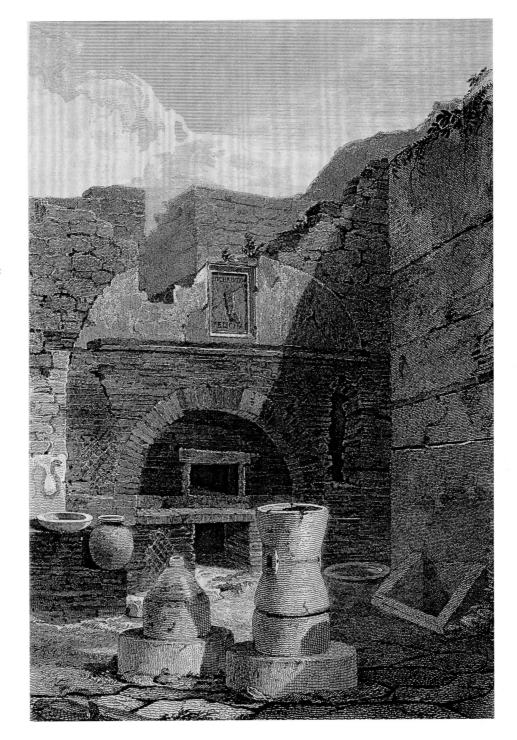

Priapus, Protection, and Penetration

In the Introduction, I spoke of my first encounter with the two images of Priapus—one a painting, the other a statue—in the House of the Vettii in Pompeii. Priapus was an ancient Roman fertility deity who protected orchards and gardens from thieves. The unforgettable image of a man sacrificing a pig to a statue of Priapus in the dark of night underscores his role in bringing back a man's erection when he is suffering from impotence (fig. 70).

His is like the plight of the impotent man who addresses this poem to Priapus:

> Are you pleased [by my impotence], Priapus,
> who under the tresses of a tree
> likes to sit, red, with your reddening phallus,
> your holy head bound about with vine tendrils?
> But, O thrice-penised, often with new flowers
> I have tied back your tresses, without art,
> often I have driven them away with my voice,
> when an ancient raven or busy jackdaw
> was striking your holy head with his horned
> mouth.
> Goodbye, unspeakable deserter of my loins,
> goodbye, Priapus: I owe you nothing.
> (*Virgilian Appendix*, 6–18, trans. Amy Richlin,
> *The Garden of Priapus*, New York, 1992,
> 119–120.)

But it is a different Priapus we meet at the doorway of the House of the Vettii (see fig. 2). It's broad daylight, and the focus is on *three* kinds of prosperity, symbolized by the god's enormous member, the bag of coins, and the basket of fruit. When someone left the street to enter a house, he passed from the protection of the street deities to the protection of the deities of the house he was entering. The Vettii brothers were providing a welcome to visitors with the painting of Priapus. What is more, they wished fertility and financial prosperity on their visitors by equating the god's huge member with a bag of coins and by placing the basket of fruit at the god's feet. Phallus competes with coin-sack across the arms of the scale that Priapus holds. This connection between the phallus and financial prosperity is even more common in images of Mercury, the god who protects commerce (fig. 71).

But Priapus' huge phallus is also his weapon. There is a large collection of humorous verses in honor of the god, called the *Priapea*, that delight in spelling out just how god punishes those who might steal from his garden:

70

▼ **Midnight sacrifice to Priapus,** Villa of the Mysteries. A man seeking a cure for his impotence prepares to sacrifice a pig to the phallic god. Cupid, another god of sexual love, accompanies him.

71

▼ **Painting of Mercury from the entrance to a bakery in Pompeii.** Mercury's three attributes—the serpent rod (*caduceus*), the money bag (*marsupium*), and his huge phallus—brought prosperity and protected customers.

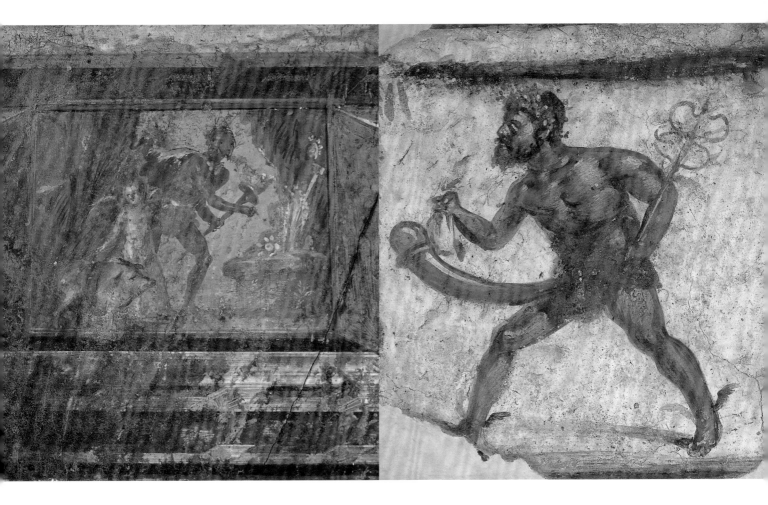

This scepter [Priapus' phallus], which
 was cut from a tree,
will now be able to grow green with no leaf,
this scepter, which pathic girls seek out,
which certain kings desire to hold,
to which aristocratic fags give kisses,
will go into the guts of a thief all the way
up to my crotch and the hilt of my balls.
(*Carmina Priapea*, 25, trans. Amy Richlin,
The Garden of Priapus, New York, 1992, 122.)

It is a refined version of *this* Priapus (the protector of gardens and orchards) that the Vettii brothers placed in their garden as one of twelve fountain statues. And they positioned him right on the line of vision established at the entryway: this visual axis went through the atrium to meet the jet of water spurting from Priapus' member (fig. 72, see also fig. 3).

▼ **Visitors immediately**
saw how Priapus doubly
blessed the House of the
Vettii—at the doorway
and in the garden.

73

▼ **The sculptor intended a**
viewer coming upon this statue of
Sleeping Hermaphroditus to
think he was admiring a beautiful
woman with shapely buttocks,
breast pressed into the drapery,
elegantly coifed head cradled in
her right arm.

74

▶ **Surprise! What the viewer**
could not imagine from the
back view is the "woman's" penis
and testicles on the other side,
pressing against the drapery.
There are many examples of this
type, and some museums curators
push the statue against the wall,
to hide the male genitals.

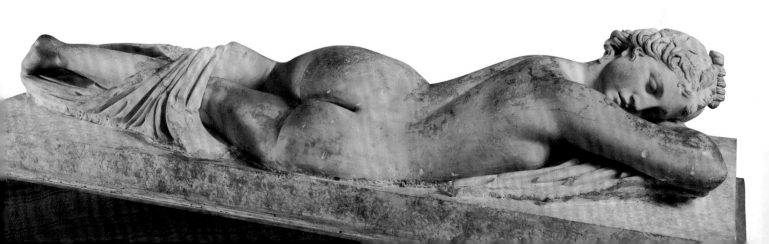

Man-as-Woman and Woman-as-Man: Hermaphroditus

In Roman visual culture, Priapus provides protection (and punishment) with his huge phallus. Hermaphroditus also protects, but because he/she is both woman and man, rather than being overendowed like Priapus, he/she is *doubly* endowed, with body and genitals of both man and woman. According to Ovid (*Metamorphoses* 4, 285–388), Hermaphroditus started life as the male child of Venus and Mercury. Salmacis, the nymph of a spring, fell in love with the boy but he rejected her advances. But when Hermaphroditus dove into the spring, the gods fused him with her, creating a new person with both male and female sexual characteristics. Hermaphroditus is biologically both sexes at once and forever, a sign of gender confusion.

In the most famous rendition of the sleeping Hermaphroditus, originating in the second century B.C., he/she rests, belly pressed into a mattress, head turned to the right side (figs. 73, 74). But the torso twists just enough to the left to reveal his/her left breast and his/her genitals. Viewing the statue is a game of gender-bending peekaboo. You first take in the beautiful "woman's" legs, buttocks, back, and ornately dressed hair. Moving around the statue, you see the equally beautiful face, but then, glancing down, you see the combination of female breasts with penis and testicles.

Like Priapus, Hermaphroditus encodes both humor and sexual power. If the suprise of the double-take is the stuff of all humor, Hermaphroditus is supremely funny, but he/she is also a god, associated with fertility like Venus and Priapus. Literary sources tells us that in pre-Hellenistic times, Greeks and Romans feared sexually androgynous creatures and even destroyed them, only gradually coming to accept them as amusing and even as good-luck charms. (Pliny, *Natural History* 7. 34)

Sculptures of Hermaphroditus, like those of Priapus, often adorned Roman gardens. What is more, many paintings of Hermaphroditus come from houses, where they were often placed near important doorways.

In the House of the Vettii, already doubly protected by a painting and a statue of Priapus, we find two paintings of Hermaphroditus, each located near the entrance to a large entertainment space. In the paintings, you see a Pan or a Silenus approaching Hermaphroditus from the rear—often with rape in mind. You see what is in store for the would-be rapist: a creature with female breasts and a fully erect penis. Hermaphroditus remains a disquieting visual reminder that things are not always what they seem, and for this reason representations of the god occur in spaces where one might seek protection from unseen evil forces.

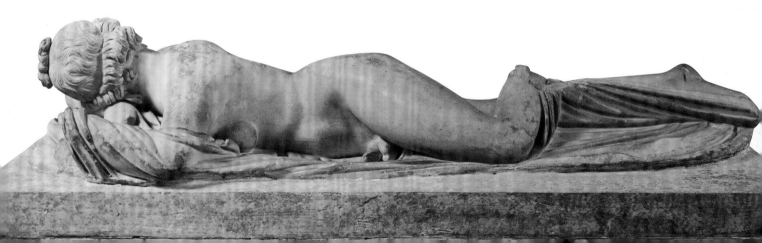

75

▼ A phallus in black-
and-white protects the
entryway to the House of
Jupiter the Thunderer at
Ostia (c. A.D. 150).

76

► Antioch, House of the
Evil Eye (c. A.D. 150).
The owner placed this
mosaic—a compendium
of anti-Evil Eye
imagery—in the entryway
to his house. A trident
and sword pierce the Evil
Eye; a scorpion, snake,
dog, centipede, feline,
and bird attack it. The
dwarf turns his back to
the Evil Eye, but he aims
his huge phallus at it
while clicking crossed
sticks. The inscription
says "The same to you,"
a warning to any
malevolent person or
spirit who might enter
the house.

The Phallus and the Evil Eye

Priapus' position at the doorway to the house, like the placement of images of Hermaphroditus, connects these gods to a whole host of images designed to thwart the Evil Eye. Sometimes, the visitor entering a house encountered just the phallus, like this image in the mosaic threshold of a second-century house at Ostia, Rome's supply city (fig. 75). At other times, the phallus would be the property of a hunchback or a dwarf, as in this mosaic from the entryway to a second-century house at Antioch, in modern-day southeastern Turkey (fig. 76). On the right we see an all-out attack on the Evil Eye. The dwarf, who wears a spiky crown, turns his back—but not his phallus—to the Evil Eye. In a third example, from the entrance to the private bath in the luxurious

House of the Menander at Pompeii, it is a black African bath servant who sports a huge phallus (fig. 77). What the Priapus, the dwarf, and the bath servant have in common—aside from their big members—is that in Roman culture they were comic figures.

In our culture, we are taught *not* to laugh at persons with physical peculiarities or disabilities, and to accept without remark the Other: persons with a body or a skin color different from our own. For the ancient Roman it was perfectly proper to laugh. And when we encounter outlandish, phallic images of the black African or the hunchback, laughter is the point. For laughter dispels the Evil Eye.

Just what is the Evil Eye? Ancient Romans believed (as do many Mediterranean people up through the present day) that someone who envied your physical beauty or material prosperity could fix his eye upon you and cause it to emit harmful particles. These particles entered you and could make you sick or even kill you.

How to protect against the Evil Eye?

Often, by directly addressing the envious person. On the floor of a humble fish shop at Ostia, the proprietor had the mosaicist write in large letters: "Envious one! I crush you beneath my feet." You could, as in the Antioch hunchback mosaic, represent the Evil Eye under attack. You could wear amulets. Or you could use images of beings

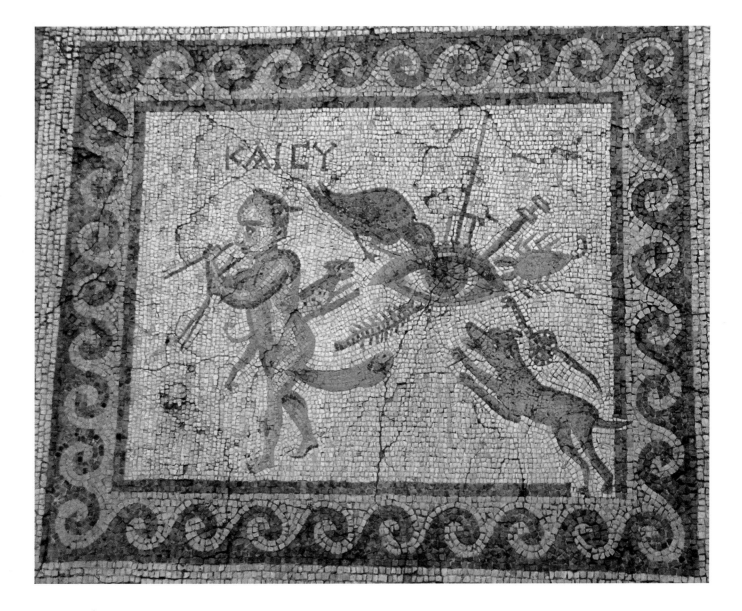

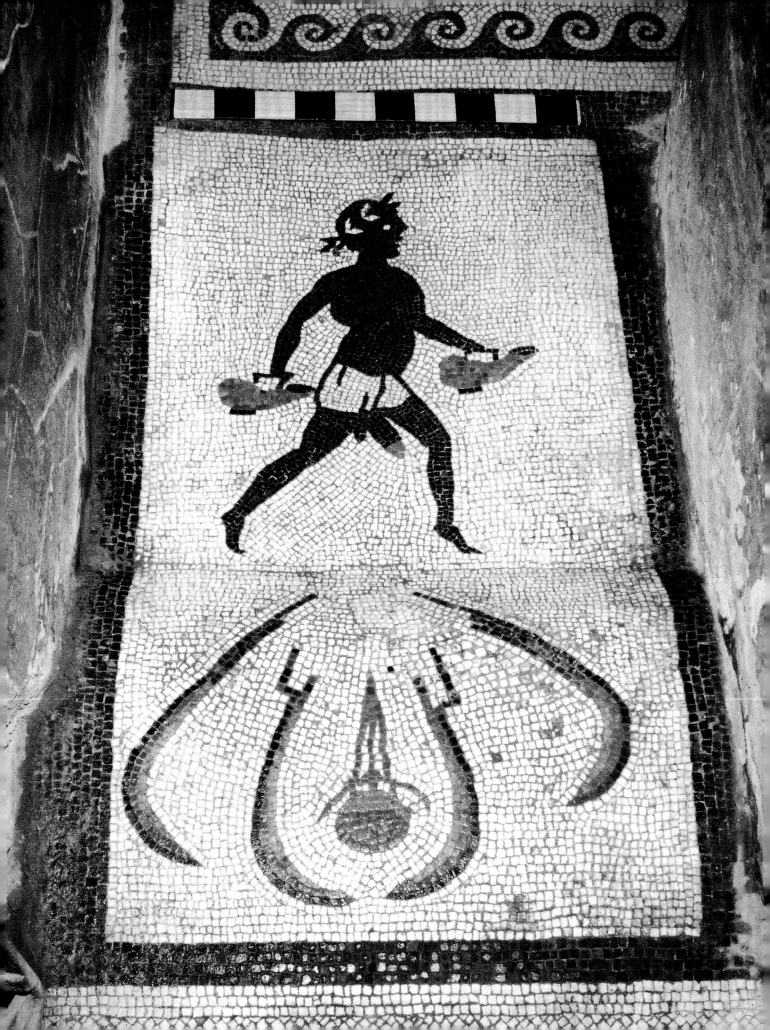

◀ **An African bath servant carrying two water** pitchers decorates the little corridor between the tepid room and the hot room of this private bath in the House of the Menander at Pompeii. He was a comic figure for the ancient Romans, placed here to make bathers laugh and thus dispel evil spirits.

you considered to have a funny appearance or that had some accentuated obscene detail. Laughter, being the opposite of evil, disarms the Evil Eye.

Although the envious person could turn the Evil Eye on you anywhere, you were particularly at risk in the baths. There you removed your clothes, making yourself particularly vulnerable to someone who envied your physical beauty. It was to incite laughter, not lust, that the owner of the House of the Menander had the mosaicist pave the entry to the hot room of the bath with the image of a black servant. His huge member immodestly hangs, perhaps partially engorged, below his kilt. The artist comically framed the servant's penis between his spindly legs and emphasized it by using purple tesserae to detail the exposed *glans*. What is more, he is carrying two water pitchers that look suspiciously phallic.

Beneath the figure of the servant may be another reference to the phallus, this time within a vagina, but disguised as an ointment jar suspended on straps framed by strigils (skin-scrapers used in the bath). In this visual pun, the ointment jar becomes the phallus and the strigils the labia of the vagina. A mosaic from Sousse in Tunisia makes a similar statement, where two pubic triangles representing female genitalia flank a fish-shaped phallus.

The Ideal Versus the Monstrous Penis

Crucial to the humor of Priapus and the Ethiopian bath servant is the unusual size of their members. The belief that large penises were both ugly and comical stems from the classical Greek definition of the ideal male body type—and its opposite. In *The Clouds*, a comedy by Aristophanes first performed in 423 B.C., the character "Better Argument" is trying to persuade young men to abandon the school run by the Sophist philosophers: "If you do these things I tell you, and bend your efforts to them, you will always have a shining breast, a bright skin, big shoulders, a minute tongue, a big rump and a small prick. But if you follow the practices of youth today, for a start you'll have a pale skin, small shoulders, a skinny chest, a big tongue, a small rump, a big dick and a long-winded decree"(Alan H. Sommerstein, trans., Chicago, 1982). The right-size penis—a fact that we can observe in all Greek and Roman visual art—is small; the wrong size is large. Even six centuries later, in representing the hero Perseus liberating Andromeda, the artist made sure he had a dainty penis (fig. 78). The same is true for all visual representations—except those that aim to get a laugh out of the viewer.

This is not to say that in real life, as opposed to art, there were no men and women who liked men with big penises. As we noted in the previous chapter, in Petronius'

► ▼ *Perseus*
Liberates Andromeda.
Perseus exhibits the
ideal male body of about
A.D. 50—including a
decidedly small penis.

novel, *Satyricon,* bathers admire Ascyltus'
huge penis, applauding him like the bathers
in Martial's satire about Maron's large
member. Yet it is instructive that both
Petronius and Martial (who also satirizes
Caelia for covering her bath slave's large
penis with a brass sheath to keep her prize
a secret, 11.75) are writing for laughs. Big
penises, whether in literature or visual rep-
resentation, are outside the conventional
standards of beauty; they represent excess.
When artists and writers want to accuse a
person of liking excess, they often have
him or her liking big penises. As late as
the fourth century, the author of the *Scriptores
Historiae Augusti* defames the emperor
Heliogabalus by relating his taste for men
with big penises *(exoleti).* His fault is not
that he wanted to have sex with males, but
that he wanted endowed, full-grown men
rather than boys with little penises
(Heliogabalus 8.6, 12.3, 26.5).

Within this framework, we can see that
the Romans conceived the over-large penis
as an unbeautiful physical peculiarity, like
the black skin of the Ethiopian, the red hair
of the German, or the deformities of the
dwarf and hunchback. All of these peculiar-
ities were fair game for derision, and artists
used all of them to ward off evil.

If these images seem to us to be in bad
taste, with their combination of phallic dis-
play and unabashed caricature of uncommon
human beings, it is because we live in a world
dominated by rational explanations of evil.

The Roman world was full of unforeseeable
and seemingly unpreventable dangers. Over
the centuries, the Romans developed a whole
range of practices, from organized religion
to what we would term black magic, to
counter these dangers. The concept of phallic
images providing protection seems strange
to us because (in developed countries) we
believe that the police force and modern
medicine can address most dangers we
might encounter. But imagine a world before
antibiotics and radio communication, and
it becomes a much scarier place. If we get
pneumonia, we know how to treat it with
antibiotics, whereas an ancient Roman might
attribute the symptoms to the Evil Eye or
any number of demons and evil forces.

Within official religion, when the Romans
perceived a threat, they personified and
tried to propitiate it. For example, when
wheat rust destroyed crops, the priests
named a goddess after wheat rust and insti-
tuted her worship. The phallic representa-
tions and images of nonstandard bodies,
although unofficial, worked in an analogous
but opposite way: rather than personifying
the danger, they overpowered it with the
force of fertility or disarmed it with laughter.

In the following chapter, we will see yet
another strategy to create the laughter that
dispels the Evil Eye. Rather than giving us
beings with unusually large penises or with
unusual physical deformities, the artist rep-
resents "abnormal"—and thus laughable—
sex between "normal" human beings. 🍆

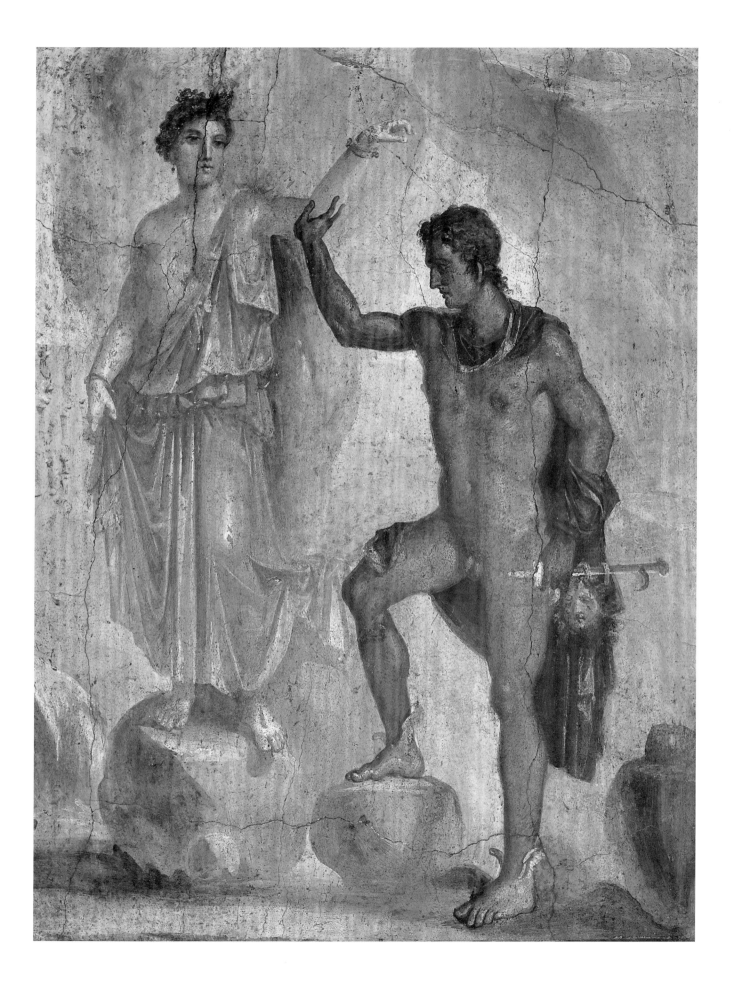

LAUGHING AT TABOO

SEX IN THE SUBURBAN

BATHS

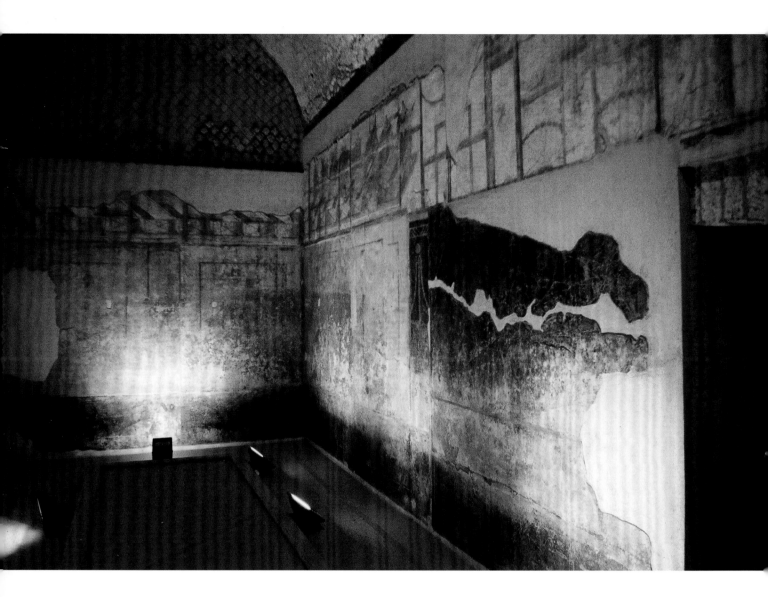

If phallic markers and outlandishly phallic characters like Priapus were not about sex but rather protection, what do we do with images of taboo sex acts? This was precisely what excavators asked themselves when eight paintings showing taboo sex acts came to light in the 1986 excavation of Pompeii's Suburban Baths. Unlike the positive images of sexual intercourse we have seen so far, these paintings portrayed forbidden acts: fellatio, cunnilingus, "lesbian" sex, and group sex. In sum, a catalogue of what the proper Roman was not supposed to do.

So far we have seen sex between pairs of appealing lovers. Even in the squalor of the Lupanar, the artist presented sex as a beautiful, elevated, and luxurious pleasure. But it would be misleading to imply from these positive representations that Romans had no taboos, no restrictions on sexual acts. There is another side to Roman sex that comes through in both defamatory literature and in visual art. It is the scorn heaped

upon men and women who break the sexual rules. This scorn was a powerful tool wielded by elite men to keep their enemies in check, to maintain control over women of their own class, and to justify their sexual use of nonelite men and women.

Taboos against sexual practices are a common form of social control. In our own day and age, some religions—and even some governments—forbid specific sexual practices, such as premarital sex, adultery, or homosexual intercourse. Punishments range from excommunication to imprisonment and even the death penalty. Yet as strong as the power of taboo might be, the sex drive is even stronger. For some, taboo adds the extra thrill of breaking the rules. Perhaps this is the reason why there was such a high demand in Roman society for images that show people breaking the rules. We find Roman artists insistently—sometimes gleefully—depicting the very sexual practices that the law and elite social mores forbade.

79

◀ **The dressing room of the Suburban** Baths, discovered at Pompeii in 1986.

80

▲ **A digital reconstruction showing how the painted representations of boxes** for clothing related to the real shelf with boxes below it. Each painted box has a number—and a different sex act pictured above it. These sexual locker labels were designed to make bathers laugh. Laughter dispels the Evil Eye.

The Active-Passive Rule

Notice that in the positive sexual images we have looked at, the penetrator is always an adult man. Rule number one in Roman sex: there can be no stigma attached to an elite man inserting his penis into any orifice of the body of another, as long as the other person is of inferior status. In man-woman sex scenes, artists tend to emphasize the woman's eagerness to be penetrated, whether in her vagina or anus. Man-boy sex scenes emphasize the difference in age between the couple, so that the Roman viewer immediately understands the boy to be a slave or other social inferior and therefore fair game for penetration. The big taboo for the elite man is to like to be penetrated anally. Romans called men who liked to be penetrated by other men *cinaedi* or *pathici* (roughly translated passive homosexuals) and marked them as outcasts. They suffered the legal status of infamy, the same status that prostitutes, gladiators, and actors suffered. They could not vote, nor could they represent themselves in a court of law.

The Pure Mouth and Oral Sex—Voluntary and Forced

An immediate corollary of the Man-Must-Be-Active Rule (what we could also call the He-Who-Must-Insert Rule) is the Oral Purity Rule. The Romans had a fixation on the mouth that seems quite obsessive to us. The word for mouth, *os,* meant not only the organ of speech and eating, but also a person's face and facial expression. Because

public speaking was so important to what was purportedly a democratic society, the Romans saw the mouth as a kind of public trust and duty. To speak in the Senate was to use the mouth in the service of the Republic. To accuse a senator of having used his sacrosanct mouth to perform a sexual act was tantamount to accusing him of betraying his public trust, sullying all of society.

By extension, ordinary Romans saw the mouth as a kind of social organ, since social encounters (as today in the Mediterranean) required kissing as a form of greeting. The focus on the purity of another's mouth pervaded Roman society.

Romans combined the rule that the man must always be the penetrator (and never the penetrated) with the concept of the impure mouth, and came up with three Big Taboos: fellatio, "forced fellatio," and cunnilingus. Invective literature (writing designed to debase one's enemies) is full of accusations of oral impurity. Fellatio, whether performed by a man or a woman, made the fellator the guilty party. If the Clinton-Lewinsky scandal had erupted in ancient Rome, the only guilty party would have been Lewinsky, who would have allegedly incurred oral impurity by performing fellatio. The person being fellated retained his proper active (and male) status, whereas the fellator sullied his or her mouth.

The worst possible insult, then, is to accuse a man of fellating another man, and the worst possible threat against a man is to force him to fellate another man. Only recently have scholars succeeded in understanding the full brutality of the verb that describes this forced fellatio, *irrumare.* For

► **Scene I is a standard representation of the** position that the Romans called woman riding. The owner had the erotic vignettes cancelled sometime shortly before the eruption of Vesuvius in A.D. 79. Although the new paint layer helped preserve the erotic paintings, in some places it adhered too well and destroyed them. Here part of a green garland covers the woman's left side and two decorative borders cancel out the man's head.

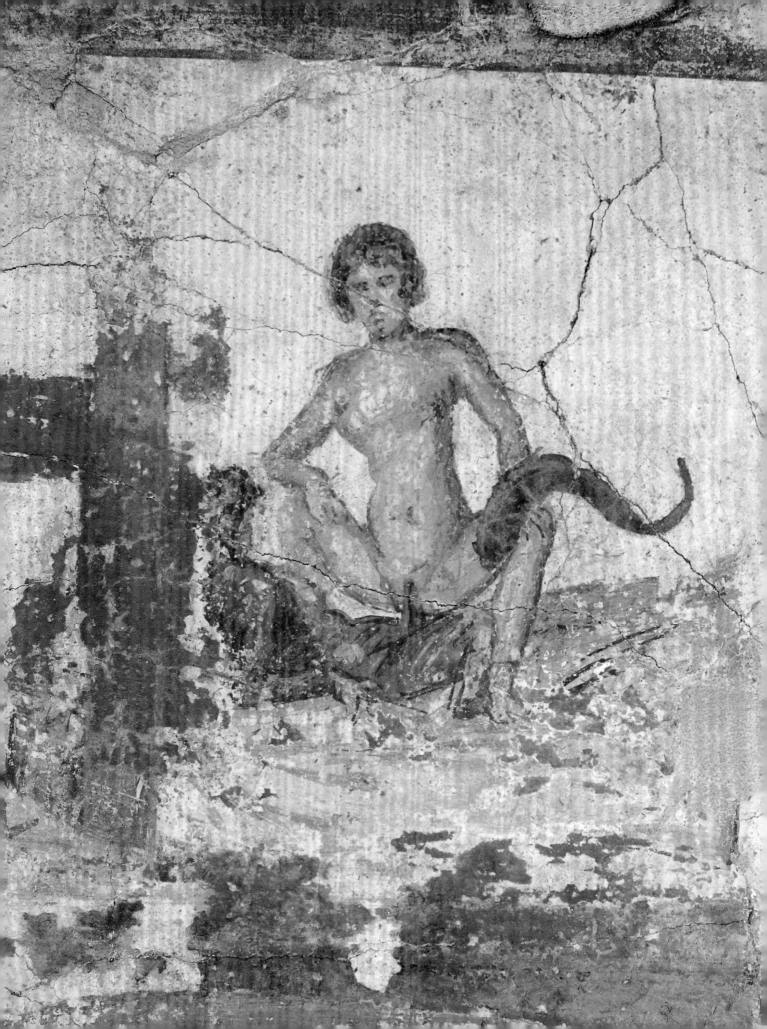

► Scene II. Rear-entry sex.

instance, Catullus' infamous hate-poem against Aurelius and Furius puts anal penetration and forced fellatio together in its first line and then goes on to explain why he is angry at them; it is through buggery and forced fellatio that Catullus will both punish them and prove his own virility: "I will fuck you up the ass and I will fuck your mouths, / Aurelius, you pathic, and you faggot, Furius, / who have thought me, from my little verses, / because they are a little delicate, to be not quite straight." (Catullus 16.1)

Artists Manipulating Taboo Sex

Over against all the textual evidence of sexual taboos is the abundance of artwork showing these taboos in astonishing detail. Some artists go out of their way to accumulate as many taboos as possible within a single work. Why does the visual record tell such a different story from the texts?

For one thing, elite men wrote most of the texts (we have no writing from elite women). We are hearing from the top 2 percent of Roman society. The only way we hear from the rest is in graffiti scratched on walls. For another thing, we should not assume that the threat of infamy kept men and women from seeking the full range of sexual pleasures available, including anal intercourse, fellatio, and cunnilingus. After all, laws and rules against these practices came about precisely because people were doing these very things.

Art illustrating—and even celebrating—taboo sex acts is ubiquitous in ancient Roman culture, like a lamp celebrating the joys of reciprocal oral sex, or "69" (fig. 87). Like the elevated images of lovemaking that graced the walls of the home or the elegant table, art showing outrageous, stigmatized sexual acts seems to have been everywhere. Excavations from Great Britain to North Africa have turned up quantities of terra-cotta lamps and bowls with such imagery. But if there is a new key to understanding how the ancient Roman viewer dealt with images of taboo sex, it is in the most remarkable suite of wall paintings ever found: the eight erotic vignettes of the Suburban Baths at Pompeii.

Sex and Laughter in the Suburban Baths

Pompeii. It is a cold February day in 1986. The workmen uncover an opening in the volcanic fill, and Luciana Jacobelli, the archaeologist in charge, climbs down into a room far beneath the surface. The workmen remove loose debris, but the walls of the room are still covered with mud. As the conservators slowly begin to remove the layers of grime that cover the wall paintings, Jacobelli sees images that will change the history of Roman sex forever. Even in the faint light she can see, preserved for 2,000 years, paintings that depict all kinds of taboo sex. By the time that Jacobelli studies and publishes the eight paintings in this room of the Suburban Baths at Pompeii (for this was what the building turned out to be), it is clear that the owner of this bath wanted the artist to illustrate just about every sexual taboo. Less clear is the reason why the owner of this bath wanted, or needed, these outrageous images in this particular space. With study, the owner's motives became clear.

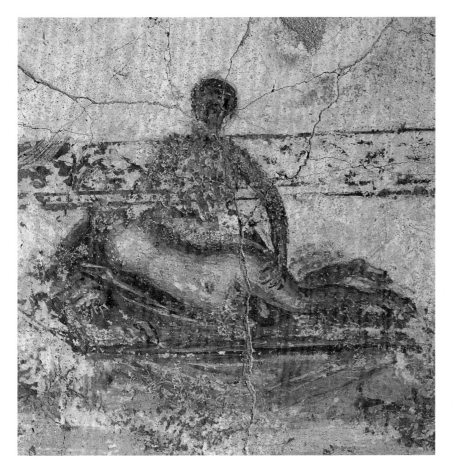

Bath—Not Brothel

In a December 2001, *New York Times* article announcing the opening of the Suburban Baths to the public, Jacobelli squared off against Pier Giovanni Guzzo, Superintendent of Pompeii, over the meaning of the erotic paintings. After many years of debate (and in spite of Jacobelli's publications to the contrary), Guzzo still insisted that the presence of the erotic paintings meant that the building was some kind of brothel—that they "advertised" available sexual services. No doubt leering guides are offering this explanation to unwitting tourists as you read this.

Working independently, both Jacobelli and I arrived at a very different interpretation. As we have seen, Pompeii's only proper

whorehouse, the Lupanar, had chambers outfitted for sex directly below the erotic pictures. There were no rooms for sex anywhere within the many rooms of the Suburban Baths. And unlike the Lupanar, it was a luxury building—and an expensive one—with all kinds of bathing amenities (heated swimming pool, saunas of various temperatures) complemented by fine decoration (marble and mosaic floors, a dazzling mosaic waterfall). The owner was selling bathing, not sex.

What is more, there is another big difference between the paintings of the Lupanar (and other possible rooms used for prostitution at Pompeii) and the dressing-room paintings. In all the houses of prostitution, the paintings show exclusively male-female sex in a variety of positions—and they present that sex as a refined luxury. In the Suburban Baths, only two of the eight vignettes show what we might consider "straight" or "proper" sex between a male-female couple. The other six break the rules.

Making Your Customers Laugh—For Their Own Good

If we step back and look at the decoration of the whole space, it turns out that it is a witty commentary on its function as a dressing room (fig. 79). The room had two decorative systems: one for the circulation area (the front part of the room) and one for the area where the bathers undressed (the back area). Simple motifs on a black ground, with a white upper zone, decorated the circulation area. A tall, thin panel divides the wall at midpoint, signaling a dramatic change in the

decorative scheme: the color switches from black to yellow. What is more, in the white upper zone the artist depicted a deep shelf in perspective that seems to support sixteen numbered boxes.

Jacobelli puzzled over this representation and came up with a clear explanation. The sixteen boxes are two-dimensional representations of the real containers for bathers' clothing that once rested on wooden shelves directly below (fig. 80). Although none of the boxes survived intact, since they were of wood, Jacobelli did find the little metal × straps that served as reinforcing. The artist represented these reinforcing straps at the front and along the sides of each box.

What was the purpose of the numerals? On the right wall they run right to left, from I to VIII, and on the back wall from IX to XVI. (Unfortunately, only eight of the pictures survived, the ones corresponding to the numbers I through VIII on the right wall.) By representing the boxes with numbers, the artist also numbered the real containers below, where each bather deposited her or his things. As if the numbers were not sufficient, he added an unforgettable "label" atop each box: a sex picture! Even if a bather forgot the number of the box, he or she was not likely to forget the picture.

But the sex pictures were more than just locker labels. As we saw in chapter five, the Romans believed in the Evil Eye. Someone who envied your beauty could emit particles from their Evil Eye that would enter you, harm you, and possibly kill you. A person undressing at the bath was particularly susceptible to the Evil Eye of someone who envied his or her beauty. The principle that laughter dispels the Evil Eye works here, in the dressing room of the Suburban Baths, much as it worked in the little private bath of the House of the Menander (see fig. 77). There it was the mosaic showing the randy sexuality of the black African bath servant that made the bathers laugh. Here it is the surprise of seeing taboo sex between unabashed Romans.

Now imagine this scenario. You enter the dressing room of the Suburban Bath. The decoration of the anteroom is completely neutral and wallpaperlike. You proceed to the rear of the room, where you see the shelves and take down a numbered box. You have undressed, placed your clothes in the box, and just as you reach up to place the box under its number, you see the perspective of the painted box leading to the sex-picture. Not an ordinary sex-picture, but an outrageous one. You laugh, and thus dispel the Evil Eye of the envious man or woman who has been eyeing your beautiful body. Safe!

As far-fetched as this explanation might sound to us moderns, it fits the ancient Roman mentality perfectly. It also explains several peculiarities of the erotic paintings in the dressing room of the Suburban Baths. For one thing, they are quite small and very high up on the wall. To photograph them for this book, we needed scaffolding, ladders, and bright lights. Such aids were not available to the ancient bather, who had to crane his neck and take some time in this dark room to make out the imagery. All of this craning and squinting must have added to the comedy and general mirth. (Of course, with repeated visits the comic intensity would have faded. Perhaps that is why the owner later had them covered up.) A first-time bather must have made quite a spectacle of him- or herself—nude and on tiptoe—trying to decipher the goings-on depicted on the wall high above.

One final fact: both men and women used this dressing room. Unlike the other, older bath buildings at Pompeii, there is no separate women's section. Whether they bathed together, or—as seems more likely— they bathed at different times of the day, the fact remains that both men and women looked at these dressing-room sex vignettes. I suggest that the artist played to both audiences, male and female.

83
◄ **Scene III. A woman wearing only a breastband fellates a** clothed man. The artist added a humorous touch by placing a scroll in the man's left hand— indicating that he was literate and likely of the elite class.

83-1
▲ **Drawing of scene III.**

Because of strict Roman notions of oral purity, fellatio was an act that no freeborn person would do (or admit to doing). The artist emphasizes the woman's reluctance to suck the man's penis by showing the man pushing her head down.

85
▶ **Scene IV is unique, for it makes the man performing cunnilingus** on the woman small, subservient—and not even receiving fellatio from the woman in return.

Fellatio

Scene I is an example of the woman riding (*mulier equitans*) position, where the woman, facing the man, is the object of both his gaze and ours (fig. 81). She composes her body to meet these dual gazes. In scene II, the artist also emphasizes the woman's fashionable body, but by turning her torso, thighs, and legs to the viewer (fig. 82). It is also a rear-entry pose, the preferred pose for showing a man penetrating a boy, and for similar reasons. In man-boy sex scenes, it allows the artist to feature the boy's genitals; here it permits him to show the woman's breasts. The comic message here is subtler than the other scenes: it is about the woman dominating the man. In scene I, the woman is larger than the man; in scene II, not only is the man behind the woman, he is quite clumsy, trying to position himself to enter her. With scene III the artist ups the comic ante with a scene of a woman fellating a man (figs. 83 and 83-1).

Scenes of women performing fellatio are rare in Roman art, and this one has several unusual features. The man, sitting upright on the bed, holds a scroll in his left hand while he hikes up his tunic to uncover his genitals. He has got his hand on the head of the woman, who sits on the edge of the bed and leans down to suck the man's penis. There are only six scenes of fellatio known in Greek vase painting, all of them in the context of the orgy (see fig. 15), and none in Hellenistic art. In the first century A.D., lamps (fig. 84) and coin like tokens called *spintriae* feature versions of scene III, and then the motif disappears from the visual record. Although the composition on the lamp reverses that of the painting, the essentials are there: the man pulling up his tunic to expose his erect penis while he places his hand on the woman's head to push her down on it.

Given the stigma attached to the practice of fellatio, it was an act that no freeborn woman would perform. Slaves and freedwomen had little choice in the matter, yet the man's gesture—about to force the woman's head down on his penis—suggests the woman's expected reluctance to perform fellatio. The artist, intent on shocking the unsuspecting viewer and making him or her laugh, also encoded the social difference between the man and the woman by putting a scroll in the man's left hand. The scroll signifies the man's literacy and upper-class status.

A man looking at this scene would be well aware of the irony in representing an "intellectual" man pursuing a pleasure that—because of Roman attitudes toward oral purity—was supposed to be difficult to obtain. The freeborn woman would find the painting amusing, but for different reasons. She could laugh at the unfortunate woman—certainly a prostitute or slave—who had to fellate the man in the picture.

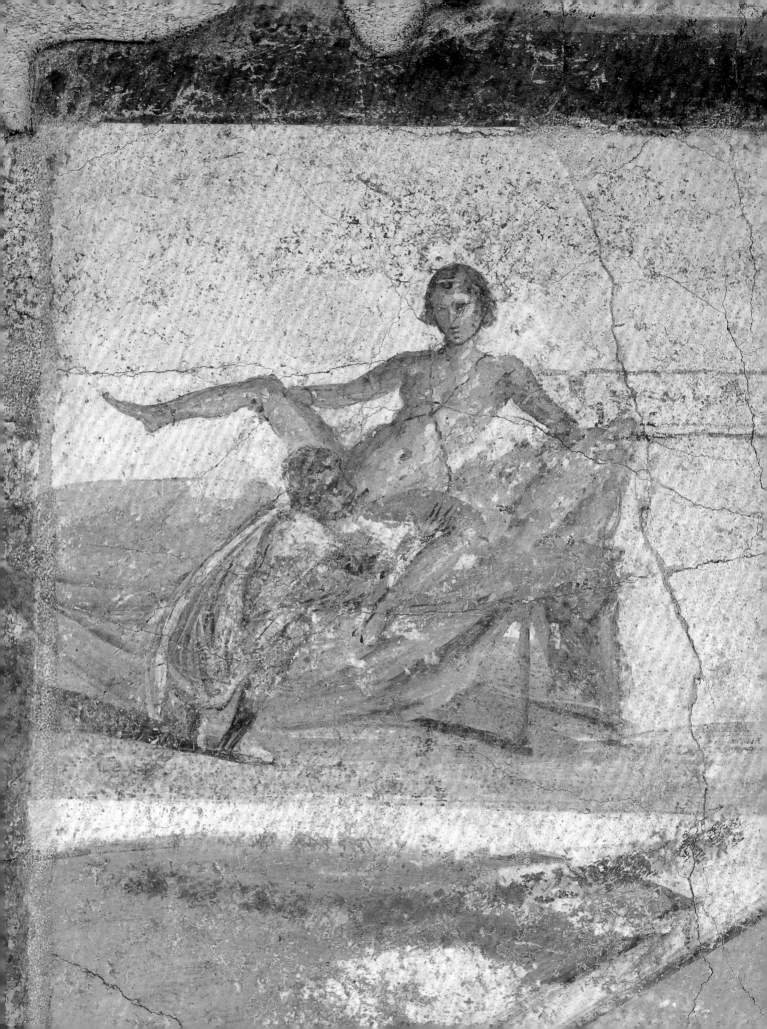

Cunnilingus

86

▼ **In all other scenes representing cunnilingus,** as in this lamp from Cyprus, the woman reciprocates by fellating the man—"69."

It is the man's impure mouth that scene IV explores (fig. 85). What is unusual about the image is that it gives equal space to the man and the woman—and the woman clearly comes out the better. All of the images of men performing cunnilingus on women show the woman reciprocating by fellating the man. They are doing "69" (fig. 86). But scene IV in the Suburban Baths shows a man so enthusiastic about licking the woman's genitals that he has not even bothered to take off his tunic or his ankle-high shoes. The woman seems indifferent to the man's attentions. The artist has done everything to make her the focus: she is larger and her body more carefully composed than the man's. Her gaze may not even meet the man's, although he clearly looks up at her.

Why did the artist emphasize the woman while making the man small and subservient? Cunnilingus, like fellatio, brought the disgrace of the unclean mouth on the person who performed it, but in the hierarchy of Roman sexual debasement, the man suspected of performing cunnilingus was even more defiled than a man who was penetrated by another man. In one of his epigrams, Martial first accuses Coracinus of being penetrated by males, then switches his attack to something much worse: he accuses him of practicing cunnilingus on women. "I did not call you, Coracinus, a passive homosexual; I am not so rash or daring, nor one willing to tell lies . . . yet what did I say? This light and insignificant thing—a known fact that you yourself will not deny. I said that you, Coracinus, were a cunt-licker" (Martial, *Epigrams* 4.43). The artist of the Suburban Baths paintings has given us a visual rendition of a Coracinus: all hands, mouth, smaller than the woman—and not even getting fellated in return for licking the woman's genitals. He is all *cunnilinctor*.

It is hard not to imagine clients of both sexes laughing at the role reversals encoded in the painting, for the artist knowingly played with a deeply ingrained Roman attitude to produce side-splitting parody. A Roman woman putting up her clothes in place number IV saw a *woman*—contrary to male expectations—in control of the sexual proceedings and the object of genital worship. It is "woman on top" taken to the extreme. A man might notice another reversal: the man is clothed and the woman naked, for the Roman a clear sign of his subservience.

Satirizing the Liberated Woman: The "Lesbian Penetrator"

87

▼ **Although badly damaged, scene V must represent two women** making love in a well-known heterosexual position, for the figure on the left has a woman's hairdo and light skin.

87-1

▼ **A drawing reconstructs the figures' positions.** The standing woman would probably have used a dildo to penetrate her partner.

It should come as no surprise that the male response to the increasing liberation of women in the first century included attempts to slander liberated women by casting them as lesbians. It is surprising, however, that the visual record is just as explicit as the verbal one. After Jacobelli's discovery of the erotic paintings of the Suburban Baths, it was not just Martial and Juvenal accusing (in)famous women of pleasuring each other sexually—accusing them of being *tribades* (lesbians). We had at least one artist depicting the very acts that the writers described.

Overpainting has obscured scene V (figs. 87 and 87-1). Sometime before the eruption of A.D. 79 the owner had the erotic paintings covered with an innocuous wall-paper design. To a certain extent this over-painting preserved the erotic pictures, but in some places it adhered so well that restorers could not remove it. The problem in scene V is that the motif of a pavilion

covers the person on the left, making it difficult to determine whether it is a man or a woman. This figure stands on the floor with the right hand at the side. The head is inclined downward, as if to gaze at the genitals of the woman on the bed. She reclines, supporting herself on her left elbow while raising her right leg high up to rest on the standing person's left shoulder. She also inclines her head, but the artist rendered it in three-quarters view rather than in profile like her partner.

In her publication of the erotic paintings of the Suburban Baths, Jacobelli interpreted this standing figure as a man on the basis of another painting from Pompeii showing a male-female couple. Today she agrees with my interpretation: that the standing figure is a woman, with a dildo strapped on, playing the man's role. There are two indications that the figure is female. Her hair is dressed just like that of the woman on the

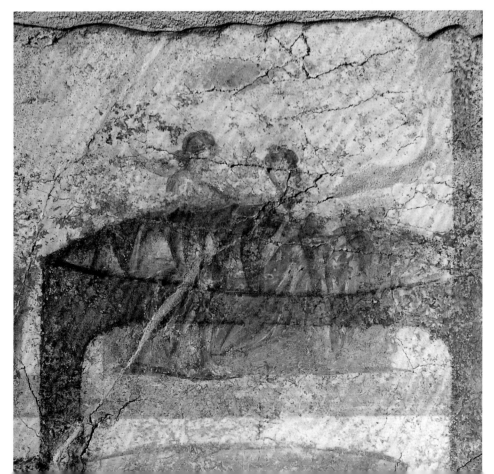

bed, pulled back from the face in a curly
mass at the nape of the neck. What is more,
her body is quite pale. Unlike the dark tones
used consistently for men in Roman paint-
ing, this pale color matches that of the
reclining woman. As for the means of sexual
stimulation, it is true that the women could
pleasure each other by rubbing their clitorides
together, but, after all, the painting repli-
cates a male-female pose where the man
raises the woman's leg to increase the
degree of penetration. In all the Roman
literary accounts of woman-to-woman sex
(written, of course, by men), the "lesbian"
is a phallic woman who uses a fake phallus
to be "just like" a man.

It is important to remember that there is
nothing in ancient Roman culture resem-
bling our contemporary notions of lesbian
social culture (hence my use of quotation
marks around the term "lesbian"). In the
few instances where authors describe
woman-woman sex, they depict one of the
couple as an unnatural monster who must
penetrate her partner using a dildo. Seneca
the Elder has a man catching his wife with
another woman in bed (*Controversiae*
1.2.23). He killed them both (and got away
without punishment), but could only make
sense of what he saw by casting one of them
as the penetrator, or "the man." The hus-
band says: "But I looked at the man first, to
see whether he was natural or artificial."
Indeed, the man turned out to be artificial—
a woman with a dildo strapped on.

Although no paintings or sculptures sur-
vive showing a woman wearing a dildo to
penetrate another woman, there are many
images in Greek vase painting of women
fondling or even sucking dildoes. Martial,
writing his satires about twenty years after
the painting in the Suburban Baths, pro-
vides several descriptions of women acting
like men by using dildoes to penetrate their

partners. In epigram 7.67 he writes:
"Abhorrent of all natural joys, Philaenis
sodomizes boys," and in 1.90: "yet Bassa—
oh monstrous—you were, it seems, a poker."
Remember that Martial and other men of
his class are making up a kind of woman
who conforms neither to our modern con-
ception of the lesbian nor, most likely, to
the reality of woman-to-woman sex in
Roman times. These men are frightfully
anxious about the emancipated woman, and
are using satire and hearsay to defame her.
If she can divorce easily and take her prop-
erty with her, she must want to do what men
do. In fact, in 7.67, Martial has Philaenis
not only sodomizing boys but exercising,
drinking, and eating like a man. She is the
unnatural woman, taking over the man's
role and penetrating (women, girls, and
boys) rather than taking her natural role
and being penetrated.

Given the Roman man's anxieties about
woman-to-woman sex, he must have been
startled when he realized what the painting
above box V depicted. If one of the mecha-
nisms of visual humor is to overturn expec-
tations, here was a great joke: a female
couple copulating using a time-honored
male-female sexual position.

The Man in the Middle

In Scene VI, the artist depicted a sexual three-
some: the man kneeling at the left is anally
penetrating the man in the middle, who in
turn penetrates the woman crouching on the
bed, her face in the pillow and her buttocks
raised (fig. 88). Once again the Suburban
Baths presents a unique image of lovemaking.
The most standard component is the woman's
pose. We have seen it in the Lupanar (see
figs. 38, 39, and 40) and in the House of the

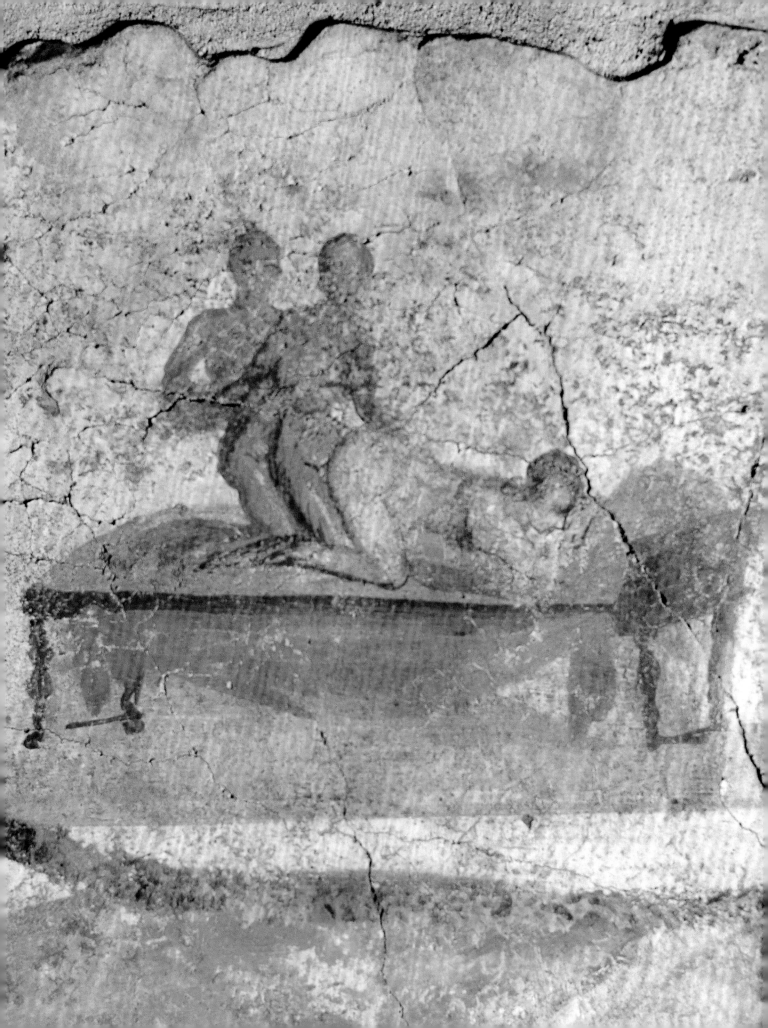

▼ The woman in scene
VI assumes the most
uninhibited position for the
Romans. They called it the
"lioness," and it appears
universally—even on costly
cameo-glass, like this frag-
ment from the Metropolitan
Museum of Art, New York.

90

► Scene VII, a foursome. The
man at the left penetrates
another man, who is being
fellated by a woman. She
raises her leg high so that
the kneeling woman can
perform cunnilingus on her.
The relative levels of
debasement must have
sparked animated exchanges
in the dressing room—and
lots of laughter.

90-1

▼ Drawing of scene VII

Restaurant (see fig. 49). The Greeks of the
fourth century B.C. called this pose the
"lioness;" we saw it on the engraved side of
the Boston mirror (see fig. 6). It is also the
pose that the woman takes on a fine cameo-
glass fragment in the Metropolitan Museum
of Art—an object made for an elite patron (fig.
89). Roman artists used this position when
they wanted to show the uninhibited woman.

But it is not the woman's position so
much as who is doing what to whom that a
Roman viewer would consider outrageous.

After all, the woman is being pene-
trated by a man who has lost
his phallic status by being
penetrated by another man.
He is a *cinaedus*, or passive
homosexual. To drive this
point home, the artist has
depicted the man in the
middle as a man, not a boy.
He is the same size as the man
who penetrates him, and—to
emphasize that he likes being
penetrated—the artist has him
reaching back to grasp his pen-
etrator's hand. This man, a bit
more muscular, turns to the
viewer as if to say: "Look at
me/us—see what we're doing!"
His gaze is the only link to the viewer,
since the other two are fully engaged
in their pursuit of pleasure.

Woman-to-Woman
Cunnilingus—in a Foursome

The next scene is even more outrageous, for
it includes a woman performing cunnilin-
gus on another woman (figs. 90 and 90-1).
This act occurs in a sexual foursome. The
man on the left of the bed looks out at the
viewer and raises his right hand while he
penetrates the man kneeling in front of
him. The man being penetrated leans for-
ward as a woman, kneeling on her left knee
but with her right leg raised in the air,
crouches on her elbows to fellate him. A
second woman, kneeling on the floor, per-
forms cunnilingus on her. (Remains of a
green garland from the later painting cover
the back of the woman performing fellatio
and the knees of the woman performing
cunnilingus.)

Despite the strong taboos expressed in
the written word, in the Suburban Baths an
artist has painted two scenes of cunnilin-
gus—both demonstrating acts that result in
the impure mouth. Although scene IV is
unique in its composition, at least it con-
forms to the known images where it is a
man performing the act. What makes scene
VII unique is that for the first time we have
a representation of a *woman* making her
mouth impure—not by fellating a man, but
by performing cunnilingus on another
woman.

A Roman man looking at scene VII would
have seen not one—but two—phallic acts.
The obvious phallic penetrator is the man

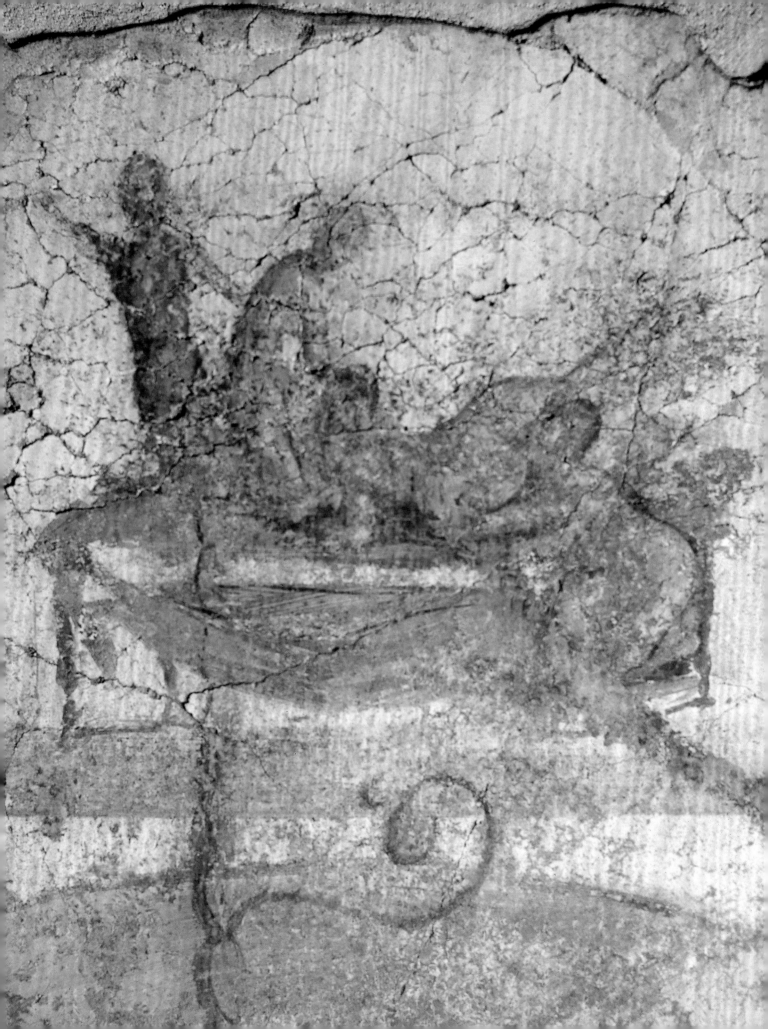

▶ **A naked man afflicted with hydrocele (enlarged testicles)** reads from a scroll. A Roman viewer would have identified him as a poet—perhaps a poet of erotic verses—who because of his affliction can only read about the sex acts that all the others actually perform.

on the left, whose raised right arm was a standard gesture for the victorious general. But, strange though it may seem to us, the Romans believed that the woman receiving cunnilingus wasn't "receiving" at all—she was *penetrating* the mouth of the woman performing the act! Knowing this, we can understand why the artist made the *cunnilinctor* of scene IV so abject. The phallic woman was not only giving him an impure mouth, she was penetrating him. But here, in scene VII, the woman whose genitals are being licked also acquires the stigma of the impure mouth by performing fellatio on the man being penetrated. The humor lay in the fact that *both* women were using their mouths improperly.

The Erotic Poet

Given the crescendo of increasing debasement, from the relatively tame scene I through the sexual and moral entanglements of VII, we would expect an outrageous sexual coupling for the last vignette on this wall, above box VIII. Instead, we find the lone figure of a naked man reading from a scroll in front of a table, his head crowned with leaves (fig. 91). Roman viewers would have immediately identified him as a poet, but with two twists: he is nude, and he has a conspicuous genital deformity. His testicles descend nearly to his knees.

His condition, called hydrocele, was well known in antiquity. A standard comic type represented in terra-cotta figures was the dancing dwarf with hydrocele. But our poet is no dwarf; he is an elite man. In this context, the Roman viewer would imagine him to be reading erotic poetry or an illustrated sex manual. But he can only read; he could not easily join the acrobatic couples of scenes I–VII, where his huge testicles would get in the way.

Given the originality of the eight preserved vignettes in the Suburban Baths, the loss of the eight on the back wall is all the more lamentable. Even so, the eight little sex scenes in this dressing room have had enormous repercussions for the study of human sexuality. Their function—as humorous locker-labels—demonstrates a very Roman use for "pornographic" imagery: to dispel the Evil Eye by getting viewers to laugh.

If we look at contemporary pornography, most of it is utterly humorless. As cultural historian Elizabeth A. Grosz once quipped, "The problem with pornography as cinema is that its script is so tight." Given the pornographic film's singleminded purpose—to excite the viewer to sexual arousal—the script has to be repetitive, always ending in the triumphant money shot. Although some viewers might have found some images in the Suburban Baths sexually exciting, we have seen that their setting dictates a very different purpose. Understood on their own terms, the Suburban Baths paintings reveal attitudes toward sex that are worlds apart from our own.

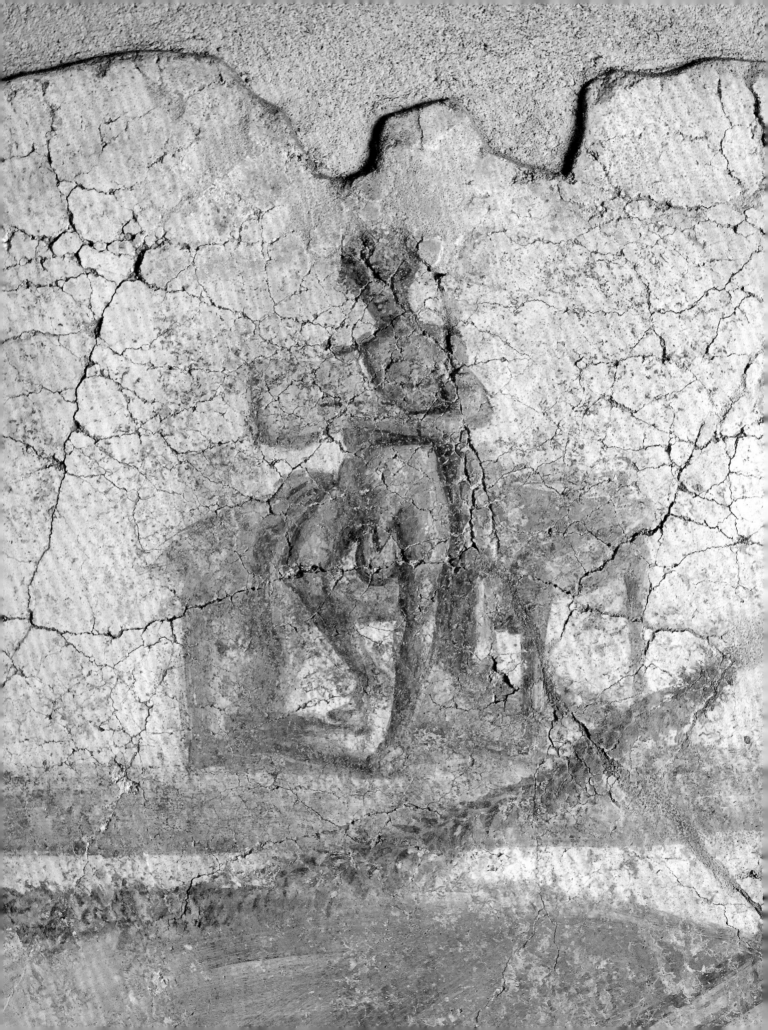

NEW SEXUAL

IMAGERY

FROM ROMAN

FRANCE

So far, our story of Roman sex has centered on central Italy: Rome and the buried cities of Pompeii and Herculaneum. Was Roman sexual art peculiar to this area, or was it being produced in other parts of the Roman Empire? The eruption of Vesuvius in A.D. 79 preserved whole buildings, making it possible to study the erotic paintings and mosaics that decorated them in context. We do not have this advantage with other sites, abandoned over time rather than being sealed in volcanic ash in a single day. Even so, we do have a wealth of evidence in the sexual art that decorated ceramics produced in factories along the Rhone Valley. As the Italian ceramic factories near the modern town of Arezzo ceased production in the 30s A.D., workshops sprang up near Roman army installations on the Rhone. By the 70s, ceramic factories along the Rhone had replaced the Arezzo factories, and their production—lamps, bowls, plates, and wine jugs—were exported throughout the Empire.

Despite their importance for documenting the wide distribution and development of sexual art after Pompeii (Rhone Valley factories continued to be active through A.D. 300), the Rhone ceramics have received little attention. What is worse, until quite recently publications censored them, typically by publishing the images in simple line drawings that removed the penises from the men in the sex scenes.

Yet on these lamps and pots we find many original sex scenes that go beyond what we know from Pompeii and Rome. The ceramic artists, even while replicating time-honored sexual compositions, invented new positions and new combinations of lovers. Most interesting of all, they created a series of sexual scenes with captions that put words into the lovers' mouths—some of them one-line sexual jokes.

As at Pompeii and Rome, these sexually explicit ceramics caused the excavators great embarrassment. We do not even have to *imagine* the embarrassment of Frédéric Hermet, a man of the cloth who excavated the ancient Roman ceramic factory at the site of La Graufesenque, near the modern-day town of Millau on the Dourbie river. We can *see* it in his 1934 publication. Hermet refused to print an illustration of a standing satyr penetrating a maenad. He called it *"La Grande Érotique"* and cut the composition in two, printing the figure of the satyr on one plate and that of the maenad on another (fig. 92). Predictably, Hermet blamed the Romans for importing filthy art and morals into innocent Gaul: "When Roman civilization was not yet well established in Gaul, under the reigns of Tiberius, Claudius, and Nero, the potters made no erotic subjects lest they shock and lose their clientele. Only when Gaul was completely Romanized under Vespasian . . . did such scenes appear on the vases. This observation is a palpable proof that the Romans

imported into Gaul, with civilization, the corruption of morals." (Frédéric Hermet, *Vases sigillés*, vol. 1 of *La Graufesenque [Condatomago]* Paris, 1934, 284.)

Hermet is telling us more about his own morals than about those of the ancient Gauls or Romans. The more likely scenario is that the ceramic factories in Gaul were filling the void left by the closing of the central Italian manufacturers, where sex scenes were stock-in-trade. By the 70s, they had invented their own repertory of sex scenes to meet the demands of their clientele—both Roman soldiers and native Gauls who were eager to possess ceramics—whether with sex scenes or scenes of gladiators, gods, or goddesses. For these newly Romanized customers, many of them earning citizenship after their military service, figured pottery was an affordable product that represented the luxury and high culture to which they aspired. It was the very possession of a ceramic piece with figural decoration—not the fact that it represented copulation—that had meaning for the indigenous Gaul.

One way to understand what the sexual ceramics meant to their buyers is to crunch the numbers. In a catalogue of 1,121 Roman lamps (most made in France but found in Switzerland), 159 have erotic scenes. The only other categories with higher numbers are representations of animals (233) and gladiators and gladiatorial weapons (198). Another study, of Roman lamps in the British Museum, corroborates the great popularity of sex scenes, by one estimate the largest coherent group among the many subjects represented in the Museum's vast collection.

92

▼ **Frédéric Hermet, a man of the cloth who** excavated this fragment of Gaulish ware, called this composition "La Grande Érotique." He cut the image in half in his 1934 publication, so that the Satyr is on one plate and the Maenad he is chasing on another— several pages away.

▶ **The potter Vitalis**

signed his clumsy

but inventive

foursome of two

men and two

women, made

in Roman Gaul

but found in

excavations at

Bregenz, Austria

(A.D. 65–80).

Vitalis's Foursome

A bowl stamped with the name of Vitalis is similar in its framing to *"La Grande Érotique:"* amidst a veritable jungle of vegetal ornament stands a bed hosting a crowd of four lovers (figs. 93 and 93-1). But here the actors are human beings, not mythical satyrs and maenads cavorting in the wild. The bed is simple, with a low headboard. A woman lies with her torso and head propped up by two long, wedge-shaped cushions. Her buttocks rest on the bed while she draws her knees up in preparation for penetration. She extends her left arm to the shoulder of another woman, whose buttocks appear in three-quarter view. Behind this second woman is a man who kneels at the extreme left side of the bed. He pushes his upper body toward the woman, his head in profile. The man at the far left is penetrating the kneeling man. He is standing, not on the bed at all. He grasps the kneeling man by the shoulders with both of his hands to ensure full penetration.

This composition is like scene VII from the Suburban Baths (see figs. 92 and 93). In both cases, the artist placed the two women at the right and the two men at the left, rather than alternate them in male-female pairs. Both highlight the position of the man on the far left. Since he is merely penetrating another man and not *being* penetrated or otherwise debased, he is different from the other three—free from impurity. In terms of the Roman rules about sex, he is the winner. Although the two women in Vitalis's composition do not perform the cunnilingus and fellatio of Suburban Baths scene VII, their embrace, facing each other and perhaps gazing into each other's eyes, indicates that they are exchanging affections. And once again we have the "man in the middle," who seems to be trying to persuade one of the women to take his penis even while he is being penetrated (like his counterpart in the Suburban Baths) by the standing man. In Roman thinking this man is the most "debased" of the foursome, because he takes the passive role in anal intercourse.

But elite Roman conceptions of impurity probably carried little weight with the people who bought the pottery made by Vitalis and the many other potters who included daring sex scenes in their repertoire. After all, the buyers were Roman soldiers, merchants, and indigenous people living far from the center, so we wonder if the niceties of elite sexual rules had much effect on them. What is more, Vitalis's ceramics, even though decorated, were objects meant for daily use rather than for prolonged contemplation. It seems that this scene, like *"La Grande*

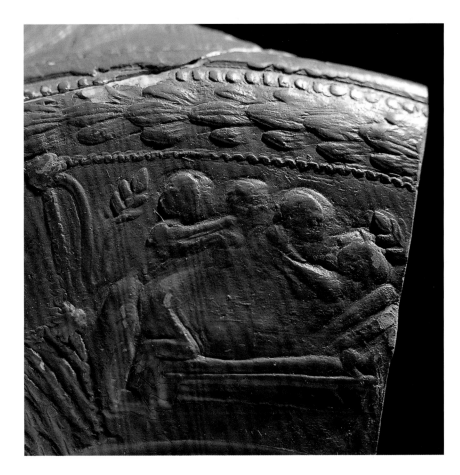

Érotique," was meant to amuse the viewer and perhaps provoke laughter—not to comment on the moral status of the four lovers.

The Elusive Applied Medallions

Although shocking to Hermet, *"La Grande Érotique"* was a Gallic interpretation of a standard, age-old mythological theme: half-human Satyrs sexually aggravating Maenads in the wild. And Vitalis's composition, although original and proudly signed by the artist, gives us bodies that veer far from the classical norms of beauty. The finest and most original sexual images appear in the

so-called *médaillons d'applique,* made in workshops along the lower Rhone Valley, in Lyons and vicinity. There is no clear precedent for the technique; ceramic artists made the medallions in molds and attached them to bulbous, hand-thrown jugs. In the firing, the medallions bonded with the clay of the pot they decorated.

Similarly, no one knows exactly why the medallions explore such a wealth of new subjects and compositions. At last count, archaeologists had catalogued 440 different compositions among the 700 medallions or fragments of medallions found. They break down into categories: images of deities, emperors and empresses, gladiators, actors, charioteers, mythological episodes—and sex scenes. What is more, inscriptions and

Talking Medallions and Uncommon Threesomes

mottoes abound—including dedications to gods, the artist's name, short poems, and wisecracks.

Among the many explanations offered, the likeliest is that these fancy pots—some decorated with as many as three medallions—were popular gift items. The pots would have made delightful gifts for occasions like the Saturnalia (the Roman precedent for our own year-end gift-giving). Imagine receiving a nicely crafted vase filled with your favorite wine, oil, or honey—and decorated with images of your favorite things.

Until June of 2002, I had only known the applied medallions from drawings and grainy photographs. Because of their relatively small size (between 6 and 18 cm— 2.4 and 7 inches— in diameter) and their subject matter, the medallions with sex scenes were notoriously difficult to study. Often they were hidden in private collections. Museums shied away from exhibiting them. The only comprehensive publication dedicated to the genre appeared in 1952. Although the author, Amable Audin, was a careful scholar, he—or the publisher—

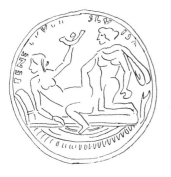

94

▶ **A medallion in relief applied to a vessel** shows a man pleading his case to his partner, who turns her head away from him. The caption tells the rest of the story. It has the man saying, "I fuck well. Turn to me" (BENE FUTUO VOLVI ME).

94-1

▲ **This drawing of the medallion, published** by Amable Audin in 1952, omits the man's penis—a standard practice at the time.

▶ **Words of praise
for the woman—**

"You alone conquer"
(TU SOLA NICA)—fit the
man's actions. Is he a
victorious charioteer
(he holds the palm of
victory) giving up his
crown to the woman
he loves?

95-1

▲ **Drawing of**
TU SOLA NICA shows
the woman with her
back to him as she
admires herself
in her mirror.

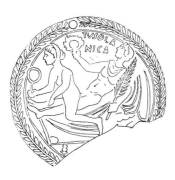

insisted that the drawings, already quite
summary, omit the men's penises.

After much advance preparation, I arrive
at the Museum of Gallo-Roman Civilization
in Lyons. The conservator cordially greets me
and ushers me into a study room. On the
table is a relief medallion that I have been
tracking for some time (figs. 94 and 94-1).
Although it is battered and worn, I am happy
finally to lay hands on my first medallion. I
know that it is rare, one of two examples of
the type, and in the smallest format, only
6 cm in diameter. But it is also one of my
favorite examples of a "talking" sex scene.

The man, at the right, kneels at the foot
of the bed, his face in profile (and yes, I
discover, he does have a penis). The woman
leans back, nearly touching the headboard
and supporting herself with her right arm.

With her outstretched left arm she holds
an object. I believe it is a drinking horn,
although Audin describes it as a lamp.
No matter—the most important detail is
absolutely clear: She turns her head fully
to the left, away from the man—this even
though she parts her legs dramatically,
seemingly in anticipation of the man's
entry. The caption explains the situation:
BENE FUTUO VOLVI ME "I fuck well. Turn to
me." The man is pleading his case even
while boasting of his sexual prowess.

The other talking medallion that I
examine, although slightly larger (9 cm), is
fragmentary (fig. 95). Audin reconstructed
the scene from six fragments and provided
a drawing (fig. 95-1). Rather than boasting
about his own sexual know-how, here
the man is praising the woman's sexual

▶ **The finest—and most recent—erotic vessel** from Lyons is a clever pun. The man demonstrates how to steer a riverboat while he steers his penis. The caption reads NAVIGIUM VENERIS: "The Navigation of Venus"—or better— "On Course for Sex."

96-1

▼ **Drawing of** NAVIGIUM VENERIS.

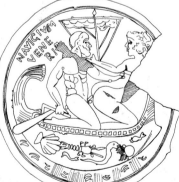

performance. He holds the palm of victory in his left hand and is about to crown the woman with a laurel wreath. The artist has him say to her: "TU SOLA NICA" or "You're the only conqueror." There may even be an implied narrative here, if we read the man with the palm as a victorious charioteer, giving up his crown to the woman who has "conquered" him in sex.

It is interesting that she seems to have just dismounted from the reverse position of the "woman riding," that is, with her back to the man's gaze rather than facing him (what the Romans called the *adversus* position). She holds a mirror. Typically, a hand mirror symbolizes feminine beauty; here it could also refer to the Roman practice of outfitting lovemaking chambers with mirrors. Suetonius writes that the poet Horace (65–8 B.C.) lined a room with mirrors, and had whores so arranged that whichever way he looked, he saw a reflection of copulation (*De Poetis* 24.62-64).

While I study and take notes, the conservator telephones Armand Desbat, an archaeologist who has devoted much of his life to the excavation and study of the applied medallions. We had corresponded but never met. He had sent me his most recent drawing, of large, well-preserved applied medallions with a unique sex scene (figs. 96 and 96-1). The vase itself had just gone on exhibit in the museum, the centerpiece of a case with new ceramic finds. Unlike the worn fragments I have been

examining in the study room, this piece is in excellent condition and still attached to the large jug that it decorates. It highlights the wit and fine technique of the artist, who combined text and image to hilarious effect.

We see a couple on a little boat. He is steering it with his right hand on the handle that controls the dual rudder—even as he grasps her left flank with the other arm and pushes his penis into her ample, extended buttocks. She turns to him to touch his bearded chin—an age-old gesture of affection in ancient art. To the left we read the words NAVIGIUM VENERIS, literally "The Navigation of Venus." Romans often used the name of the goddess Venus for the concept of sexual love, so an ancient viewer would understand the caption less literally as "Sexual Steersmanship" or even "On Course for Sex." In any reading, it is an unforgettable image of what we call multitasking.

The artist's talent for portraying details is evident. He carefully articulates the woman's complicated hairdo and profile as well as the man's muscular torso. Each species of marine creature below is identifiable. Even the boat, although diminished in scale to emphasize the couple, is true to shape and rudder fittings. (On view in the archaeological museum at nearby Saint Romain-en-Gal is the reconstruction of a nearly identical boat—used for transport along the Rhone in Roman times.) Even so, there are telltale signs of deterioration in the mold used to

▼ **Unlike all other threesomes featured** in Gaulish ceramics, this applied medallion puts one of the men—the beardless one—in the middle, so that the bearded man is penetrating him while he penetrates the woman. Both look back—in surprise?—at the bearded man. The artist has portrayed a well-appointed lovemaking chamber with a shuttered erotic painting on the wall.

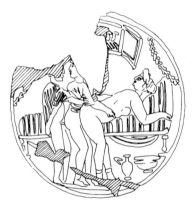

make the medallion; on close inspection you can see tiny rodlike protrusions caused by tiny holes or bubbles in the mold (for example, at the man's buttock, waist, and armpit).

A Threesome with the Man in the Middle

These are the pieces I could examine first-hand, but Desbat had some disheartening news for me. The two large medallions that he had studied, drawn, and published in 1980 could not be seen or photographed. The excavations were at La Solitude, a convent belonging to the Marist Brothers. They had retained all the ceramics and kept them in a make-shift museum that was always closed—even to Desbat. Fortunately, Desbat's drawings were much more accurate and detailed than Audin's.

The more complete medallion (fig. 97) is also the rarer of the two, because it is the only known composition illustrating a threesome with two men and a woman—but with the man in the middle. The only parallel is scene VI in the Suburban Baths (see also Suburban Baths scene VI, fig. 89). The artist packs a lot of detail into the 4¼ inch (11 cm) medallion. He creates a well-furnished lovemaking chamber with a fancy bed, two vessels, a hanging garland, and even a shuttered painting. The threesome is standing in front of the bed rather than

reclining on it, and the woman bends deeply like her counterpart in the three-some scene from the Suburban Baths. The young man in the middle grasps her at the waist with his right arm while he penetrates her. Behind him stands a man with a cloak over his right shoulder: He seems to have his right arm around the middle man's chest while his own penis, clearly visible, slips between his buttocks.

The artist took pains to differentiate both the faces and the gazes of the three protagonists. The woman in the medallion (unlike the woman in Suburban Baths) sharply turns her head, in a rendering that is as detailed as it is anatomically impossible. We see her classical profile and complicated hairdo. She attentively gazes at the two men gazing at each other. The man in the middle is beardless; he too has a Greek profile, with straight nose, deep-set eyes, and generous, square jaw. The man who is penetrating him seems to be bearded—a convention for showing the age differences between the adult man and the youth that goes back to sixth-century Greek pottery.

What is significant about the fragmentary medallion is the emphasis on communication among the participants. None of them looks out at the viewer. This strict adherence to profile views creates a self-contained narrative—even without the captions that we have seen on the other medallions. Although the beardless youth is having intercourse with the woman, he actually turns to look at the

bearded man, not at her. Has the artist connected the two men—to the exclusion of the woman—to highlight the affection between the two men? Or is the bearded man a transgressor who has surprised the lovemaking couple and is attempting to enter the younger man from the rear?

Threesomes with the Woman in the Middle

The other medallion from the excavations at La Solitude was the piece of a puzzle that enabled Desbat to reconstruct the largest medallion with an erotic subject (fig. 98). Audin had published the left half (in his own collection) and Desbat found the join that made it possible to determine the size (7 in.; 18 cm) and composition.

It is a complex threesome with the woman in the middle. The two men recline on a bed to the right and left, their legs extended beneath a woman who sits between the two while holding up a palm. The palm is the symbol of victory, and the woman holds it aloft to signal her success in doubling her pleasure. It is unfortunate that only part of the caption survives (the fragments ITA and SE)—not enough to reconstruct what the protagonists might be saying.

A lamp from Kavousi, Crete, depicts a standing threesome, but the men's positions—one facing the woman and the other behind her—indicate that one is penetrating her anally while the other penetrates her vaginally (fig. 99). The poet Martial seems to be describing this very scene in 10.81: "On Phyllis one morning a couple of bucks / paid a lecherous call: they were looking for fucks. / But each wants to strip her and have the first thrust, / While Phyllis is eager to seem and be just. / So one lifts up her legs for the tool's firm caress, / As the other lifts up the back of her dress." (Trans. by J. P. Sullivan in *Epigrams of Martial Englished by Divers Hands*, Berkeley, 1987.)

Literary sources talk specifically about group sex of various sorts. There are mentions in Catullus, the *Palatine Anthology*, and in Propertius. According to Martial (12.43), the poet Sabellus, as part of his effort to outdo the sex manuals of Elephantis, described lovemaking in "chains." Suetonius, writing about the emperor Tiberius, uses the phrase "triplici serie connexi" to describe girls and boys arranged in group sex for the emperor's entertainment. "In his retreat at Capri, he put together a bedroom that was the theater of his secret debauches. There he assembled from all over companies of male and female prostitutes, and inventors of the monstrous couplings (which he called *spintriae*), so that, intertwining themselves and forming a triple chain, they mutually prostituted themselves in front of him to fire up his flagging desires." Graffiti from Pompeii, Herculaneum, and from second-century Ostia Antica also make frequent references to group sex.

▶ **A standing threesome with the woman in the middle** decorates this lamp from Kavousi, in eastern Crete. It suggests simultaneous penetration, but with the man on the right penetrating the woman anally.

An Acrobatic Threesome

In contrast to the two large medallions from La Solitude, a small medallion that I studied in the Archaeological Museum at Nîmes gets its visual interest—and humor—by depicting the lovers in a complex balancing act (fig. 100). It is unfortunate that only one replica of this little medallion exists, for it is a poor impression and badly battered. I could still make out the composition. The woman reclines on the back of a man at right, who holds a large object with a handle in his right hand, perhaps a lantern or a pail. She leans back as a second man, at the left, parts her legs—seemingly to enter her, although her legs are at his waist, not his groin. (Damage to the fragment has obliterated all but his testicles.) The artist complicated these acrobatics by making the woman hold a lamp in her outstretched hand. It is a delicate situation, since any slight motion might spill the oil and flame. If the lovers achieve their feat, they could easily compete with the couple from the Inn of Mercury at Pompeii, where it is wine, rather than hot oil that the woman is trying not to spill (see fig. 43).

Lamps in lovemaking scenes have a special symbolism in Roman literature: Only the sexually debauched make love in a brightly lit room (*Palatine Anthology* 5.7; 8; 128; 166). We have seen lamps in several paintings from the Lupanar at Pompeii. The poet Horace has prostitutes using lamps in the lovemaking chamber (*Satires* 2.7.48). Martial even writes a satire where the lamp becomes a kind of spy, telling the reader what it sees in the bedroom (12.43)! Of course, it is impossible to know if the lamps we see in the applied medallions had these meanings for second- and third-century artists and viewers living in Roman Gaul.

Back to the Man in the Middle

Having studied all these threesomes, I return to the medallion from La Solitude with the man in the middle (fig. 97). Like scene VI in the Suburban Baths, it reminds me of Roman attitudes toward sex between men, since it puts the man in the middle— rather than the woman—into the spotlight. Everything in the composition draws your eye to him. Put in contemporary terms, the focus on the man in the middle celebrates "gay" as well as "straight" sex. A Roman viewer most likely saw this celebration as the ultimate in sexual pleasure, whether he or she identified with the man in the middle, the woman, or the bearded penetrator.

A Comic Reversal

Michel Martin, conservator at the new Museum of Ancient Arles, had written me to say that one of the few well-known applied medallions was lost, having disappeared from the old Arles lapidary museum many years ago. Audin had produced a drawing of it in his 1952 publication, and a black-and-white photograph appeared in Jean Marcadè's *Roma Amor*, published in Switzerland in 1961. I would have to be content with a black-and-white photograph and Audin's drawing.

What intrigued me about the lost medallion was how the artist had wittily reversed sexual roles for the sake of humor. It is the

100

▶ **Although modest in size and much worn,** the threesome shown is acrobatic. The woman, who holds a lamp in her raised right hand, reclines on the back of one man while the standing man at left parts her legs to enter her.

▼ **Sexual role-reversal.**
Both replicas of this medallion, found at Arles in 1951, are lost, but the photograph, along with Audin's drawing, reconstructs the scene. The woman on top brandishes the man's sword and shield. He reacts with alarm and says "Look out! That's a shield!" Note that the man has lost his erection.

102

▶ **A pause for praise.**
The man drinks deeply from a drinking horn while one of the couple says: "I like it like that" (ITA VALEA[M] DECET ME).

woman, rather than the man, who takes up sword and shield (fig. 101). She straddles him, as if about to assume the woman riding (*mulier equitans*) position, but she is actually leaning back to brandish her weapons. The man registers some alarm by raising his right arm to shield his face with his hand. The words "ORTE SCUTUS EST" mean, literally, "Look out! That's a shield." In a reversal of roles the woman has become the aggressor, the "soldier" in the battle of love. The man, although he should be armed with a sword (his erection), is in fact flaccid. He is powerless to defend himself against the woman's real weapons. Given the fact that many such medallions decorated vessels used by the Roman military, the image takes on a further level of irony. The soldier looks at the "defenseless" woman in a situation where she could easily defeat (castrate) the man—using the soldier's own weapons.

A Talking Medallion in Arles

Martin encouraged me to come to the Museum to study new finds with sexual imagery. But one of the first pieces I encountered was an old friend—known, of course, through the expurgated drawings of Audin (fig. 102). The artist has captured a lull in the sexual proceedings, the man pausing to imbibe heartily from his drinking horn, his mouth stretched wide open, the woman looking at herself in the mirror. We should not take this pause as a definitive one, though, since the artist has recorded a snippet of their conversation with the words ITA VALEA(M) DECET ME: "I like it like that."

We might assume that the woman is saying these words as she attends to her face and perhaps her complicated hairdo, with a bonnet of curls in the front, braids at the back, and a bun at the nape of her neck, but her left hand rests between the man's knees rather than trying to fix her hair. The artist has the woman in profile, straddling the man with her buttocks just touching his penis, but he has taken pains to turn the man's torso so that we see his nicely muscled chest and torso. He has also taken care with the swagged blanket, striped mattress, and sham that cover the bed.

New Sexual Lamps

The new material consisted of recently discovered oil lamps from local excavations—all with sexual compositions that revealed the creativity of ceramic artists in Roman Gaul. A particularly intriguing lamp, although terribly worn, shows a different type of threesome from anything I had ever seen. It portrays a man, a woman, and a winged cupid on bed (fig. 103). The woman, to the right, does a shoulder stand, holding her lower body in a nearly vertical position so that the man, standing on the bed, can penetrate her. We see his right leg as he seems to stride into position, and although his head is worn away, he seems to be gazing down at the woman. The most remarkable feature about this composition is the figure of the cupid, pushing the man's buttocks with both arms to increase his pleasure in penetrating the woman.

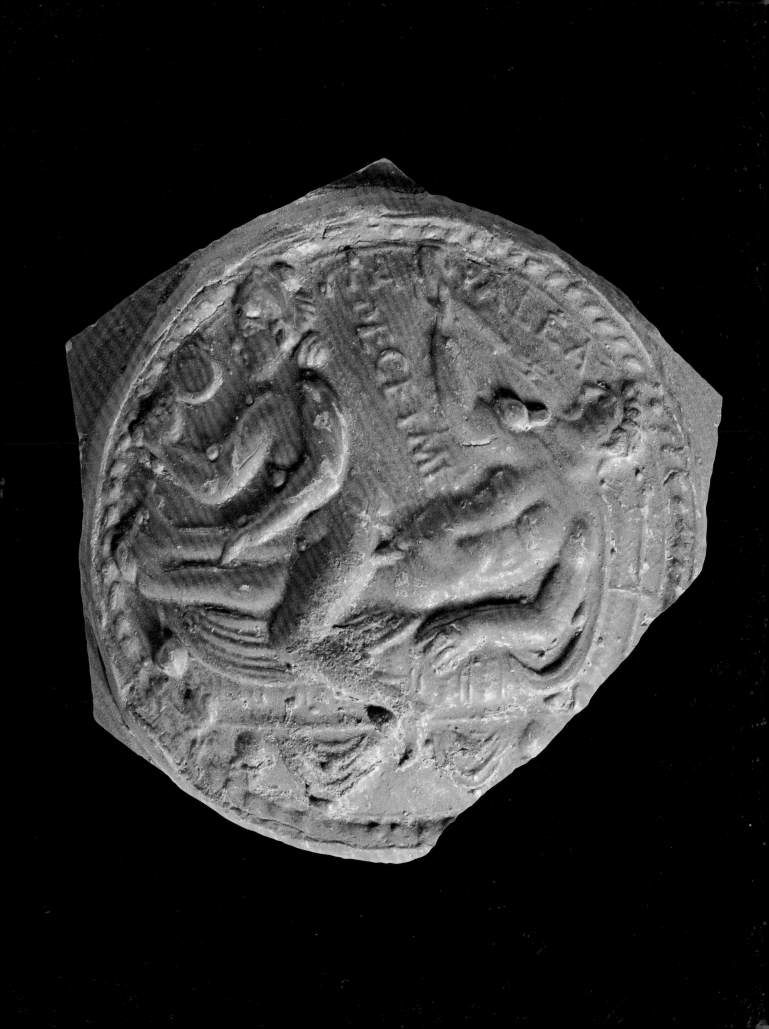

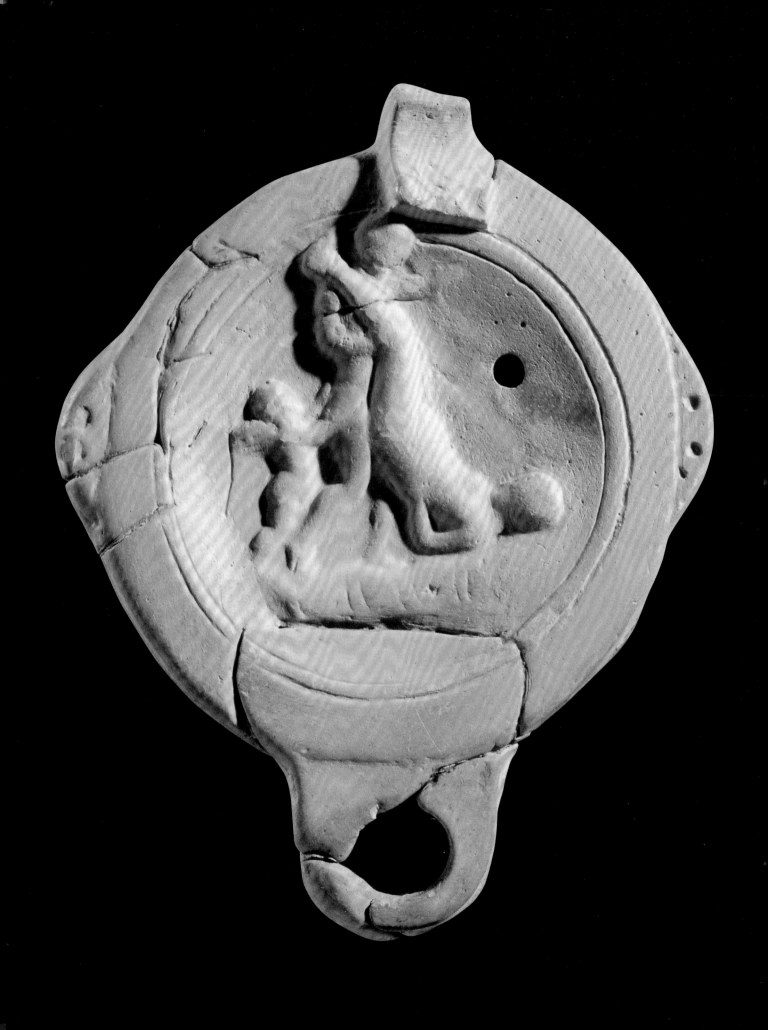

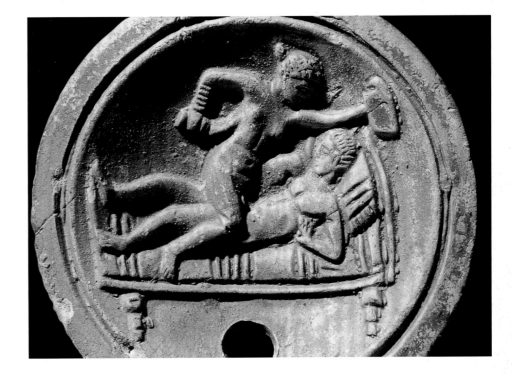

I had seen only one precedent for this figure of the cupid-pusher in a relatively rare composition of Leda being penetrated by Jupiter in the guise of a swan—but this was in a large marble statue from the late Hellenistic period (150–27 B.C.). How did the lampmaker from southern Gaul know about the cupid, and why did he adapt the motif for a scene of human lovemaking? Despite the loss of detail caused by wear and abrasion, this triangular composition still cleverly lets the viewer feel the dynamics of weight and support of the three protagonists' different roles in an acrobatic sexual situation.

The other Arles lamp was even more original; it took sexual acrobatics to a new level (fig. 104). The woman is not just assuming a difficult position, like the woman doing a shoulder stand in the lamp we just looked at, she is actually working out with weights while the man penetrates her. He seems utterly passive, in contrast to her aggressive physicality. Her body is robust and compact; her pose, half-crouching, half standing over the man's erect penis while she holds a weight in each hand, is dynamic and even a bit menacing. How is she maintaining the alternating rhythm of swinging the weights to and fro while controlling the in-and-out of the man's penis?

The artist has emphasized the woman's command over the sexual proceedings by giving us a bird's-eye view of the bed. We look down on the flat image of the man, his puny left arm and hand folded back in a seemingly defensive gesture even while the woman looms over him and the bed. Yet she is not unbeautiful. She has her hair done up in curls pulled back into a bun, like the women in the paintings of the Suburban Baths (figs. 87 and 88), and she wears five bracelets on her right arm.

105

◀ **The artist cleverly combined two talismans** against evil spirits— dwarf and phallus—in this hanging terra-cotta lamp from Arles. Pointy nose and pointed cap add to the lamp's power to avert evil.

The third lamp took me by surprise as well, for it was an unusual anti–Evil Eye composition invented in southern Gaul (fig. 105). A dwarf with a huge head, diminutive body, and protruding buttocks hugs his own phallus—nearly as large as his body. The artist placed a tubular hook just behind the head so that the lamp could hang. Pointy nose and pointed cap add to the lamp's apotropaic power (since pointy objects pierce the Evil Eye), and like the phallic hunchback from Antioch, the dwarf is a grotesque creature that a Roman could laugh at with impunity. The wick was inserted into a hole near the tip of the phallus (not visible in the photo). When I remembered all the phallic lamps in both bronze and terra cotta in the Pornographic Collection of the Naples Museum (fig. 7), I realized that this was a hybrid composition that succeeded in cleverly combining several apotropaic images. Another example of Romano-Gallic creativity.

▼ **A cast in Nîmes,
France, preserves the**
image on a lost applied
medallion with a couple
having sex beneath a
shuttered painting. The
woman praises the man,
saying "You see how well
you fuck"(VA. . . VIDES
QVAM BENE CHALAS).
CHALAS literally means
"you open me up." The
woman's hairstyle dates
the medallion to the
period of the Emperor
Trajan (A.D. 98–118).

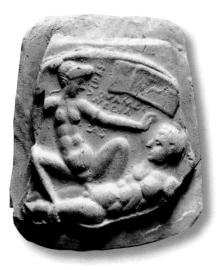

More Sexual Praise—
for the "Opener"

My final stop in southern France is Nîmes,
where I am hunting for another applied
medallion featuring dialogue between
lovers. The curator has written me that the
museum does not own the object, originally
found at Orange. There is only a photograph
of a plaster cast made sometime after its ini-
tial publication in 1929. The museum's cast
can no longer be found, and the medallion
itself has disappeared into a private collec-
tion in Paris and is no longer traceable. I am
content to study the excellent photograph of
the cast.

Despite its small size (2¼ in.; 6 cm) the
artist achieved a high degree of detail and
elegance (fig. 106). The man, reclining full
length on a bed with his right arm curved
around his head (in the gesture of sexual
readiness that we have seen in many composi-
tions), is looking at a woman who poises her
vagina at the tip of his erect penis. She turns to
her left to look at him; although her torso faces
the viewer frontally, the artist has depicted her
head in profile, like the man's. She wears her
hair in a three-part hairdo with a bonnet of
high curls around her forehead and temples,
hair pulled back and upward behind the bon-
net, with a bun at the back. This hairstyle was
popular among the women in Trajan's court
(A.D. 98–118). She wears an armband on her
left arm, the same one that extends to touch
the man's crooked right elbow.

The shuttered painting, or *pinax,* fills the
wall between the couple. It represents a
four-horse chariot galloping to the viewer's
right. The painting proposes a witty visual
pun, since the Romans called the woman's
position *mulier equitans,* or the woman rid-

ing. Here, of course, the implication is that
she is not just riding but galloping. As if not
content with this clever word/image play,
the artist has put words in the woman's
mouth that comment on the sexual per-
formance of her partner. "VA . . . VIDES QVAM
BENE CHALAS." Aside from the missing first
word, perhaps her partner's name, this
clearly translates "Va . . . ! You see how well
you fuck." (The word CHALAS literally means
"you open me up.")

A parallel representation—although
much less elegant in its execution—is a
painting removed from a room of the tavern
near the Forum at Pompeii (fig. 107). The
excavator who found this picture concluded
that the entire tavern was a whorehouse,
although it now seems clear that at most this
was a single room for a prostitute, a so-
called *cella meretricia.* In this picture the
woman, who has assumed the position for
rear-entry sex, turns to her partner, kneel-
ing behind her, to say "LENTE IMPELLE," or
"Put it in slowly."

When the woman "speaks" in both the
Rhone Valley medallion and in the picture at
Pompeii, her remarks focus on the man's
virility or his sexual expertise. Her speech
may, in fact, be an attempt to assuage male
fears of poor performance through positive
reinforcement. The woman addresses the
man to tell him how well he makes love
while she "rides" his penis, so that even
though the woman riding position is one
that gives the woman a great deal of control,
it is the *man's* powers of lovemaking that
she praises. In the Pompeian painting, a
rear-entry scene, the implication of "Put it

107

▶ **"Put it in slowly,"
says the woman**
in this rear-entry
scene, a painting
found in a room of a
tavern at Pompeii.
Despite his modest
talents, the artist has
given her a glam-
orous hairdo of
piled-up curls and
has labored to make
her lover appealing.
Although the exca-
vator concluded on
the basis of this one
painting that the
whole tavern was a
whorehouse, it is
likely that just this
room was used for
sex (the room was a
cella meretricia).

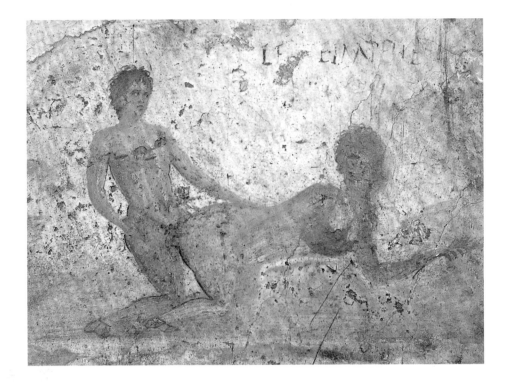

in slowly" is that the man should enter the
woman slowly; although elite literature and
art favors the small penis, here the artist
flaunts this convention by suggesting that
the man's penis is especially large. In short,
the words that the artist puts in the woman's
mouth are ones any man would like to hear:
that he performs well in bed. As we might
expect, the picture embodies a male fantasy
that not only celebrates the beauty and
desirability of the woman but also empha-
sizes the man's outstanding performance.

Erotic Art for All

I leave southern France with a much clearer
sense of how universal sexual art was in the
Roman Empire, and with a respect for the
creativity of artists who developed ideas

(like images with sexual conversations
and clever sexual acrobatics) that went far
beyond what artists at well-known sites like
Pompeii were doing. There was a continuity
of creativity in sexual art that spread to the
provinces and found new subjects there.

Clearly, the buyers of vessels with wild,
acrobatic, and even humorous erotic
imagery were like the viewers of the erotic
vignettes in the dressing room of the
Suburban Baths: They did not blush at any
sexual invention that the artists produced.
This candid, anything-goes attitude seems
to have inspired the Rhone Valley artists
to create the new compositions that we
have seen in this chapter. And the fact that
relief medallions found their way to the
far reaches of the Empire—and well into
the third century—tells us that Pompeii
had no monopoly on erotic art. It was, in
every sense, an art for all.

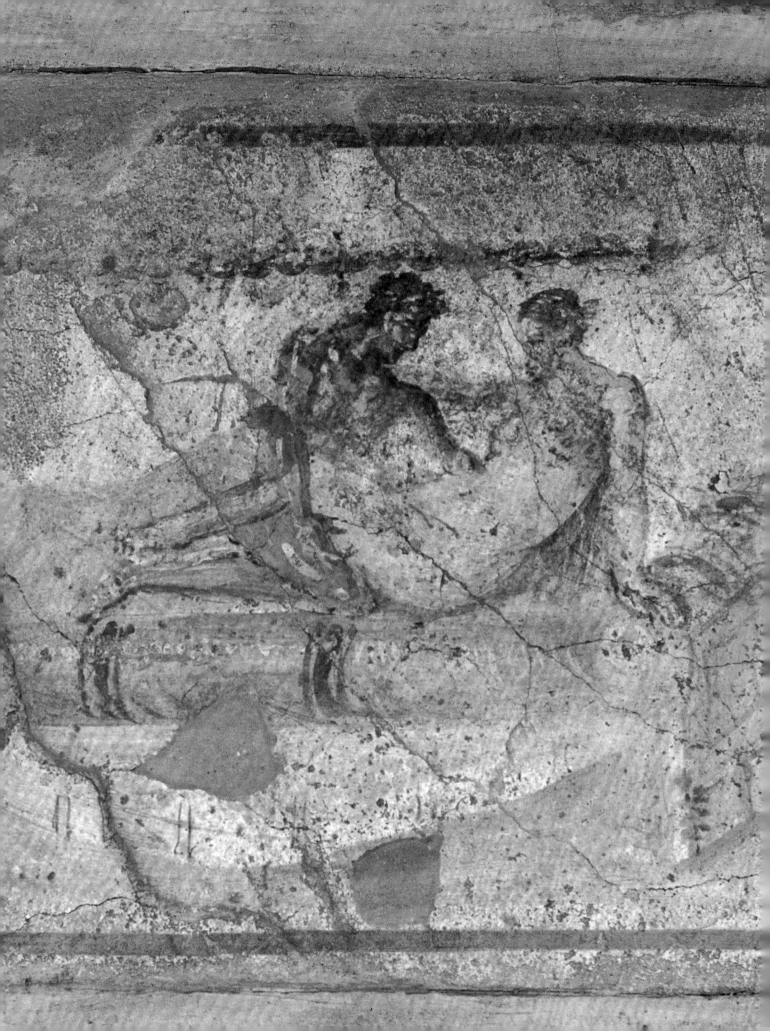

Conclusion *Sex Before Puritan Guilt*

Sex Before Regulation

UNTIL THE EMPEROR CONSTANTINE paved the way for Christianity to become the state religion, Roman attitudes toward sex remained relatively stable. Most people saw sex as a wonderful pleasure to be pursued. Ecstatic sex with a beautiful partner—whether male or female, adolescent or adult—was a gift of the gods, one of life's most important moments. Although it is true that some philosophies and religions stressed sexual abstinence, the pervasive attitude toward sexual pleasure, as expressed in both the law and in art, was highly positive. We read of the Stoic philosophers (like the Emperor Marcus Aurelius himself) practicing self-denial, or the male devotees of the goddess Isis even emasculating themselves, but most Romans saw such sexual practices as unnatural and even perverse.

The Romans regulated sex only insofar as it threatened elite institutions. For example, among elites, bastard children threatened the rights of legitimate children to the family's property. Hence the rule that you do not have adulterous sex with those of your own class. Yet sex with non-elite individuals, including forced sex with your slaves and

former slaves, was a standard—and guilt-free—practice. A similar framework underlies the regulation of what Romans considered to be taboo sexual acts: cunnilingus, fellatio, and receptive anal sex. Since elite prestige rested on family reputation, elites employed prostitutes of both sexes, or used their slaves, to perform sexual acts that could bring potentially damaging accusations of oral impurity or passive homosexuality.

But the elites constituted only about 2 percent of the population. In Rome, a city of over a million people in the period between Augustus and Constantine (27 B.C.–A.D. 315), these elite sexual rules were not what you saw on the street or in homes. The great majority experienced no legal or moral restrictions on sex. Institutions that we take for granted today, such as the necessity of legal marriage for all classes, were simply not relevant for Roman non-elites (the free-born working poor, former slaves, slaves, and foreigners). Although many of these ordinary Romans could marry, procreate, and leave inheritance to their children, just as many (slaves, for example) could not, because of their financial or legal status.

A few inscriptions from tombs give us a glimpse of the free invention of sexual and marital bonds that go far beyond our conceptions of love, sex, and marriage. A stone coffin from Ostia, Rome's busy port city, shows two men at work in a shoe shop on one side, and the same two men sexily dancing together on the other side. The inscription reads: "We, Lucius Atilius Artemas and Claudia Apphias, [dedicate this sarcophagus] to Titus Flavius Trophimas, incomparable and trusted friend, who always lived with us. We have given his body a place to be buried together with us, so that he will always be remembered and will find rest from his sufferings. The straightforward one, the cultivator of every art, the Ephesian, sleeps here in eternal repose." The implication is that Lucius, Claudia, and Artemas were a sexual threesome. Much more explicit is the epitaph of Allius, the owner (*patronus*) of Allia Potestas, a slave whom he shared sexually with another man. Allius writes: "She while she lived so managed her two lovers / That they became like the model of Pylades and Orestes. / One home contained them and there was one spirit between them." The inscription goes on to recount how after Allia's death her two men no longer got along with each other.

If we have a hard time imagining our society permitting us to memorialize sexual arrangements like this, in public tomb inscriptions, it is because—despite our sexual liberation—we see the open acknowledgment of sexual threesomes as something shameful or just plain wrong. No matter how sexually "open" individuals or groups in contemporary Western society might be, the major religions of Christianity, Judaism, and Islam are highly prescriptive about sexual practices, sanctioning monogamous marriage, straight sex, and sex for procreation—even while condemning the opposite.

Ancient Romans would find such obsession about the regulation of sex absurd. In their view, when Cupid's arrow stung you, there was nothing you could do but hold on for dear life. It was foolish to resist the power of sexual desire—no matter what the object of that desire. If your passion found fulfillment—and no one got hurt—you thanked Cupid and Venus and considered yourself blessed. If not, cursed. As simple as that.

Sex Before the Invention of Pornography

If this exploration of Roman erotic art reveals anything, it is that we cannot apply our own concepts of what is pornographic, sinful, or shameful to the Romans. They bought and enjoyed objects, or even commissioned paintings for their homes, that frankly represented sexual intercourse in many different forms. We have seen images of men and women making love, but also men making love to boys and sometimes other men, women pleasuring women, and sexual threesomes and foursomes. Artists represented sex in many different ways, varying not only sexual positions but also picturing apparently taboo practices such as fellatio and cunnilingus. By looking at these images—not in museums or in books—but in their original settings, we learn that the ancient Romans, rather than considering these images "pornographic" and hiding them away, usually associated them with luxury, pleasure, and high status. Looking at these images of lovemaking with the eyes of the ancient Romans allows us to enter a world where sexual pleasure and its representation stood for positive social and cultural values.

Today's society is obsessed with sex as transgression. This is the framework for nearly every kind of sexual representation, whether in high art or low telejournalism. Whether it is the "deviants" on the Jerry Springer Show or the guilt-ridden secret lovers on stage and screen, our pleasure in watching them comes from our own attitudes toward sexual right and wrong.

Add to this our huge pornography industry, and you have a good idea of the attitudes we have developed toward what is—after all—an essential and natural part of being human. What thrills us is sexual transgression—"doing the dirty," as we say. In her study of pornography over the ages, Isabel Tang asks whether pornography would still be transgressive if it became an everyday event, and if not, would it still be pornography? She concludes: "If pornography does change, however (and already the new technologies are reconfiguring its contours), one thing remains certain: whatever pornography we get will be the pornography we deserve." (Isabel Tang, *Pornography: The Secret History of Civilization*, London, 1999, 179)

In the Introduction, I explained how pornography—and the linked concept of the obscene—came to be. The Romans had no concept of pornography, but rather they represented sex—whether in writing or in images—for the sheer pleasure of it. Romantic or ribald, beautiful or laughable, sexual imagery was integral to their lives, and sex was sport, fun, the blessing of Venus and Priapus. If our society sees ancient Roman images as pornographic, it is because we have made a fetish out of sexual representation.

Even our institution of marriage partakes in the creation and maintenance of sexual hypocrisy. Marriage is supposed to safeguard sexual fidelity. Yet, with an estimated divorce rate in the United States of 50 percent, it is hard to see contemporary marriage as anything other than a sex license, bought with the promise of fidelity and lost through infidelity and (costly) divorce. Look at the pages of any popular magazine and read about the loves of the celebrities, and you begin to understand our national preoccupation with the sex lives of others. Call it voyeurism or vicarious pleasure—it is the way many of us liberated moderns frame sex and romance—through the glamorous and sexually transgressive lives of the stars.

In contrast, the ancient Romans looked upon and talked about sex openly, even to the point of proudly displaying paintings, silver, and even humble terra-cotta vessels with all the varieties of sexual play that we have looked at. They worshiped gods and goddesses of sexual love. If they were just as obsessed with love and sexual desire as we are, it is also true that the average person had open access to a much greater variety of sexual experience than we moderns do—legally and without fear of recrimination.

Not "Just Like Us"

The single most startling conclusion that I came to after studying sexuality in the Roman world is that the Romans were not at all like us in their attitudes toward sex. In my quest to reconstruct how ancient Romans handled sex over the course of three and a half centuries, it became clear that I could not look at their images of sex in art and literature with my twenty-first-century eyes. My own attitudes toward sex were a product of my culture, and as liberated as I thought I was in sexual matters, I was blind to Roman concepts of sex.

In the end, I came to the conclusion that these marked differences between contemporary and Roman models of sexuality

". . . whatever pornography we get will be the pornography we deserve."

—Isabel Tang

stemmed from religious, legal, and social structures. It was not only the association of guilt with extramarital sex in many prevailing religions today that kept me from understanding Roman sex. It was also the sexual attitudes represented in our laws, institutions, and communications media. Our most extreme stances about sex—still prevalent in many communities today—allow people to practice sex only if married and for purposes of procreation. Strictures like these shroud sexual acts in secrecy and associate sex with guilt, sin, and punishment. They make what is a guilt-free and ubiquitous human pleasure in other times and other societies into a sick thing.

The artworks that we have examined tell a story quite different from ours and demonstrate that the ancient Romans, rather than hiding sexual images, enjoyed seeing them—primarily because they associated sex with pleasure rather than sin. True, it was sex conceived in terms of male dominance, but Roman people of both sexes and of all classes delighted in looking at lovemaking. And they could look at a wide range of sex acts that included the outrageous behavior of sexual specialists like the prostitute and passive male homosexual as well as comic phallic representations that protected the viewer from the Evil Eye. All these representations kept sex in plain sight of all.

Paintings, sculptures, vessels, and lamps pictured sexual intercourse in a great variety of ways, from the tastefully elegant to the outrageously burlesque. On the one hand, you had images of "perfect" sex—and this was not sex just for procreation. Procreation was a duty, but sex with a great variety of possible partners who would not bear legitimate offspring (or any offspring at all) was the sex that artists portrayed: sex with the most beautiful male and female prostitutes, slaves, freedpersons, and foreigners. On the other hand, these same Roman viewers also

enjoyed looking at images of outrageous sex acts—the sort of thing that no freeborn person would admit to enjoying: cunnilingus, fellatio, being penetrated anally, taking part in group sex. The coexistence of both kinds of images, to my mind, proves that sex was for fun and enjoyment, and there were no holds barred.

Did Roman parents shield children—or even adult women—from sexual imagery? The fact that objects of everyday household use, such as ceramic lamps and vases, bore sexual imagery argues against the notion that their owners kept them hidden away (as our own museums have done until recently). These same objects often turn up as burial offerings. It would be a mistake to assume that our Western prudery obtained in ancient Rome. The poet Ovid's statement that erotic poetry never corrupted a person of pure heart should be taken as characteristic of elite attitudes of the time. And today, few scholars take the emperor Augustus' moral legislation at face value; they see it as a reaction to the liberal sexuality of the time. In general, the ancient Romans had no fear that representing sex in art would corrupt morals.

The wall paintings we have studied were not only permanent features in the house but were also meant to be seen by guests, whether in fancy reception rooms or in the peristyle. Nearly all of them are a sign of luxury—not an indication that the space was intended for sexual intercourse. To understand such paintings in private houses we have to remember that wherever they were displayed, they carried the cachet of the elite picture collection, since erotic pictures were an important part of the wealthy person's collection. Works of art that seem to the modern viewer to be erotic—designed to stimulate the viewer sexually—often had as their primary purpose the evocation of the life of culture and luxury.

Examination of sex paintings in public buildings undermines the frequently repeated assertion that they "advertised" sex-for-sale. They actually served a variety of purposes: to present fantasies of exalted erotic encounters in the brothel, where the environment was anything but exalted; to create a mood of conviviality in the tavern by recalling the fun of sex-shows in the theater; to make men or women who disrobed in the bath laugh and dispel the Evil Eye.

Visual art tells us what Roman literature does not. For one thing, the art is much more democratic than the texts. We have everything from the extreme luxury of the Ortiz perfume bottle and the Warren Cup to the mass-produced Arretine and Rhone Valley ceramics. Wall paintings cover a similarly broad range of quality. The fact that patrons commissioned artists to paint not only scenes of ideal lovemaking between beautiful couples, but also acts that only infamous persons would perform, reveals how far visual artists were willing to stray from the ideal to please their patrons.

The Liberated Roman Woman

If we consider Roman sex from a feminist perspective, it is clear that the ancient Roman viewer who looked at sex was not just the elite male subject whom we find in ancient literature. Women of all classes also saw the lamps, vases, and wall paintings that we have considered in this book. The best test case is the dressing room of the Suburban Baths, a space frequented by both sexes. There, the artists deliberately created sex pictures that had different messages for the female and male viewer. Knowing that the Roman woman of the first century A.D. enjoyed a greater degree of emancipation than her

predecessors, it is no surprise to find erotic art that specifically addresses the woman's role in lovemaking—whether it is a woman pleasuring another woman through cunnilingus or women taking part in threesomes and foursomes that include men.

In the absence of documentation, we can only guess that women's sexual liberation did not continue beyond the mid–third century, when warfare, political instability, and economic hardship brought about repeated reforms that extended into the realm of sexuality. In the century that followed, Christianity took hold. On the one hand, it accepted all classes—including slaves and foreigners—and gave women important roles to play; on the other hand, it reinstated the ancient Roman rules for every woman's behavior: she was to remain a virgin before marriage, chaste in marriage, and married unto death. Gone were the sexual choices open to the women of the early empire.

Sex and Humor

Our investigation of visual representations of sex puts a new face on ancient Roman humor. Although sexual satire abounds in Roman literature, it takes considerable effort to understand sexual humor in art—particularly since its audience is much broader than the audience for elite texts. The unusual difficulties we encountered in interpreting sexual humor in art underscore how culture-bound it is. Many of the images in the Suburban Baths or on the Rhone Valley ceramics baffle us because our culture, still deeply tied to a Christian and Puritan ethic, tends to frame sex as such a serious matter that Roman visual jokes are lost on us. What is more, art that represents outrageous sexual acts in public places

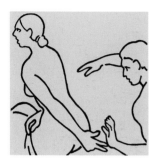

assumes an audience that is hard for us to imagine. If the Suburban Baths had not been excavated, we could not, with our twentieth-century mentality, have ever imagined the paintings in the dressing room.

Sexual Art and Sexual Life

In the ancient Roman world, not only a person's attitudes toward sex, but even the sexual acts he or she could perform depended on his or her social class, status, and ethnicity. The contrast with notions of society in our Euro-American culture could not be greater. Whereas we promote a single moral standard that applies to all people, rich and poor—a set of codes upheld by our legal system—what mattered to the ancient Roman when it came to sex was the status of the individual(s) having sex. As we have seen, Roman law ignored most of the population, since its purpose was to defend the values of the ruling classes. These values included the production of legitimate heirs and the protection of people of freeborn status from debasement (*stuprum*).

The art tells a different story from the law. Our analysis demonstrates that artists, their patrons, and viewers avidly sought imagery depicting all manner of sexual activities that the elite citizen would *not* perform with his or her social equals. The question that we have to ask, of course, is whether all of this sexual art reflects life as it was lived or whether it is artistic fantasy. I have tried to show that the context surrounding much sexual art shows that art did reflect sexual life as it was lived.

Although much of the art is conventional and even repetitive, many artists deliberately overturned conventions to represent actual sexual practices. I like to think that the artists who created the Leiden gem, the Warren cup, the paintings of the Suburban Baths, and some of the ceramics from the Rhone Valley did so because their patrons and buyers found the standard sex scenes uninteresting. Perhaps—and this is where we approach Roman attitudes toward sex most closely—they wanted the unconventional in art because that is what they wanted in real life.

The fact that some ancient Romans bought and prized works of art with images of gay lovemaking, threesomes and four-somes, cunnilingus, fellatio, or Ethiopians with huge penises makes me think that these objects expressed their own attitudes toward sex. These were the kinds of sexual acts they engaged in or, at least, what they enjoyed looking at.

Looking at sex with ancient Roman eyes takes us to another world, where both the society and the individual made sex into something quite different from what we know. If we try to understand these differences, we are on the road to understanding the most difficult fact of all: that what we call normal sex is our own creation—a creation of our own culture. And opening our minds to Roman sexualities is a step toward understanding how we inhabit and shape our own sexuality. If we look at Roman sex with open eyes, we have opened our eyes to ourselves.

Glossary

apotropaic
: adjective referring to an apotropaion, as in "apotropaic gesture" or "apotropaic power"

apotropaion, -a
: an object or action believed to ward away evil spirits, especially the Evil Eye

carpe diem
: literally "sieze the day," from Horace, *Odes* 1.11

cella meretricia
: room designated for use by prostitute, located either in a storefront shop or in a tavern

cinaedus, -i
: the passive partner in male-male intercourse, from Greek *kinaidos*. The *cinaedus* suffered the status of infamy (see below, *infamia*)

cubiculum, -a
: a small room in the Roman house, furnished with one or two beds and used for sleeping, for business meetings with peers, and for sex

cunnilinctor
: a person who performs cunnilingus

cunnilingus
: licking a woman's genitals

Evil Eye
: Romans (and many people in the modern Mediterranean area) believed that someone could emit particles from his or her eye (the Evil Eye) that entered the body of the person he or she envied or disliked and cause them harm, even death

fascinum, -a
: from the word *fas*, ("favorable"), a talisman of fertility and prosperity that could also ward off evil spirits. It usually took the form of the erect and huge penis, usually called the phallus

fellatio
: sucking a man's penis

fellator
: someone who sucks a man's penis

forced fellatio
: see *irrumatio*

freedman, -woman
: A former slave, and therefore citizen, with certain civic disabilities. Most also retained certain legal obligations to their former owners

hetaira, -ai
: female companion, a sex-entertainer, a mistress in ancient Greek culture

hydrocele
: a medical condition that causes enlargement of the testicles

infamia (infamy)
: the legal status, suffered by prostitutes, passive male homosexuals (*cinaedi*), gladiators, and actors. He or she could not vote and had restricted access to the court system.

invective literature
: writing that makes accusations against one's enemies, especially of debased sexual practices

irrumare
: to force someone to fellate a person

irrumatio
: forced fellatio

Lupanar
: whorehouse, from *lupa*, one of the Latin words for prostitute

memento mori
: an object or phrase that reminds one of death

mulier equitans
: the "woman riding" position in male-female intercourse, where the woman either faces the man or has her back to him (the *adversus* position)

nudatio mimarum
: obscene theatrical performances that often included sex acts

os impurum
: oral impurity. The Romans used this term to single out men or women suspected of performing cunnilingus or fellatio and thus to discredit them. *Os* means not only the organ of speech and eating but also a person's face and facial expression

peristyle
: the porch, supported by columns, that runs around the garden of the Roman house, typically used for access to entertainment spaces

Saturnalia
: the Roman feast held in December at the winter solstice, the precedent for our own year-end gift-giving

spintria -ae
: 1. Male prostitute specializing in complex sexual couplings; 2. a coin-like object with a sexual scene on one side and a numeral on the other

stuprum
: 1. sexual debasement of a freeborn person; 2. any illicit sex , including male-female sex between unmarried persons

patronus
: the original owner of a former slave

tintinnabulum, -a
: a hanging object, usually a phallus (see *fascinum*), furnished with bells and designed to keep away evil spirits

tribad, -es
: mannish female equipped with a dildo; "dyke"

Further Reading

Boswell, John. *Christianity, Social Tolerance, and Homosexuality.* Chicago, 1980.

Bowie, Theodore, Otto J. Brendel, Paul H. Gebhard, Robert Rosenblum, and Leo Steinberg. *Studies in Erotic Art.* New York, 1970.

Cantarella, Eva. *Bisexuality in the Ancient World.* New Haven and London: Yale University Press, 1992.

Dynes, Wayne R., and Stephen Donaldson, eds. *Homosexuality in the Ancient World.* New York, 1992.

Edwards, Catharine. *The Politics of Immorality in Ancient Rome.* Cambridge, 1993.

Foucault, Michel. *The Use of Pleasure.* 3 vols., trans. by Robert Hurley. New York: Random House, 1985.

Grant, Michael. *Eros in Pompeii: The Secret Rooms of the National Museum of Naples.* New York: William Morrow & Co., 1975.

Hallett, Judith P., and Marilyn B. Skinner, eds. *Roman Sexualities.* Princeton, N.J.: Princeton University Press, 1999.

Halperin, David. *One Hundred Years of Homosexuality.* New York, 1990.

Hawley, Richard, and Barbara Levick, eds. *Women in Antiquity: New Assessments.* London and New York: Routledge, 1995.

Johns, Catherine. *Sex or Symbol? Erotic Images of Greece and Rome.* London and Austin, 1982.

Kampen, Natalie B., ed. *Sexuality in Ancient Art.* New York, 1996.

Kendrick, Walter. *The Secret Museum: Pornography in Modern Culture.* Berkeley: University of California Press, 1987.

Koloski-Ostrow, Ann Olga and Claire L. Lyons, eds. *Naked Truths: Women, Sexuality, and Gender in Classical Art and Archaeology.* London and New York: Routledge, 1997.

Marcadé, Jean. *Roma Amor: Essay on Erotic Elements in Etruscan and Roman Art.* Geneva: Nagel, 1965.

Richlin, Amy, ed. *Pornography and Representation in Greece and Rome.* Oxford, 1992.

———. *The Garden of Priapus: Sexuality and Aggression in Roman Humor.* New Haven, 1983. Revised edition, New York, 1992.

Stewart, Andrew F. *Art, Desire, and the Body in Ancient Greece.* Cambridge: Cambridge University Press, 1997.

Tang, Isabel. *Pornography: The Secret History of Civilization.* London: Macmillan, 1999.

Varone, Antonio. *Eroticism in Pompeii.* Los Angeles: The J. Paul Getty Museum, 2001.

Williams, Craig A. *Roman Homosexuality: Ideologies of Masculinity in Classical Antiquity.* New York and Oxford: Oxford University Press, 1999.

Ancient Literary Sources on Roman Sex

Anthologia Palatina
The *Greek Anthology.* Translated by Daryl Hine as *Puerilities: Erotic Epigrams of the Greek Anthology* (Princeton: Princeton University Press, 2001).

Catullus
Poems. Catullus, c. 84–54 B.C., left 114 poems, many telling of his love affair with Lesbia, a married woman (probably Clodia). Many good translations.

Elephantis
First century B.C.? One of the female authors, (along with Philaenis (c. 370 B.C.) and Botrys (c. 340 B.C.), of sex manuals mentioned in literary sources. Only fragments of the manuals survive.

Historia Augusti
A collection of biographies of Roman emperors from A.D. 117 to 284, written by six different authors living in the fourth century A.D.

Juvenal
Roman satirist writing A.D. 120–30, author of *Satires* that stingingly condemns Roman elites, passive homo-sexuals, sexual hypocrites, and Roman wives with savage indignation.

Kama-Sutra
Aphorisms on Love, a sophisticated Sanskrit text from the Gupta period (A.D. 320–540) attributed to Vâtsyâyana, but itself a collection of earlier texts.

Martial
c. A.D. 38–104, poet, born in Spain, author of *Epigrams,* many of which wittily satirize the sexual mores of elite Romans, although some, directed mainly to boys, exude a subtle eroticism.

Ovid
43 B.C.–A.D. 17, poet, author of many books, including several dealing with sex and love: *Amores* (Loves), *Heroides* (Heroines), *Medicamina Faciei Femineae* (Cosmetics for the Female Face), *Ars Amatoria* (Art of Love), *Remedia Amoris* (Remedies for Love), *Metamorphoses* (Transformations). In A.D. 8, when he had become the leading poet in Rome, Augustus banished him to Tomis on the Black Sea, apparently because of his *Art of Love.*

Petronius
Author of the *Satyrica* (commonly known as the *Satyricon*), a frantic sex novel—preserved only in part—that follows the adventures of a homosexual triangle. Birth date unknown, forced by Nero to commit suicide in A.D. 66.

Priapea
Poems about the phallic god Priapus, well represented in Hellenistic epigrams and much developed by the Romans, whose poems focus on the god's aggressive, anally fixated sexuality. See Richlin, *Garden of Priapus* (cited above).

Propertius
c. 54 B.C.–2 B.C., love poet, famous for his devotion to a mistress he called Cynthia.

Suetonius
c. A.D. 70–130, biographer, author of *De vita Caesarum* (Lives of the Caesars), especially damning of the Julio-Claudian emperors Tiberius and Nero, whom he accuses of sexual excesses.

Index

Numbers in *italics* refer to figure numbers.

List of Illustrations

Museum, inv. 36683 G&R. Copyright The British Museum

57 Perfume bottle, side A: male-female couple on bed. 25 B.C.–A.D. 14. Cameo glass, height 5½ in. From Estepa, Spain. The George Ortiz Collection, Geneva. Photo courtesy George Ortiz

58 Perfume bottle, side B: man-boy couple on bed. 25 B.C.–A.D. 14. Cameo glass, height 5½ in. From Estepa, Spain. The George Ortiz Collection, Geneva. Photo courtesy George Ortiz

59 Fragment of multicolored cameo glass: man-boy couple on bed. 30 B.C.–A.D. 30. London, The British Museum, inv. 1956.3-1.5 G&R. Copyright The British Museum

60 The Warren Cup, side A: detail of male-male love-making. A.D. 15–30. Silver, height 6 in. London, The British Museum, inv. 36683 G&R. Copyright The British Museum

61 The Warren Cup, side A: detail of boy onlooker. A.D. 15–30. Silver, height 6 in. London, The British Museum, inv. 36683 G&R. Copyright The British Museum

62 Male-male couple on bed with Greek inscription. First century B.C. Gemstone, 1¼ × 1⅞ × ⅛ in. Leiden, Royal Coin Cabinet, inv. 1948

63 Hanging phallus with bells (tintinnabulum). First century B.C.–first century A.D. Bronze, 5¾ in. From Herculaneum. The Pornographic Collection, Museo Archeologico Nazionale, Naples, inv. 27837. Photo Michael Larvey

64 Pompeii, Street of Abundance, region VII, insula 13: phallus carved in basalt paving stone. First century B.C.–A.D. 79. Photo Michael Larvey

65 Phallus in tufa with marble plaque. First century A.D. Height 25⅛ in. From Pompeii, region IX, alley to east of insulae 5 and 6. The Pornographic Collection, Museo Archeologico Nazionale, Naples, inv. 113415. Photo Michael Larvey

66 Pompeii, northwest corner of region IX, insula 5: phallus. First century A.D. Terra cotta. Photo Michael Larvey

67 Pompeii, region IX, insula 7, 2: masonry cauldron at entrance to cloth-dyeing shop: winged phallus in little temple and phallus in relief. c. 62–79. Stucco and fresco. Excavation photograph, 1911. Soprintendenza Archeologica di Pompei, Neg. 80715

68 Plaque with legend HIC HABITAT FELICITAS ("Here dwells happiness"). First century A.D. Painted terra cotta, 9⅞ × 15¾ in. From Pompeii, region VI, insula 6, 18. The Pornographic Collection, Museo Archeologico Nazionale, Naples, inv. 27741. Photo Michael Larvey

69 Pompeii, region VI, insula 6, 18: interior of bakery, showing original placement of plaque with legend HIC HABITAT FELICITAS ("Here dwells happiness"). First century A.D. After William Gell, Pompeiana: The Topography, Edifices and Ornaments of Pompeii (3rd ed., London, 1852)

70 Pompeii, Villa of the Mysteries, room 4, east wall: midnight sacrifice to Priapus. c. 40 B.C. Fresco. Photo Michael Larvey

71 Ithyphallic Mercury with caduceus and money bag. A.D. 62–79. Fresco from entrance to a bakery at Pompeii, region IX, insula 12, 6. The Pornographic Collection, Museo Archeologico Nazionale, Naples, no inventory number. Photo Michael Larvey

72 Pompeii, House of the Vettii. A.D. 62–79. Digital reconstruction by Kirby Conn

73 Sleeping Hermaphroditus, back view. Roman copy of an original of the second century B.C. Marble, 58 in. Rome, Museo Nazionale Romano, Palazzo Massimo alle Terme, inv. 1087

74 Sleeping Hermaphroditus, front view. Roman copy of an original of the second century B.C. Marble, 58 in. Rome, Museo Nazionale Romano, Palazzo Massimo alle Terme, inv. 1087

75 Ostia, House of Jupiter the Thunderer, entryway: phallus. c. A.D. 150. Mosaic. Photo Michael Larvey

76 Attack on the Evil Eye. c. A.D. 150. Mosaic from Antioch, House of the Evil Eye, entryway. Hatay Archeological Museum, Antakya, Turkey, inv. 1024

77 Pompeii, House of the Menander, entryway to caldarium of bath: black bath servant carrying two water pitchers. 40–20 B.C. Mosaic. Photo Michael Larvey

78 Perseus Liberates Andromeda. c. A.D. 45–79. Fresco. From Pompeii, House of the Dioscuri (VI, 9, 6), peristyle 53. Museo Archeologico Nazionale, Naples, inv. 8998. Photo Michael Larvey

79 Pompeii, The Suburban Baths, room 7, dressing room, east and south walls. A.D. 62–79. Photo Michael Larvey

80 Pompeii, The Suburban Baths, room 7, dressing room, east and south walls. A.D. 62–79. Digital reconstruction by Kirby Conn

81 Pompeii, The Suburban Baths, room 7, Scene I: male-female couple on bed. A.D. 62–79. Fresco. Photo Michael Larvey

82 Pompeii, The Suburban Baths, room 7, Scene II: male-female couple on bed. A.D. 62–79. Fresco. Photo Michael Larvey

83 Pompeii, The Suburban Baths, room 7, Scene III: woman fellating man. A.D. 62–79. Fresco. Photo Michael Larvey

83-1 Pompeii, The Suburban Baths, room 7, Suburban Baths, Scene III, drawing

84 Woman fellating man. First century A.D. Terra-cotta lamp, diam. 3⅝ in. From the area of Vesuvius. The Pornographic Collection, Museo Archeologico Nazionale, Naples, inv. 27864. Photo Michael Larvey

85 Pompeii, The Suburban Baths, room 7, Scene IV: a man performing cunnilingus on a woman. A.D. 62–79. Fresco. Photo Michael Larvey

86 Male-female couple engaging in 69. First century A.D. Terra-cotta lamp. Nicosia, Cyprus Museum, inv. D 2759. Photo courtesy of Museum

87 Pompeii, The Suburban Baths, room 7, scene V: two women copulating. A.D. 62–79. Fresco. Photo Michael Larvey

87-1 Pompeii, The Suburban Baths, room 7, scene V, drawing

88 Pompeii, The Suburban Baths, room 7, scene VI: threesome of two men and a woman. A.D. 62–79. Fresco. Photo Michael Larvey

89 Male-female lovemaking. First half of first century A.D. Two fragments of cup, cameo glass, 3¾ in. The Metropolitan Museum of Art, Gift of Henry G. Marquand, 1881 (81.10.349). Photograph © 2002 The Metropolitan Museum of Art

90 Pompeii, The Suburban Baths, room 7, Scene VII: Foursome of two men and two women. A.D. 62–79. Fresco. Photo Michael Larvey

90-1 Pompeii, The Suburban Baths, room 7: drawing of scene VII

91 Pompeii, The Suburban Baths, room 7: naked man with hydrocele. A.D. 62–79. Fresco. Photo Michael Larvey

92 Ithyphallic satyr pursuing maenad. A.D. 69–96. Terra-cotta bowl from South Gaul, type Oswald A, Dressel 37. Photo C. M. Johns

93 Vitalis. Foursome of two men and two women. A.D. 65–80. Terra-cotta vessel, South Gaul, found at Bregenz, Austria. Copyright Vorarlberger Landesmuseum, Bregenz, inv. B 13.1439

93-1 Vitalis. Foursome of two men and two women. Drawing by Margaret Woodhull

94 Male-female couple on bed with caption BENE FUTUO VOLVI ME. Second to early third century A.D. Applied medallion, terra cotta, diam. 2⅜ in. Lyons, Musée de la civilisation gallo-romaine, inv. 2000.0.2679. Photo J.-M. Degueule

94-1 Male-female couple on bed with caption BENE FUTUO VOLVI ME. Drawing after Pierre Wuilleumier and Amable Audin, Les médaillons d'applique gallo-romains de la vallée du Rhône (Paris, 1952), no. 231

95 Male-female couple on bed with caption TU SOLA NICA. second century A.D. Fragment of applied medallion, terra cotta, diam. 3¾ in. Lyons, Musée de la civilisation gallo-romaine, inv. 2000.0.2567. Photo J.-M. Degueule

95-1 Male-female couple on bed with caption TU SOLA NICA. Drawing after Wuilleumier-Audin, no. 71

96 Male-female couple on boat with caption NAVIGIUM VENERIS. Second century A.D. Applied medallion on vase, terra cotta, diam. 6½ in. From Lyons. Lyons, Musée de la civilisation gallo-romaine, inv. CEL 7645. Photo J.-M. Degueule

96-1 Male-female couple on boat with caption NAVIGIUM VENERIS. Drawing by Armand Desbat

97 Threesome with two men and a woman. Second century A.D. Applied medallion, terra cotta, diam. 4⅜ in. From Lyons, La Solitude. Drawing by Armand Desbat, "Vases a medaillons d'applique des fouilles recentes de Lyon," Figlina 5–6 (1980–1981): no. E 032

98 Threesome with two men and a woman. Second century A.D. Applied medallion, terra cotta, diam. 7 in. From Lyons, rue des Fargues. Drawing by Armand Desbat, "Vases a medaillons d'applique," no. E 001

99 Threesome with two men and a woman, lamp. First century A.D. Terra cotta, from Kavousi, east Crete. Heraklion Museum inv. 9284. Photo Chrysostomos Stefanakis

100 Threesome of two men and a woman. Second to early third century A.D. Applied medallion, terra cotta, diam. 2⅜ in. Nimes, Musée Archéologique inv. 90851.1106. Photo Dejan Stokic

101 Male-female couple with caption ORTE SCUTUS EST. Second century A.D. Applied medallion, terra cotta, diam. 4 in. Found at Arles (1951), lost. After Wuillemier-Audin, no. 74

102 Male-female couple on bed with caption ITA VALEA(m) DECET ME. Second century A.D. Applied medallion, terra cotta, diam. 3⅜ in. From Arles. Arles, Musée de l'Arles antique, inv. CIM 67.00.180

103 Male-female lovemaking with Cupid, lamp. Second century A.D. Terra cotta, diam. 3⅞ in. From Arles. Arles, Musée de l'Arles antique, inv. IRP. 89.2114.333 . Photo Michel Lacanaud

104 Male-female couple on bed, lamp. End of 1st century A.D. Terra cotta, diam. of disk, 3 in. From Arles. Arles, Musée de l'Arles antique, inv. CIM 66.00.106. Photo Michel Lacanaud

105 Ithyphallic dwarf, hanging lamp. Second century A.D. Terra cotta, 3⅞ × 2⅝ in. From Arles. Arles, Musée de l'Arles antique, inv. FAN.91.00.2067. Photo Michel Lacanaud

106 Man and woman copulating with caption VA . . . VIDES QVAM BENE CHALAS. Second century A.D. Applied medallion, plaster cast of original terra cotta, diam. 2⅛ in. Nimes, Musée Archéologique. Photo Victor Lassalle

107 Pompeii, House of the King of Prussia (VII, 9, 33): male-female couple with caption LENTE IMPELLE. A.D. 69–79. Fresco, 17 × 13⅜ in. The Pornographic Collection, Museo Archeologico Nazionale, Naples, inv. 27690. Photo Michael Larvey